PIPER'S PLACES

SCOTNEY: THE 'OLD CASTLE' [frontispiece]
*In Lamberhurst parish on the Kent and East Sussex border,
Scotney Castle is really two castles. The 'old castle' is a
beautiful moated fragment of the original medieval building,
which had large seventeenth-century additions. Parts of
these were pulled down by Edward Hussey when he built the
'new castle' between 1835 and 1844 on the hill above. This
was designed by Anthony Salvin, architect of the fantastic
Harlaxton, in Lincolnshire, (p. 162–3), also built in the
1830s. The stone for the new Scotney was taken from the
south slope of the hill, and in the quarry thus created a fine
garden of roses, large shrubs and trees have flourished for
150 years. Christopher Hussey, the architectural writer and
historian (1899–1969), who left Scotney to the National
Trust, was stimulated by his life there to make the first long
study of the Picturesque movement (*The Picturesque,
*1927), which his predecessors in the family had done so much
to foster.* J.P.

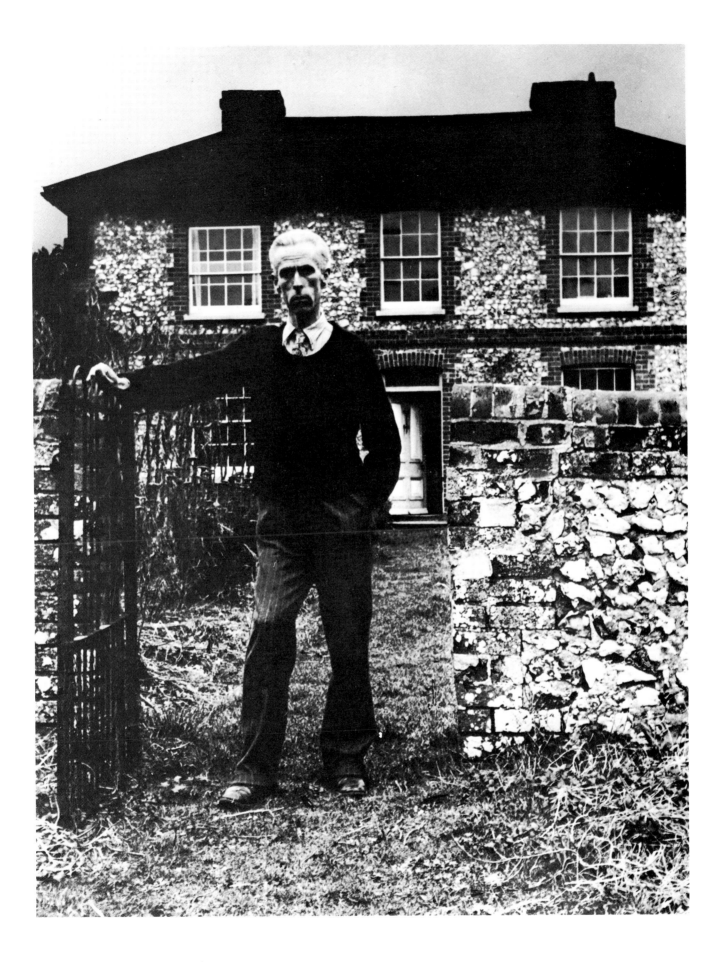

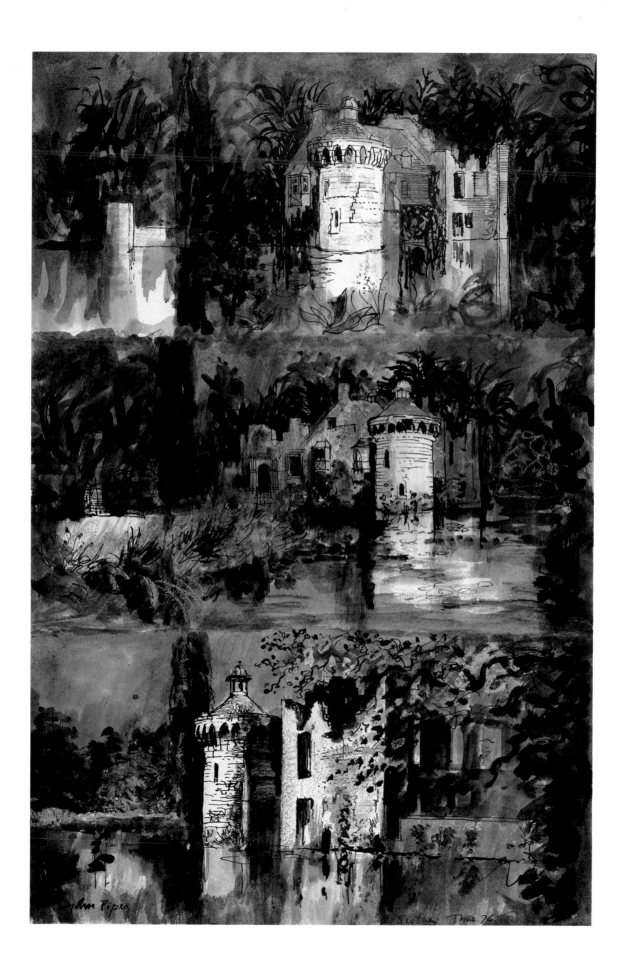

PIPER'S PLACES
John Piper in England & Wales

Richard Ingrams & John Piper

CHATTO & WINDUS · THE HOGARTH PRESS LONDON

Published in 1983 by
Chatto & Windus · The Hogarth Press
40 William IV Street
London WC2N 4DF

British Library
Cataloguing in Publication Data
Ingrams, Richard
 Piper's places.
 1. Piper, John 2. Artists—England—Biography
 I. Title II. Piper, John
 709′.2′4 N6797.P/
ISBN 0 7011 2550 0

The publishers thank Shell UK Ltd
for their sponsorship which enabled them
to provide colour reproductions throughout
this book.

Printed in Great Britain by
Westerham Press Ltd, Westerham, Kent

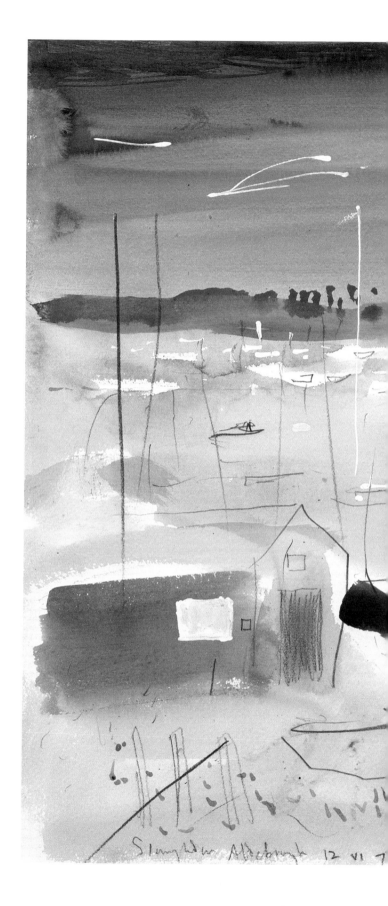

2 Looking towards Snape Maltings, Slaughden,
Aldeburgh, Suffolk 1975
*Piper's association with Aldeburgh goes back to long before
the Aldeburgh Festival. Since the mid-forties hardly a year
has passed without a visit.*

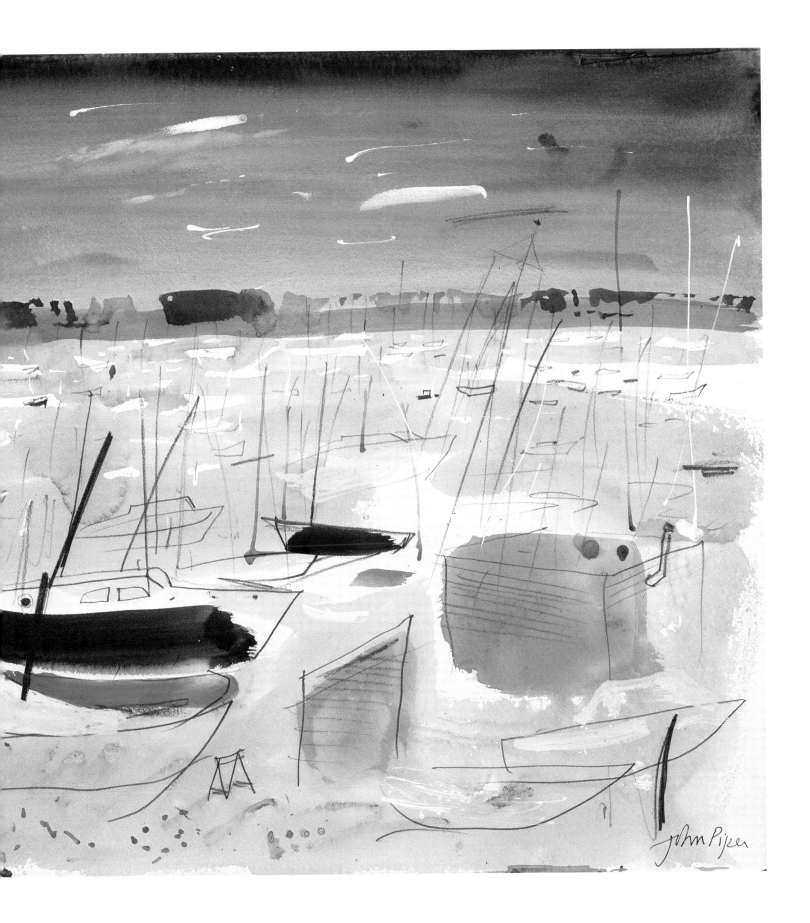

John Piper

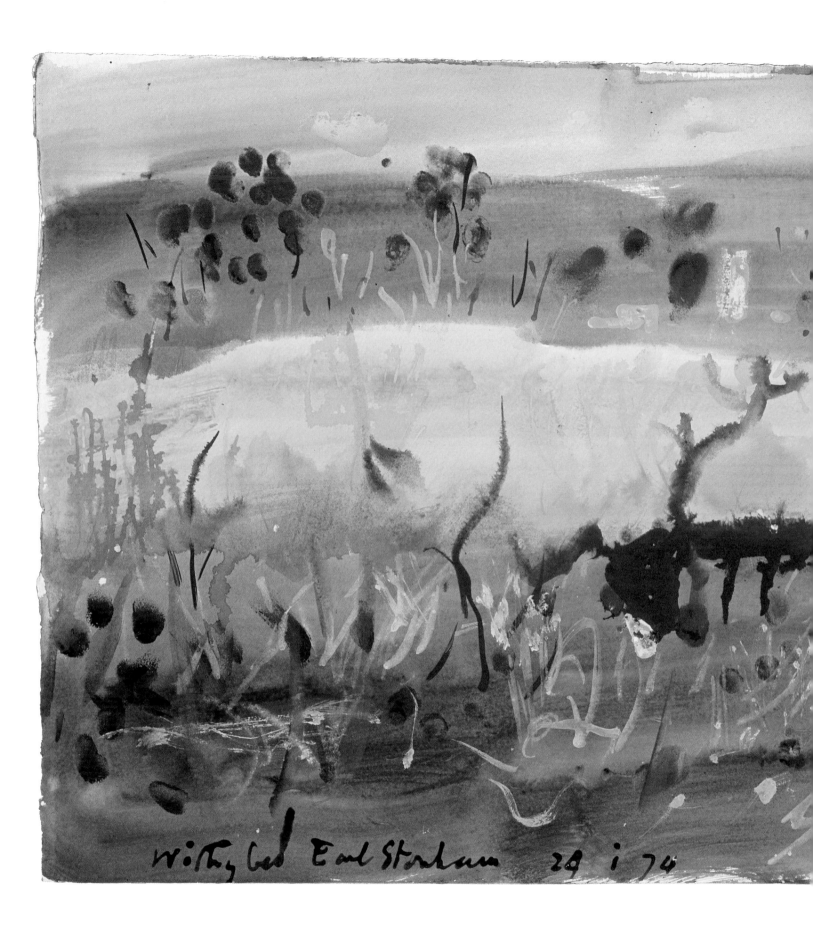

Withy bed Earl Stonham 29 i 74

'He has very different tastes
from both of the other sons . . .
He has taken us about the country
showing us all sorts of places
we should never have visited.'

CHARLES PIPER, *the artist's father*

'The basic and unexplainable
thing about my paintings
is a feeling for places.
Not for "travel", but just
for going somewhere – anywhere,
really – and trying to see
what hasn't been seen before.'

JOHN PIPER, *Sunday Times,* 1962

3 Withy Bed, Earl Stonham, Suffolk 1974

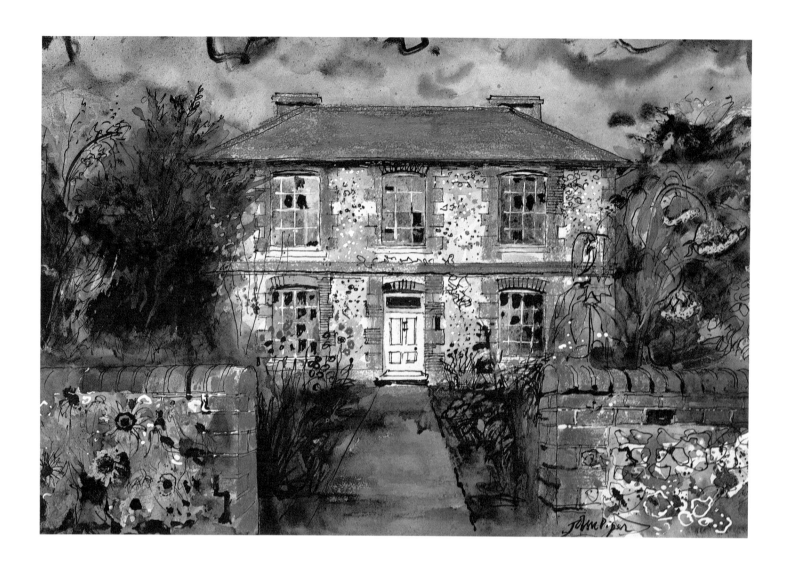

4 Fawley Bottom Farmhouse, Buckinghamshire 1980

Contents

The early years / 14

Abstracts / 21

Seaside gaiety / 25

The 'Archie' / 36

John Piper and John Betjeman / 43

Brighton Aquatints / 54

Wartime / 72

Coventry / 87

Geoffrey Grigson / 88

Derbyshire Domains / 98

Snowdonia / 105

Romney Marsh / 114

Monuments / 122

South Wales / 135

The Fens revisited / 166

List of illustrations / 180

Short bibliography / 182

Index / 183

Introduction

John Piper lives at Fawley Bottom in Buckinghamshire, near Henley-on-Thames, on the edge of a beech wood, in a 'dim shallow valley of the Chilterns'. The house itself is easily missed – a plain square farmhouse built of flint and brick, half-hidden in the trees.

John and his second wife Myfanwy came to live here in 1935. They wanted to live in the country partly because, being a topographical painter, John is always on the move to different parts of England and Wales and it is a great advantage to be able to set off on the road without having to drive for miles through the suburbs of London. They had various reasons for not wanting to live in Surrey, Kent, Essex or Hampshire. They preferred to look west or north-west, and this meant Buckinghamshire, Berkshire or Oxfordshire.

Fawley Bottom is at a point where three counties meet, actually in Buckinghamshire, three hundred yards from Oxfordshire and ten minutes' walk from Berkshire. The Pipers seem to have been almost guided to the house. Myfanwy drew a sketch on an envelope of the sort of house she wanted to live in. It had a solid rectangular façade, a door opening into a garden, and a garden gate opening into a field. Fawley Bottom answered precisely to this description: it was an abandoned farmhouse of a traditional Chiltern type – no beams, diamond-paned windows, half timber or thatch. 'A plain house, that was the ideal, one that would not tie anyone down to period elegance.'

I myself first came here on a foggy December night in 1977. We had been invited to a fireworks party along with our neighbours Osbert Lancaster and Anne Scott-James, his wife. Inside the house the first thing that strikes you on entering the flagged kitchen is the dresser made locally to Piper's own design and covered with brightly coloured mugs of every age and shape. There were drinks in the kitchen before the fireworks and then we all trooped out into the dark and watched a sensational display of rockets, as dazzling as the mugs on the dresser, the colours chosen by Piper himself. In the dark his gaunt white-haired figure could be seen running to and fro, torch in hand, making sure there was a continuous display, and showing astonishing energy for a man of seventy four. Afterwards there was food and drink in the kitchen. All the Pipers' four children were there and several grandchildren. Later Piper was persuaded to play the piano – jazzy songs from the thirties, and Osbert Lancaster sang a solo to loud applause. In the studio, a converted cowshed at the other end of the

house, Piper's latest works were on display – a selection of 'Victorian dream palaces' – vast country houses built by millionaires in the last century and not hitherto regarded as suitable subjects for 'fine art'.

Certain impressions remained from that first visit; the strength and cohesion of the Piper family; the perfectionism involved in mounting an ephemeral firework display; and the calm and order of Piper's studio.

Later I returned to Fawley Bottom to consult John about a book I was writing on Romney Marsh, and following this visit I wrote a magazine feature on the Shell County Guides which led indirectly to the commissioning of this book.

It would be possible to write many different books about John Piper: he has pursued so many different careers – not only as a painter but as stage designer, potter, designer of stained glass and tapestry. However, one activity has remained constant throughout his life – his topographical painting. Whatever his current preoccupations, he has never stopped touring round Britain, in the manner of Turner or Cotman, visiting and re-visiting, exploring, sketching, photographing – trying, as he has said, 'to see what hasn't been seen before.' In many cases Piper has not only painted but written about the places he has seen. He is therefore primarily a Guide who wants to share with others the benefits of his explorations. For this reason he has always treasured something his father said about him when he was young: 'He has taken us about the country showing us all sorts of places we should never have visited.' More than fifty years later, there are many people, including myself, who could say the same.

Piper is a Romantic – though this is easier said than explained. In his book *British Romantic Artists*, he says: 'Romantic Art deals with the particular. The particularisation of Bewick about a bird's wing, of Turner about a waterfall or a hill town, or of Rossetti about Elizabeth Siddall, is the result of a vision that can see in these things something significant beyond ordinary significance; something that for a moment seems to contain the whole world; and, when the moment is past, carries over some comment on life or experience besides the comment on appearances.'

The true Romantic is akin to the mystic – someone who discerns the extraordinary in the ordinary and who finds excitement in his own backyard. Piper is an example of this. Although he has worked abroad, notably in France and Italy, most of his work over sixty years or more has been done in England and Wales and even then not indiscriminately but in particular places. With the one exception of Snowdonia, they are not grand places, and quite often they are places, like the Isle of Portland in Dorset, which the guidebook writers have written off as nondescript deserts. More often than not his subjects are just 'ordinary' – a country church, an old lighthouse, a tumbledown cottage. 'Happy are those,' says Pissarro, 'who see beauty in modest spots where others see nothing.'

Some people have been disconcerted by the absence of the human figure in Piper's pictures. Even on the front at Brighton there is no one about in the Piper aquatint. The artist himself, I suspect, might find it hard to explain why this should be so. What is interesting is that though there are no people to be seen, these places never look deserted. There is nothing eerie or disquieting about them. This is because Piper has invariably caught 'the spirit of the place', the human atmosphere which may be felt especially in old buildings or ruins which have been loved and looked after by generations of people. His pictures are not therefore, as some critics have said, mere backcloths or slabs of scenery, against which the human drama may be acted out. The old churches, ruins, parks and landscapes are alive and welcoming, even though there is no one there.

At the same time it is true that there is a kind of austerity about much of Piper's work, which derives from the artist's own nature. He is a man of strong moral convictions which in turn spring from deeply held religious beliefs. Although he is now well off, he still lives very simply. He is a Puritan in the best sense and also a perfectionist, which means that anything he does, whether it is painting a picture or driving a car, he has to do as well as he possibly can. In some cases such traits would imply a difficult and intolerant character but, as his many friends will tell you, Piper is neither of these things. Humour plays a large and important part in his life, and so does gossip. Everyone who knows him can recall acts of kindness and generosity. To a few he has been more like a father figure, his studio a sanctuary where one could come and pour out one's troubles and go away reassured, not by any specific advice, but by his comforting presence. 'He's a marvellous person to talk to if you're thinking of committing suicide', says Mervyn Horder, his friend and publisher.

It would be impossible to exaggerate the role of his wife Myfanwy in all of this. Although a person of distinction in her own right – a critic of art and literature, and later a writer of librettos for Benjamin Britten and Alan Hoddinott – she has been a tower of strength without whom her husband might not have survived those periods when his work was out of favour.

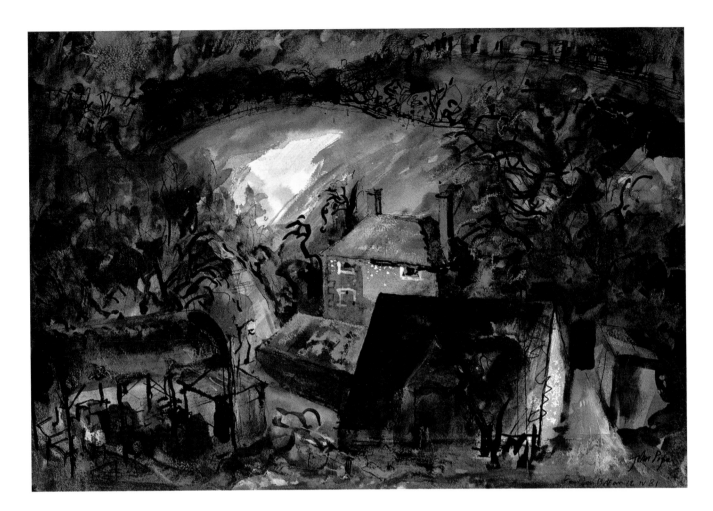

For obvious reasons it is not possible in a book of this scope to give a comprehensive survey of all of John Piper's topographical work. Such a book would probably end up by including almost every place in the country. What I have done, with his help, is to select those places which for one reason or another have meant most to him during his long career as a painter. Usually what this means is that he has not only painted them but written about them as well. Even so there are bound to be omissions, some of which may be resented by those who cherish a particular Piper painting.

There have already been a number of studies of John Piper's art and I would like to acknowledge my debt to their authors. They are John Betjeman (*John Piper*, in Penguin Modern Painters, 1948); S. John Woods (*John Piper*, 1955) and Anthony West (*John Piper*, 1979).

I would like, in addition, to thank all those who have helped me with advice and information, especially Sir James Richards, Sir Osbert Lancaster, Sir John Betjeman, Mervyn Horder, Douglas Billingsley, Vyvyan Rees, Geoffrey Grigson and John Read. My thanks are also due to Edward Piper for his help in selecting and assembling the pictures.

5 Farm at Fawley Bottom, Buckinghamshire 1982

The early years

John Piper was born in 1903. He was the youngest of three sons, the eldest of whom was killed in the First World War. His father, Charles Alfred Piper, had established a family firm of solicitors, Piper Smith and Piper, in Vincent Square, London, living over the office. But when they began to have children the Pipers moved from London to a large Victorian villa in Epsom and it was here that he grew up and went to school. Epsom was still country then and not the suburban sprawl it has since become. The Piper house was a large one standing in its own grounds. There was a cook, a gardener, housemaids, all the trappings of the comfortable bourgeois world which flourished before the First World War.

But Piper's father was by no means a dull and unimaginative solicitor. 'A Fabianish nonconformist', Piper described him later, 'a bit of an intellectual – as far as he dared to be.' He himself as a young man had aspired to be an artist and architect, attending classes at a weekly art school. He also loved the English countryside and country churches, making notes and lists of them.

These interests were inherited by his son John, who showed artistic leanings at an early age. His father wrote in his privately printed memoir *63 Not Out*: 'He has very different tastes from both of the other sons ... he has of his own volition developed a taste for drawing, music, painting, poetry and architectural lore ...'.

John Piper's topographical passion, which has stayed with him throughout his long life, developed at an early age. When only ten he was saving up his pocket money to buy copies of the *Highways and Byways* series of county guidebooks published by Macmillan. These rambling, rather too literary books gave him his first pleasure in reading, and the illustrations by artists like F. L. Griggs made a lasting impression.

Luckily for John, Charles Piper did not believe in boarding school education, so when he went to Epsom College it was as a day-boy. He was therefore spared many of the scarring influences of public school life; though even as a day-boy Piper found himself bullied by rugger thugs. His tastes were educated more by family friends than schoolmasters, in particular by a young Church of England curate, Father Victor Kenna. Kenna was an exceptional man; a pianist who had been a pupil of Arthur Schnabel and also an amateur archaeologist.

By the age of fourteen Piper had looked at every church in Surrey. At fifteen, with his school friend Frank Milward, he made his first trip to Romney Marsh and the two boys camped in a tent near Snargate. They visited the Mermaid Inn in Rye, where they were befriended by the landlady, the ex-wife of Richard Aldington. One day they bicycled over to Great Dixter and were let into the house by giggling servant girls and spent the afternoon playing the pianola and singing songs.

Piper made other explorations with Milward to Derbyshire and also to Cornwall. Already he had established a routine which he has followed all his life, that of making expeditions to different parts of the country for four or five days at a time, usually with a travelling companion – his wife Myfanwy, his eldest son Edward, John Betjeman, Geoffrey Grigson and, in later years, Alan Hartley, family doctor and friend – taking notes, photographing and sketching as he goes. Though, obviously, his style of drawing and of writing has changed and developed over the years, his methods have not. His power of observation, his knowledge of good and bad architecture, seem to have been fully developed when he was quite young. In 1921 when he was eighteen he went with his parents and his brother Gordon on a trip up the Thames to Oxford, through the Cotswolds to Stratford, then via Cambridge into East Anglia. Throughout the fortnight he kept a detailed record of the journey, illustrating it with his sketches and photographs in a notebook which is really a kind of prototype of the later *Shell* or *Murray Guides*.

The influence of the *Highways and Byways* is very noticeable in these early sketchbooks. The drawings are imitation Griggs and the writing echoes the rather quaint and old world phrases of the Edwardian guidebook writers. Thus Blakeney Church beacon is a guide to 'mariners' rather than sailors; Yarmouth boasts a 'seeming multitude of theatres' while 'the trying odours of bloaters pervades the back streets'.

At the same time it is noteworthy that his knowledge of architecture is very considerable and his tastes fully developed: 'Ingworth receives a very inadequate description in the *Little Guide to Norfolk* which says "tower (of church) fell: 1822". The quaint appearance of the outside is due to the fact that the roof is thatched. A stump of the tower remains at the W. end and a bell-cot has been erected on the W. gable of the nave. Inside the church presents a pleasing, old world appearance, as it has suffered little from "restoration". Box pews remain on the N. of the nave (one with carving similar to that which appears on the pulpit). The tower arch at the W. end of the nave has been built up. It is very plain, circular-headed and has plain square capitals: it is generally of the form usually attributed to Saxon archi-

tecture, many of the Norfolk round towers being known to be of Saxon origin (e.g. Haddiscoe and others). It may well be so.'

Piper's relentless energy when it comes to 'church-crawling' is already apparent. Thus on one typical day, 15 August, he and his brother went from Saffron Walden to Thaxted, Chickney, Newport, Wendens Ambo, Great Chishill, Barley, Wimbish, Melbourn, Harston, Trumpington and Cambridge.* Also apparent is his liking for countryside which others dismiss as nondescript: 'From Aythorp Roding we went by winding lanes to Willingale Spain and Willingale Doe through some very pretty country. Traversing this part of Essex shows the traveller how untrue that favourite saying of those who do not know the country well is – that it is flat and uninteresting and monotonous over the whole of its area. The country is beautiful and the villages as quiet and rural as could be wished. Willingale Spain and Doe have the curiosity of two churches in one churchyard (one of the eight examples of this phenomenon in England) and the curiosity is accounted for by the wildest of local traditions.'

On leaving school Piper became an articled clerk in his father's firm of solicitors. But though Piper senior was pleased with his son's progress and assumed that he would inevitably follow in his own footsteps, Piper was not happy with his lot. When his father died suddenly in 1926 he at once abandoned the law and went to the Royal College of Art, having at last decided that what he wanted to be was a painter. 'I was undoubtedly a flop', he writes of his time at the RCA. 'When I arrived I was a bit sophisticated and arrogant and not at all humble. I managed to scrape into the Painting School through the kindness of Hubert Wellington, the Registrar; but he said I must go to Richmond Art School for a year before I could be accepted and I was lucky enough to be

*A similarly hectic itinerary was noted by Mervyn Horder in his diary for 1941: '17 Jan. Ice-cold but sunny day touring the churches of N. Northants, *duce* John P. Not a very inspiring lot, I thought, but he likes the dim and unassuming. Dingley, Brampton Ash, Stoke Albany, Wilbarston. E. Carlton, Cottingham, Gretton, Deene, Bulwick, Southwick, Woodnewton, Apethorpe and Fotheringhay were those we managed . . .
18 Jan. 'Much even colder snow and a piercing wind but John wasn't daunted. The Langtons, Stonton Wyville, Stockerston (good old glass), Brooke, Braunston, Uppingham (interlude talking to local photographer who has a good selection of church postcards), Whitwell (a wedding just about to start here and the rector gave us a quick look round while the congregation was filing in), Normanton (an astonishing folly-like erection in the middle of fields like a ship at sea), the Luffenhams, Lyddington, Duddington and several more, mostly Rutland, made up the bag.'

taught my first elements of drawing by Raymond Coxon, who had recently been at the Royal College with Henry Moore.

'It was by far the best teaching I ever had. I can remember some of the things he told me to this day, and if I ever feel like writing "self-taught" after my name I immediately correct myself with shame.

'I was a bit shocked when I got to college to find that life-drawing – in which I believed profoundly and wanted to do passionately – was made so boring. However, young ex-student teachers again gave one hope – Tom Monnington and Morris Kestleman among them – and I survived to paint, do summer camps, make my first lithographs and copy a Cézanne in the Tate on Tuesdays.

'I did not see a great deal of the Principal, Sir William Rothenstein, and I know now that I never made proper use of the opportunities. I did not learn any profound truths except from fellow-students – who, after all, can be the chief point of even a fine art school.

'Anyway, within two years of entering I got married and left, not exactly under a cloud because I do not think my departure was of any more interest than my arrival. Since I had not even completed the course I left without a diploma and without prizes or honours of any kind.

'I feel gratitude to the college all the same, for its freedom, its unfussiness (in other words for leaving one alone) and for its other students.'

Impatient to be married and embark on a painter's career, Piper left the Royal College of Art in 1928. He was twenty-five. His first wife was Eileen Holding, a fellow student at Richmond. But there was no money to be made, at that stage, from painting. To begin with he supplemented what his mother gave him by writing, reviewing books, plays, concerts and films for the *Nation*, then owned by the Cadburys. The literary editor was the poet Edmund Blunden, who invited Piper down to his home in Kent and encouraged him to write. Under Blunden's tuition he developed the art of writing short descriptive pieces, which was later to be invaluable to him when he became a writer of guidebooks. Blunden, as it happened, was also Myfanwy Piper's English tutor at Oxford.

In his work for the *Nation* Piper showed not only his artistic versatility, but a firm and authoritative critical sense which seems to have been with him from his earliest years. Whatever his likes and dislikes, he has always had a very clear idea of what artists are trying to do in their different fields and the ability to decide whether they have pulled it off; and he was always ready

to find good things in overlooked and unlikely places. Thus, after dismissing the Mary Pickford/Douglas Fairbanks film of *The Taming of the Shrew*, Piper remarks: 'The "comic" which preceded the "big film" really *was*, its subject being a half-brother of Felix the Cat; while an "Educational" on the life of a pea (in a quarter of an hour or so) was not only "educational" but enthralling.'

At the same time he was getting his first taste of the fierce feuding which goes on in the supposedly dignified world of the 'the arts'. Cecil Beaton published in 1930 *The Book of Beauty*, a collection of photographs of fashionable figures. Virginia Woolf had declined to be photographed, but this did not stop Beaton including a drawing of her in the book. Piper was given *The Book of Beauty* to review, and the *Nation* being pro-Bloomsbury in its outlook and therefore on the side of Virginia Woolf, his inclination was to attack it. He did so, so successfully that Beaton ever afterwards refused to speak to him and only relented shortly before his death when the two were reconciled.

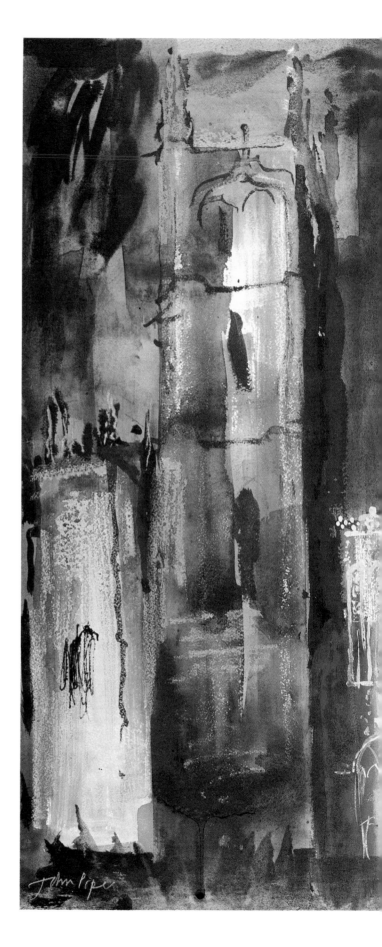

6 Six Somerset Towers 1980
left to right: Kingsbury Episcopi, Backwell, Batcombe, Long Sutton, Huish Episcopi, Ruishton

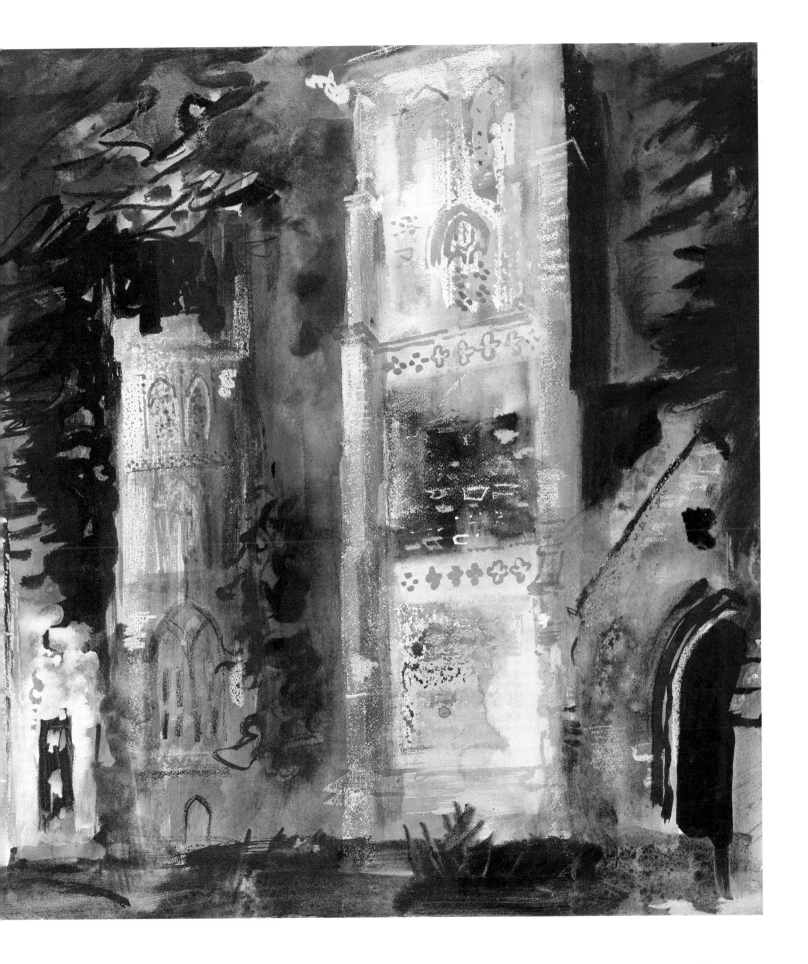

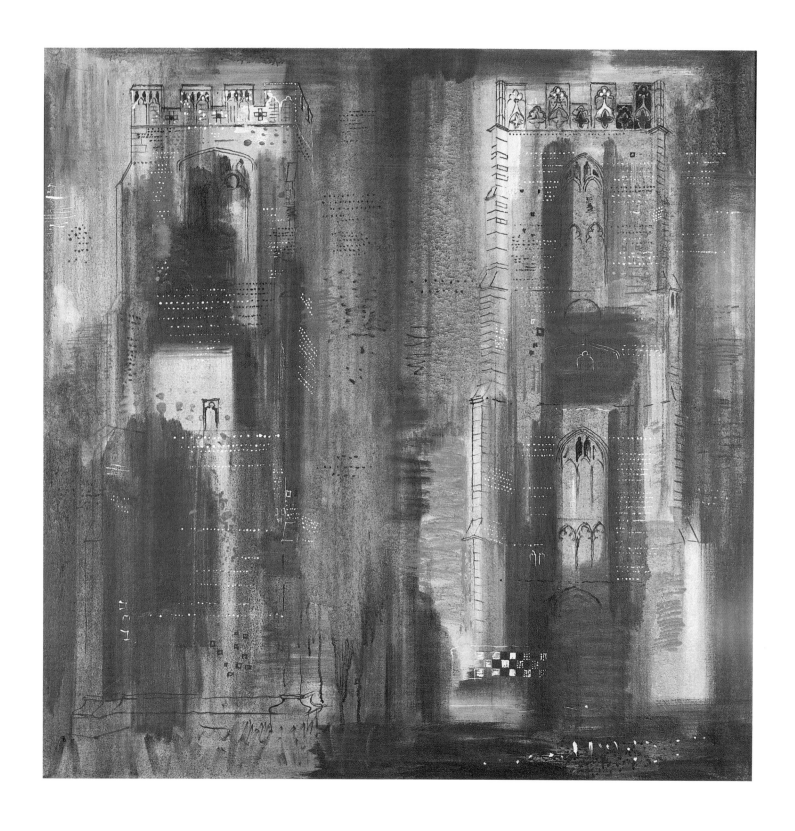

7 Two Suffolk Towers: Alpheton and Stansfield 1969

8 Wymondham Church from the west, Norfolk 1965

19

9 Two Suffolk Towers
[left] Brundish and [right] Lavenham 1969

Abstracts

The authoritative tone which Piper evinced in his written criticism was also now to be seen in his painting. In 1931 at the age of twenty-eight he exhibited a painting called *Rose Cottage, Rye Harbour*. With this picture, as Anthony West says, Piper 'found his own voice at last', while other artists who saw it 'would remember it as the first Piper they had ever seen'. All the same it was not for a few years that the artist himself recognised the nature of his achievement. During the greater part of the thirties, he experimented with the techniques of the Avant-Garde. Partly under the influence of Ben Nicholson, he tried his hand at Abstracts, constructions and collages.

Of this important phase in his development Piper writes:

'In the early thirties, when I had not long left the Royal College of Art, my work was undisciplined, dependent on various likes and supposed dislikes – admiration for Picasso, Braque, Léger and Matisse, and strong anti-Academic prejudices. I began to make totally abstract pictures for a few years from 1934. I never had any intention of remaining an abstract artist but I took the abstract practice very seriously and became interested, and later personally involved through friendships, with other abstract work here and abroad. This kind of work at the time was looked on as an affectation or an amusing hobby, though artists such as Mondrian and Brancusi were already beginning to worry critics and other serious people who would not have worried had the paintings and sculptures they made not been so obviously beautiful *as objects.*

'But I knew I must keep in touch through my paintings with other things beside object-making and pure abstraction – things outside myself that I had long loved: standing stones and hill forts, harbours and lighthouses and fishing boats pulled up on stone quays. And with English topography in general, especially English landscape painting and in particular Turner. He was a great abstract painter but never a pure and total one, and I loved his work from the age of ten when it was anything but popular except with connoisseurs and cranks.

'My first totally abstract pictures were constructions, with straight and bent rods and discs on a different plane from, but near the surface of, the picture, which in itself was often varied in its own surface (for instance, smooth enamelled areas were neighboured by coarse sandpaper areas. I had not met Alexander Calder about this time for nothing. These constructions were made at Betchworth in Surrey in the summer of 1932. They succeeded

10 Rose Cottage, Rye Harbour, Sussex 1931

some paintings using string glued to the canvas surface (itself glued to board, to keep it flat). One of these, called *String Figure*, was shown at the "Seven and Five" (Seven Painters and Five Sculptors) exhibition in 1932. Quite abstract paintings succeeded the constructions, the first done in the winter and early spring, 1934–5. They continued for three years, and at the same time I was also making collages on paper. I had seen a show of Picasso's *papiers collés* of 1912–13 (just after the invention of Cubism), at the Galerie Pierre in the Rue de Seine in Paris, and was deeply impressed by the intense poetry that he generated by putting two or three bits of Ingres paper on a white sheet, with a few ink marks here and there. My collages used bits of paper cut or torn and applied in a more or less arbitrary way to a sheet of paper – some had paper doilies (usually representing draped and hooked-back window curtains). Others had torn strips of used blotting paper (clouds), or paper run through a printing press several times (the impressions out of register with one another), picked up off the floor at a music printing works (waves, stormy seas or textured walls could be indicated by these), and flags, numbers, scraps of old posters and other things that have a double "read-over" of abstraction and reality. I produced a large number of landscapes using such methods and materials, a lot of them done on the spot at small ports and fishing quays (Newhaven, Dungeness) on the south coast and in Ireland and Wales. I carried about a portfolio full of torn and cut strips of paper of different colours, (and a variety of shades of the same colour), saved or picked up at random and in the heat of the

moment, stuck or pinned insecurely, then applied more carefully at leisure in the studio. The colours of these "casual" pieces of paper often influenced the colour of the more formal abstract paintings I was doing at the time. The collages were my means of keeping in touch with natural appearances. The bits of paper were parallels for seen things – not representations of anything concrete.

'This whole painting/collage procedure was carefully planned, and satisfied me as a procedure for work until about 1937 or the beginning of 1938. Working in this way, one was living in a protected world which very few people understood at the time, or had any desire to share. It was a means of isolating oneself for a time completely from the shoddy world of "effective" sketching and casual, bright, hit-or-miss colouring. For twenty years the Paris Post-Impressionists had been making clear and definitive statements. They could not be ignored.

'By 1938 the looming war made the clear but closed world of abstract art untenable for me. It made the whole pattern and structure of thousands of English sites more precious as they became more likely to disappear. Anyway, what I had learned was now part of me, and an integral and prominent part at that. The abstract practice taught me a lot that I would not have learned without it, and all the time I had hold, through the collages, of a lifeline to natural appearances – and so to early Palmer, to Turner, early and late (topographical and less purely topographical) and to our whole Romantic tradition in which it has always been possible for meaningful details to shine like beacons in the damp, misty evanescence of our beautiful island light and weather.'

What Piper could never shed was his nationality and upbringing, as he was half-expected to do by the extremists of the Modern art movement, whose aim was to reproduce a supposedly international style. He has therefore been dismissed in some quarters as provincial, a slur that could be, and probably has been, levelled at most great English artists – Blake, Samuel Palmer, Constable – who never went far beyond their native England. (Piper has never been to America and has never been in an aeroplane.) It was no accident that his disengagement from the Abstract Movement coincided with a growing friendship with Paul Nash (1889–1946), the most distinguished of modern British Romantic painters. 'Paul Nash', writes Anthony West in his recent study of Piper's work, 'who was a very English character indeed, was fond of declaring that there was such a thing as "Englishness" that no English artist should try to evade. Nash's view was that a painter could neither disown his cultural legacy from the past nor repudiate his visual experience of the local scene.'

Being an English or British painter meant resigning oneself to the probable lack of any international recognition. Piper himself writes: 'I don't think British painting is likely to win wide international acceptance in the immediate future any more than in the past. A painter here and there is appreciated abroad; but in the past, it has always been because he has conserved and consolidated personal convictions and a personal gift, not because he has allied himself to a movement or thrown in his lot with international styles, though he may quite sensibly be influenced by both. Blake has never really 'made it' abroad as a painter; Turner has, at intervals, and has then been forgotten again; Constable was admired by Delacroix perhaps; Kline has expressed admiration for the drawings of Augustus John and so on. But it is all very desultory and haphazard and I don't see why this should change. The real merit of British painting is that it is at its best romantic, unclassical, particular, fanatical, self-obsessed, the product of close observation in a misty country that has long winter evenings, a climate that produces Bewick and Jack Smith, Cotman and Roger Hilton, Fuseli and Francis Bacon and the drawings of Romney and Frank Auerbach.'

And, of course, John Piper.

11 Dungeness, Kent 1936

22

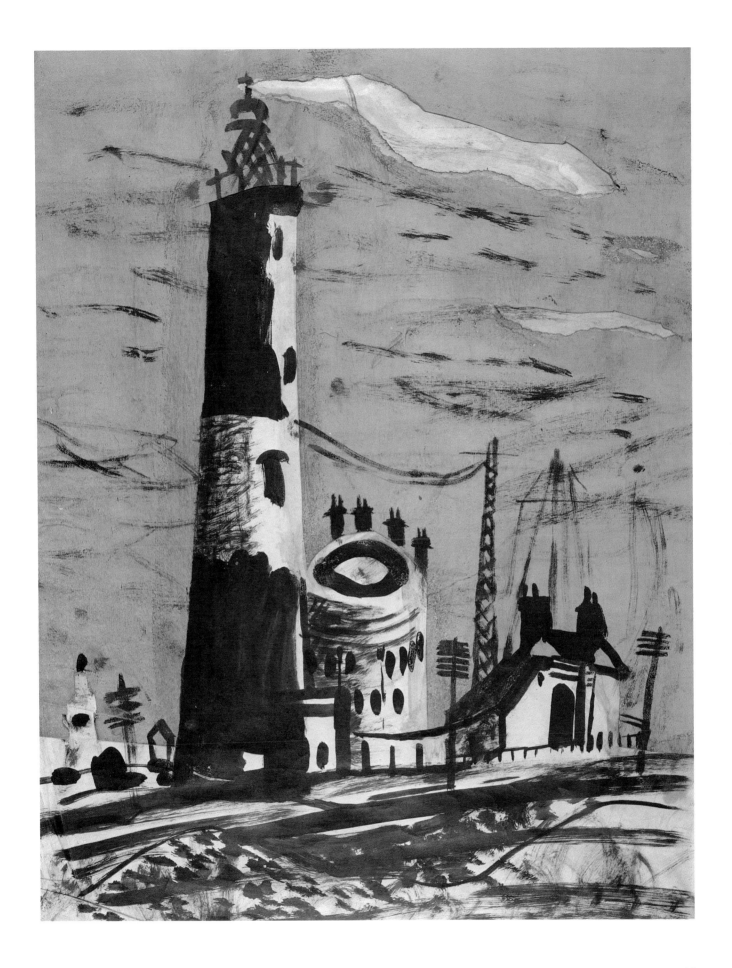

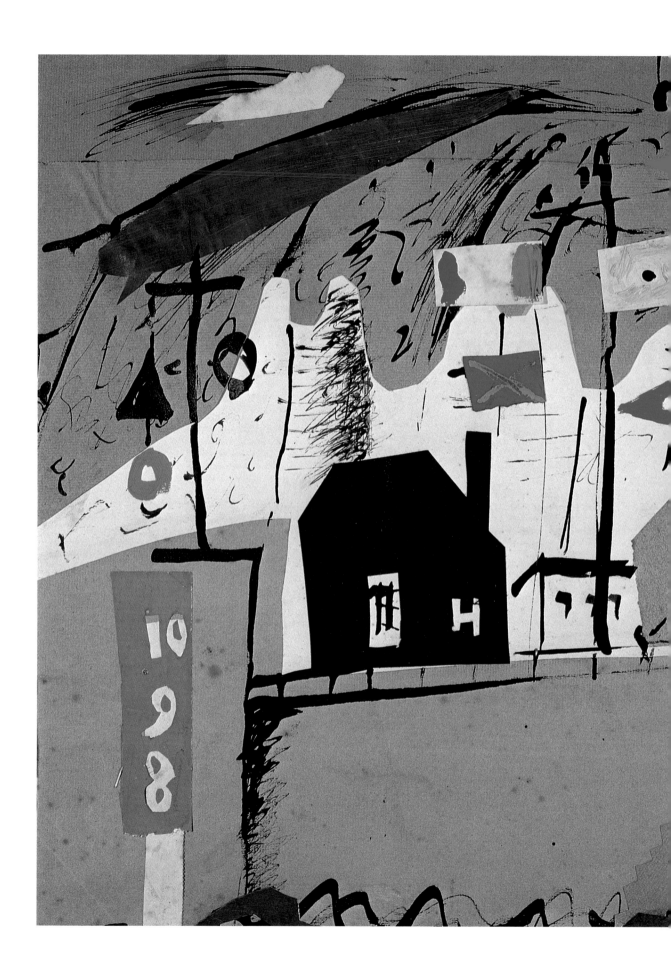

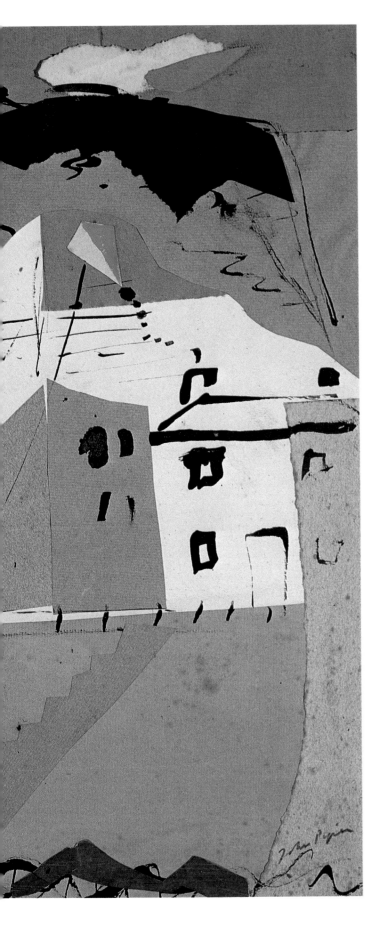

Seaside gaiety

In 1930–31, Piper and his first wife lived briefly at a cottage at Betchworth in Surrey. One advantage was that it was near to the South Coast. 'There is no place in England', Piper once wrote, 'more than seventy miles from the sea. The sea is the mystery that lies beyond the flat fields and the woods, the downs, the rough moors and the black country recesses; never far away.' Many of his earliest paintings were done on the South Coast, especially Selsey, Newhaven, Dungeness and Rye Harbour. The seaside has always been a happy hunting ground for Piper. But typically, he has not gone after white sandy beaches or towering cliffs and rolling breakers, as one might expect of a conventional 'Romantic' artist. He is drawn more to the architectural features of the coastline. He wrote in the *Architectural Review*: 'The lighthouse, the lifeboat house with its slipway, the customs house, the boat building shed are all functional buildings, but the builders of them never thought of attempting to banish personal taste from them. They are functional but they are something else as well. They have strength, gaiety of design and colour (even if it is only the gaiety of black and white) and they are usually in startling contrast with their surroundings.'

Dungeness and Newhaven, ships and lighthouses, are continuing Piper themes. But there was one particular place which seemed to epitomise all that he liked about the coast. This was the 'Isle of Portland', near Weymouth in Dorset. Though connected with the mainland by a causeway Portland is an island in everything but name, quite different in character from the mainland. For a start it has no grand houses and little or no tourist trade, as I discovered when I visited it with the Pipers in 1981. It looks at first sight bleak and forbidding especially on a November afternoon. 'I don't know why we've come here,' Piper said, as we drove up the hill and headed toward Portland Bill. 'There's nothing to see.'

The film-maker John Read described the atmosphere in the film he made there with Piper in 1958: 'The place has an abandoned air. A litter of isolated objects lie about, scattered over the shore and landscape. Rocks and lobster pots. Old boats on a deserted coast. A new lighthouse, and stones piled like toy bricks. Heavy derricks on empty quays. The village streets have an unfamiliar look, and strange houses are strung out in a line, as in a

12 Newhaven, Sussex *c.* 1936

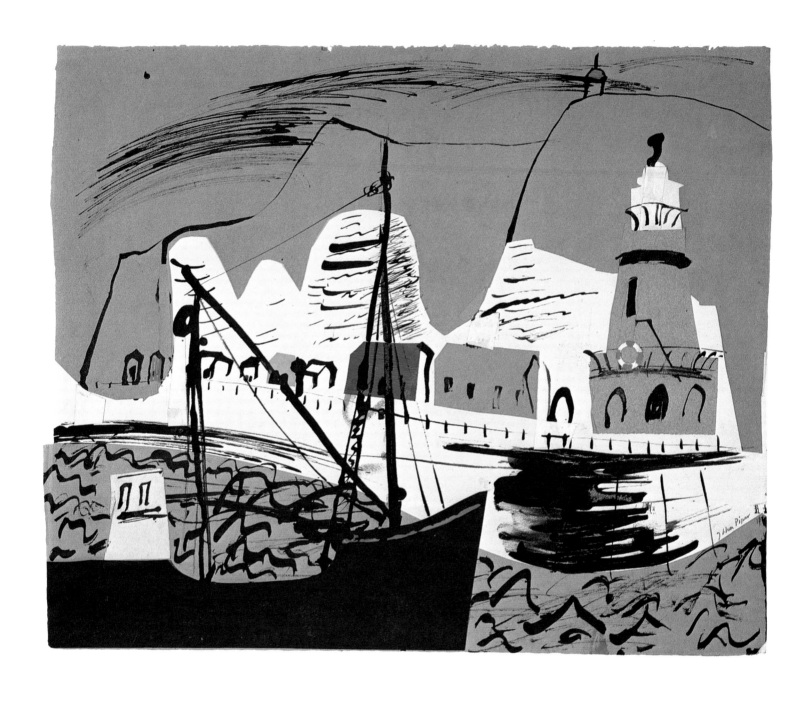

13 Newhaven Harbour and Cliff, Sussex 1936

14 Seaford, Sussex *c.* 1936

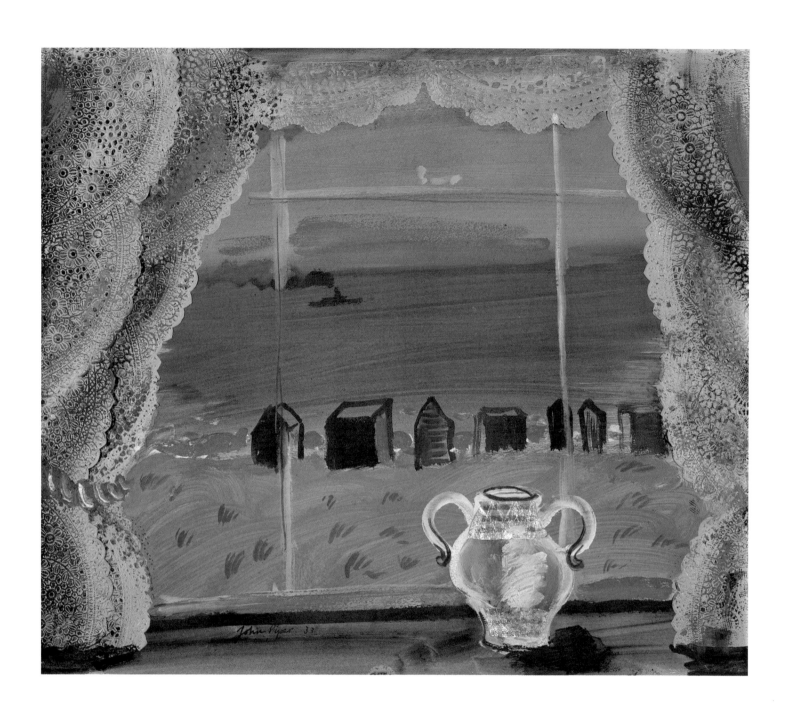

15 Beach Huts, Kent 1933

child's painting. They pick their way across a surface pitted with disused quarries, huts and heaps of rubble. A broken skyline is made untidy with rooftops, and the cables, poles, masts and aerials that link together this scattered community.'

Like many Piper locations, Portland has been written off by other visitors. Sir Frederick Treves, a Dorset-born surgeon, patron of the famous 'Elephant man', once described the place in *The Highways and Byways of Dorset* as it must have struck many who gave it only a cursory glance: 'A dismal heap of stone standing out into the sea.... The island was ever wind-swept, barren and sour, tree-less and ill-supplied with water.... There are a few plots of ground where depressing phases of agriculture are being carried out, and where patches of corn and potatoes are grown under protest. There is not a tree to be seen from the summit of the island, for the flora of the Portland plateau consists of harsh grass, a few teazles and an occasional starving bramble bush.'

It is this air of romantic desolation that attracts Piper. The island is famous for its stone – Portland Stone which was used by Inigo Jones and Wren to build their London churches, and later for modern landmarks like Bush House. Although quarrying still goes on here, Piper is drawn to the relics of the past:

'Great rectangular blocks, with cutting marks in regular rows, lie about everywhere, weathering in the rain and wind and odd unrectangular but still angular blocks have been thrown aside, blocks whose stratification has defeated the expert quarryman; other blocks wait to be shipped from the low cliffs, and now wait for ever, for the shipping of stone from the shore near the Bill ceased about fifty years ago and the moss and wind and lichen have had their way with them. In the quarries yet more stone lies half cut, surprised by the light, with the straight strata joints exposed as if it had all been cut and packed away and hidden there by men in the first place, and has been waiting all this time for other men to unpack it and take it out again. And among the debris of the whole island, among the half-humanized blocks thrown about, stand the equally miraculous-looking consolidations of blocks into neat dwellings, low and solid among the strips of common land, with new crazy-paved villas here and there, and newer collections of pre-fabs and concrete and brick houses, and another crazy tangle of electricity wires overhead, the skyline cut by television aerials, and by more distant derricks and radar masts...'.

Piper came here first in about 1929. He returned with his wife Myfanwy in 1934 and they stayed in a house in Abbotsbury, nine miles from Weymouth, a village famous for its ruined abbey and the swannery by the sea. John and Myfanwy walked all the way along the Chesil Beach, an arduous journey over miles of shingle, commemorated by one of the very few Piper landscape drawings which has a human figure in it.

Not much has changed since Piper's early visits, though many of the white slabs of stone which at one time seemed to cover the whole of the island have been removed. At Portland Bill itself there is now a large car park but the rows of brightly painted holiday huts are still there and the triangular 'sea-mark' next to the lighthouse and the little stone cottage with the stepped roof standing near the derricks which are now used by fishermen to lower their boats into the sea.

The church of St George Reforne at Easton, deserted at the time of the BBC film, is now being restored. It is made from 'Roach' stone – 'from a design sent down from London – in return for all the stone that had built so many London churches'. Piper has drawn and painted the church from almost every angle, as well as the forest of tombstones which surrounds it and which provide a wonderful variety of funereal motifs all carved by local craftsmen.

Portland 1933

John Piper

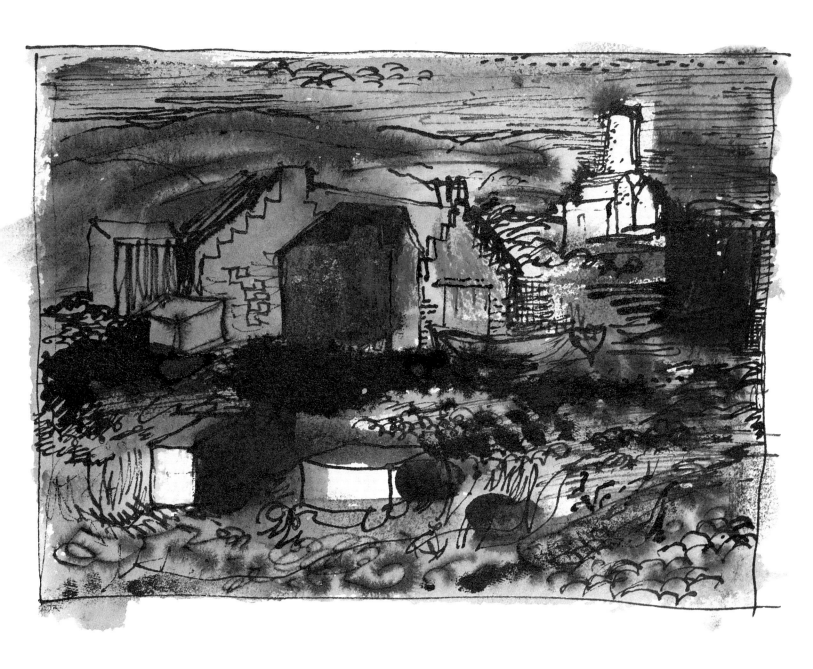

16 Portland, Dorset 1933

17 Portland, Dorset 1981

18 Portland, Dorset 1942

John Piper

19 Chesil Beach, Dorset 1934

20 St George Reforne, Easton, Portland, Dorset 1954 21 St George Reforne, Easton, Portland, Dorset 1954

22 [left] Detail of gravestone
St George Reforne Churchyard, Easton, Portland,
Dorset 1954

23 Local craftsmanship in stone, St George Reforne
Church, Easton, Portland, Dorset 1954
Illustration from *Ambassador*

24 Corbels, East Riding, Yorkshire
Illustration from *Architectural Review*

The 'Archie'

In 1936 Piper began a long association with the *Architectural Review*, one of two journals owned by the Architectural Press. Its editor was Hubert de Cronin Hastings whose family also owned the controlling interest in the two papers. Although Hastings was a shy rather non-communicative type he was an inspired editor who turned the *Architectural Review* into something much more exciting and less narrow than its specialist title suggests. Contributors in the pre-war period included John Piper, Eric Ravilious, Geoffrey Grigson, Edward Bawden and many others whose interests ranged beyond the narrow confines of architecture.

In May 1935 J. M. Richards succeeded John Betjeman as assistant editor of the *Architectural Review* and it was Richards who took on Piper as a regular contributor. Richards, nicknamed 'Karl Marx' by Betjeman on account of his supposedly left-wing views, was in fact no more left-wing than many other young men during the thirties. He was an Anglo-Irishman who had practised as an architect in Dublin and America before taking to journalism and the *Review*. He was immediately attracted by Piper's way of looking at buildings not with the eyes of an historian or an antiquarian, but as an artist, seeing them as objects of beauty. One of Piper's particular enthusiasms at that time, one which has remained with him throughout his life, was for Romanesque sculpture and he had just been motoring round the country taking photographs of some examples. At Richards's suggestion he contributed an article to the 'Archie' (another Betjeman nickname) on the subject which was published in October 1936 under the title 'England's Early Sculptors' – his first contribution to the paper.

From the word go Piper's message was to tell his fellow countrymen that if they wanted to find things of beauty or visual interest they need look no further than under their noses. 'England's Early Sculptors' was headed by a favourite quotation from Langtoft's *Chronicle*: 'A wander wit of Wiltshire rambling to Rome to gaze at antiquities and there skrewing himself into the company of antiquarians, they entreated him to illustrate unto them that famous monument in his country called Stonage [Stonehenge]. His answer was that he had never seen, scarce ever heard of it, whereupon they kicked him out of doors and bad him goe home and see Stonage. And I wish that all such Episcopale Cocks as slight these admired stones and scrape for barley cornes of vanity on foreigne dung hills, might be handled, or rather footed, as he was.'

The inferiority complex of the Englishman extended to his art and architecture. 'We dare not think we have any merit', Piper had written elsewhere. 'Our island is not remote enough. We are conscious of the discouraging examples of France and Italy, with their overwhelming artistic riches, and we are also – less excusably – cowed by the constantly wagging finger of the German (and his student, the British) Art Historian. We are not allowed for one single minute to imagine that Moore might be a British Michelangelo, or Turner nearly as good as Claude. One (literary) critic tells us that Constable is overpraised, another that it is absurd to regard most of Blake's drawings as anything but incompetent bungles. As to our architecture, we are apt to be steered off by some learned men with their eyes half shut into regarding it as a matter of specialized interest not universal beauty. There are bigger and better foreign prototypes, for most individual British specimens. It is not true, but again we are cowed.'

The message was repeated in 'England's Early Sculptors', in which Piper picked out a number of early medieval carvings like the font at Toller Fratrum, Dorset. (This was a favourite subject of his. Once he and Myfanwy drove through the night from their home near Henley just to look at it and show it to a friend, returning the following morning.)

Another example which he later painted was the tympanum at Rowlstone in Herefordshire. 'Here', he wrote, 'a sustained line is used in a most subtle way to charge a design which is at once rhythmical and rigid – as if the Christ enthroned is both a seated, immovable Majesty and a flowing, abundant Life. Not again until Blake did this specially English genius show itself so well: this genius for making a line at once create a shape and enrich it with meaning as part of a whole design, for making, in Blake's own words, "Firm and determinate lineaments unbroken by shadows, which ought to display and not hide the form. ... Leave out this line and you leave out life itself; all is chaos again, and the line of the Almighty must be drawn out upon it before man or beast can exist."'

This tympanum was certainly a masterpiece but, 'English modesty cropping up again, it is very little known – compared with the tympanum at Vézelay, for instance, which is bigger, grander and richer, but no "better": unless the landscapes of Rubens are "better" than those of Constable.'

This article was to be the first of many which Piper contributed to the 'Archie'. For a fee of £20 a year he was taken on as 'guide, adviser, chauffeur and photographer'. He and Richards made two trips round England

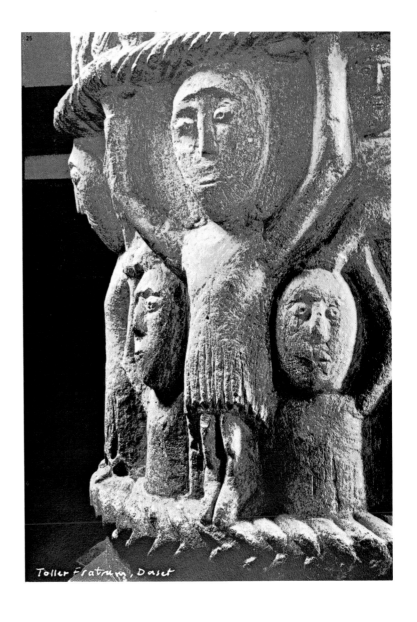

Toller Fratrum, Dorset

25 Detail of the font, Toller Fratrum, Dorset 1936

26 Romanesque tympanum with hanging lamp,
Rowlstone, Herefordshire 1952

27 The font, Avington, Berkshire 1952

Holdgate Ser p 21/b /vii /73

John Piper

28 Holdgate, Shropshire 1973

in Piper's two-seater Lancia ('I always went in for rather grand second-hand cars in those days.') They went to Lincolnshire, to the South Coast, to Yorkshire, taking note of everything that caught their eye. As always Piper sketched, took photographs and made notes. The result was a series of highly original articles on such subjects as lighthouses and pubs. To us who take the artistic worth of eighteenth-century warehouses and the cut glass in Victorian gin palaces for granted, it is difficult to grasp just how far ahead of their time these essays were. Once again Piper and Richards seemed to be saying, 'If you want to see something good you need look no further than under your nose'.

A typical Piper/Richards expedition involved a trip down the Bath Road, noticing everything of architectural interest, with Piper stopping to take photographs and sketch – a thatched petrol station at Cranford; 'distant Windsor castle flickers between tourist inns and untidy garages'; Victorian villas at Maidenhead (one called 'Dawn') – always ready to find an appeal in apparently nondescript places. 'People avoid Reading', Piper wrote, 'but even the streets of terracotta shops and houses in the centre of town have a good deal to be said for them when you know them in different lights. A setting sun with a slight evening mist, or a damp day during open weather in February or March gives them an air that separates Reading in character from every other south country town. The washable weather-resisting surface that will hardly change with centuries of wear, changes its look constantly with the different lights of different days, and has plenty of delights to satisfy an unprejudiced eye'. (Unfortunately much of central Reading has since been demolished.)

There was nothing, however, nostalgic about this journey, and although the authors condemned a great deal of modern development and planning they were always ready to see good in the buildings of any period, including their own. Piper made detailed drawings of three unfashionable mid-Victorian villas on the Western outskirts of Reading, the kind of buildings that architectural pundits of the time would have dismissed as useless. 'It is their uselessness I like', he wrote, 'and their over-richness and their proportion all their own. These villas are the result of lithographs of Italy. They illustrate Sherlock Holmes, for it was in a house like these that the Norwood builder lived. Verandahs which are never sat in; gas light in stained glass halls; under-servants; murders in the basement; death on the first floor; plaster ceilings that the uninitiated might think were seventeenth century and a great plaster chrysanthemum for the gasolier. Geraniums in urns in the garden. ''In'' and ''Out''

Between Reading and Newbury: top, folly tower on a hill at Pincent's Farm, near Theale; second, entering Theale Village; third, fourth and fifth, roadside scenery between Theale and Newbury: an old inn, a new garage, a mansion in its park.

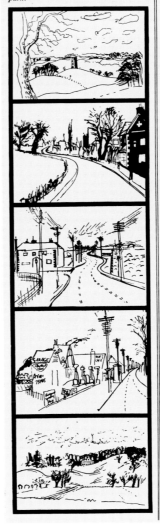

built in a slight bow, nearly opposite, but just west of St. Mary's Church, Castle Street which is 18th century, with portico and gabled cupola. Gascoigne's warehouse-front and offices (red brick). Terrace of stucco houses beyond, with round-headed Bath Road windows. Other brick houses near these, some with bowed fronts. Villas-in-their-own-grounds, mid-Victorian, Gothik, Italianate and fancy going west from Castle Street (later in date further west.) Late Victorian gate lodges to Coley Avenue.

READING TO NEWBURY "The road from Newberry to Reading leads through lanes, from which a flat and woody country is exhibited on the right, and rising grounds on the left. Some unpleasant common fields intervene." (William Gilpin, going in the opposite direction in 1789.) Today, there is sludge again going out of Reading, but it is relieved by two old Bath Road estates on the right—Prospect Park and Calcot Park (the first a public park, the second a golf club: both have fine Georgian houses). Calcot Row, in the " common fields," shows a complete indifference to road decencies. There is a lot of advertising and an air of litter, and just beyond it a glare of new villas at the moment crawling into the open fields. Theale has a narrow street, and traces of coaching character. (Theale and Thatcham are the only problems on this stretch.)

All the way from Reading through Newbury to Hungerford the Bath Road, the main line of the G.W.R., the River Kennet and the Kennet and Avon Canal neighbour one another—never much over a mile apart, usually closer. This continual counterpoint in the flat valley has a pleasant effect. The near landscape is almost treeless, with low wooded slopes lying back on each side. The villa disgrace dribbles on in patches, but the villages related to the main road are sensibly related—usually something over a mile away. Between Theale and Thatcham, to the north of the road, are Englefield, Bradfield, Beenham, Bucklebury Common, Midgham and Cold Ash and to the south, all just over a mile from the road, with their own approaching lanes, and all preserving their rural beauties, Sulhampstead, Ufton Nervet, Padworth, Aldermaston and Brimpton. The straights are not too long and " arterial," the curves are easy, the intersections well-managed (notably to Pangbourne on the right and to Basingstoke on the left) and there is good tree-planting here and there—some of it recent. In many places there are wide grass verges. People trumpet " medievalist " if any but a perfectly straight road is suggested as a model for modern road building; and yet this nine miles between Theale and Thatcham is easier for present-day traffic, less dangerous, more beautiful—and perhaps slightly slower—than nine miles on a new road.

After Theale the only places that interrupt the open run are Woolhampton and Thatcham. Thatcham has an awkward corner.

29 Between Reading and Newbury
Illustration from *Architectural Review*

on the front door and gravel sweep for the Brougham and a hot house for the orchids. Sunday dinner and a well established firm in the town. Tea and croquet.'

This affectionate interest in the suburbs later bore fruit in *The Castles on the Ground* which J. M. Richards wrote in 1946. It was illustrated by Piper with a number of lithographs of villas in Epsom and Henley.

30 [below] Bookjacket showing Piper's mother's house, St Martin's Avenue, Epsom, Surrey 1946

31 [right] Italianate houses at Reading, Berkshire 1939 Illustration from *Architectural Review*

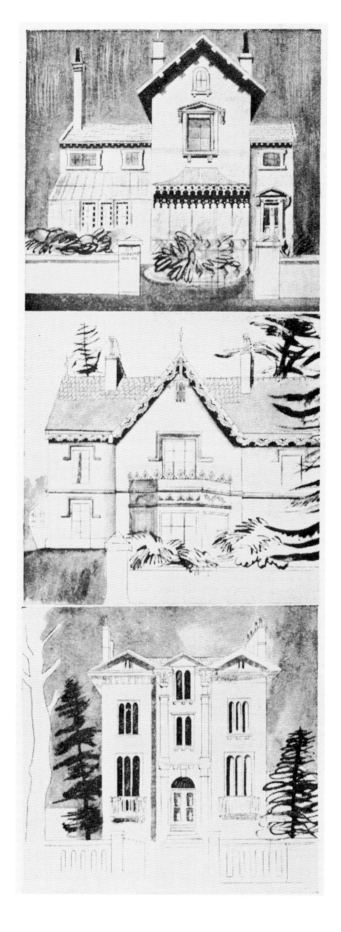

John Piper and John Betjeman

It was Jim Richards who first introduced Piper to John Betjeman, though it is hard to imagine that, given their common interests and purpose, they would not have joined forces at some time of their own accord.

Betjeman was born in 1906, the son of a prosperous furniture manufacturer. An only child, he went to the Dragon School in Oxford and then to Marlborough. Like Piper he was fascinated by architecture when he was a boy and had bicycled round villages noting all the varieties of early English style. 'Church crawling', he says, 'is the richest of pleasures. It leads you to the remotest and quietest country, it introduces you to the history of England in stone and wood and glass which is always truer than what you read in books. It was through looking at churches that I came to believe in the reason why churches were built.'

He went to Oxford in 1925 and left without a degree three years later. Politically, he said, he was 'a parlour pink' and his religion was Anglo-Catholic, as it has remained ever since, despite the strenuous efforts of his friend Evelyn Waugh to convert him to Rome. Like Waugh he taught at prep schools after leaving Oxford. Then he got a job on the *Architectural Review*. 'In those merry days of the late twenties and early thirties', he writes, 'it was still possible to find employment without passing examinations. Old friends pulled strings. My friend Maurice Bowra, then Dean of Wadham, approached the late Maurice Hastings ... and Maurice Hastings spoke to his quiet brother Hubert de Cronin Hastings and I was accepted onto the staff of the *Architectural Review*'.

Betjeman, who had a nickname for everyone, called de Cronin Hastings 'Obscurity' because of his shyness; but he had no doubts about his editorial flair. 'The leading spirit', he says, 'was Obscurity Hastings who said every page must be a surprise. Obscurity used to assemble all over the floor of our first floor room in 9 Queen Anne's Gate the photographs from which we were to choose pictures. He said you must have an idea in your mind of the issue to be laid out. We then had pieces of blank paper with the type area marked by printer's rules, and on these Obscurity would draw out where the photographs were to go. Almost every time his drawings exactly corresponded with the block to be made. We worked in half-tone 150 screen, and it was my job to scale up the blocks by holding up the photograph to the light, drawing a diagonal across the part to be reproduced and then finding out how broad and how deep it would look on the page. A general rule with Obscurity was details large, even outsize, landscapes small. The laying out of the issue was the most important thing. The text was very much an afterthought, just grey matter filling the spaces between the photographs.'

Betjeman left the *Architectural Review* in 1935 and his job was taken over by Richards. The same year he approached J. L. Beddington, Publicity Manager of Shell-Mex BP, with the idea of his sponsoring a series of guidebooks to different counties. Jack Beddington (thereafter known to Betjeman as 'Beddy Old Man' to distinguish him from his father Beddy Oldest Man, Beddy Middleman and Beddy Young Man – brother and son respectively), was a brilliant publicity man and patron of artists who had recruited to work for him at Shell a team of bright young men known as 'Mr Beddington's Young Gentlemen' which included Rex Whistler, Nicolas Bentley, Edward Ardizzone and Peter Quennell. They produced posters and other publicity material. Their best known work was the series of advertisements with a picture of a double-headed man and the slogan 'That's Shell – That Was', a formula that passed into the language.

Beddington agreed to finance Betjeman's guidebooks project and the first *Shell Guide*, Betjeman's own *Cornwall*, was published by the Architectural Press in 1934. It cost half-a-crown ($12\frac{1}{2}$p) and used a distinctive Spirax wire binding and a variety of interesting type faces. Betjeman now likes to say that his main interest in producing the early *Shell Guides* was as an experimental typographer. In fact, of course, his purpose was less frivolous. Guidebooks at that time were confined to Methuen's *Little Guides* which, Betjeman says, consisted of 'teetotal information for tourists'. The famous *Highways and Byways* series, which had meant so much to John Piper as a boy, was on the way out. Betjeman was disgusted by accepted ideas about architecture. Anything put up after about 1714 was frowned upon. John Piper noted later how the beautiful little church at Chiselhampton, Oxfordshire, built in 1763, was dismissed in *Murray's Handbook* (1894) as 'a modern church with a bell-turret such as is usually placed on stables'. Attitudes to Victorian buildings were equally snooty.

The guidebooks of the past were concerned, Betjeman said, 'with the search for style or with particular details which interested their authors such as brasses, bells or church plate or woodwork.' Churches were classified in abbreviated forms – Norm, Trans, E.E., Dec, Perp. The only alternative to the *Shell Guides* (from the fifties) was the massive *Buildings of England* project of Prof Nikolaus

Pevsner, a refugee from Germany who was in the process of cataloguing everything. Betjeman called him the 'Herr Doktor Professor' and treated him as an Aunt Sally who had turned architectural history into a mere detective game. From the other side Betjeman was viewed as something of a playboy, an exhibitionist, and certainly not a proper scholar.

Beddington now took Betjeman onto the staff of Shell. He worked for three days a week from an office in the Shell building, sallying forth from time to time into the countryside, often in the company of a photographer called Maurice Beck. ('An Old Rugbeian,' Betjeman recalls, 'very fat and full of laughter. I used to call him "the old filthy". He liked taking pictures of nude women covered in oil. He didn't like churches one bit.') Beck was also quite firm about his brief. 'Out of the county. I'm not going in there', he would say if Betjeman suggested they inspect an interesting-looking church not in the area covered by the guide.

Betjeman himself wrote two of the early *Shell Guides,* *Cornwall* (1934), and *Devon* (1936). He then commissioned some of his Oxford friends to do other counties. Peter Quennell did *Somerset* and Robert Byron *Wiltshire. Kent* was the work of Lord Clonmore ('Cracky Clonmore. He was about the least known peer there was.') Other guides, like Paul Nash's *Dorset*, were more authoritative, illustrated by Nash's own watercolours and photographs. Betjeman selected the illustrations, wrote captions and chose typefaces. He was especially proud of Stephen Bone's *The West Coast of Scotland*, which was printed in purple ink. 'It was all a lark in those days. There were no scholars.'

In his search for new writers Betjeman could not have found a better recruit than Piper. The two hit it off from the start. 'We realised we liked the same things,' Betjeman says. They had a great deal in common. They were both children of the middle class; both had rebelled against fathers who wanted them to take over the family business; both had spent their childhood and teens cycling round the countryside looking at churches. From now on they were going to do so together, by car.

To some of their contemporaries this love of old churches must have seemed perverse and antiquarian – like so many of Betjeman's passions surely a bit of a pose? But so far from pursuing some eccentric fad, Piper and Betjeman were following a respectable Romantic tradition. They looked on the medieval churches of England, quite rightly, as our most valuable inheritance

32 Adderbury, Oxfordshire *c.* 1975

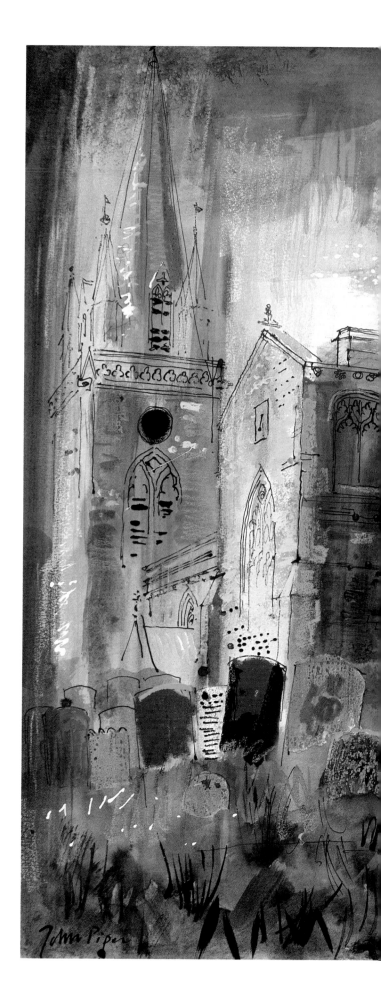

44

25 vi 73
Adderbury Oxon

45

from the past. It was an attitude that would have been understood and applauded by Cotman, Cobbett, Samuel Palmer, Ruskin, Turner and William Morris – to name only a few. People needed to be told what they were missing; and once again, as so often where Piper was concerned, the message was that you didn't have to go far from your doorstep to find beauty.

Piper was commissioned to do the Oxfordshire *Shell Guide* and the book was published in 1938. A guidebook should have two aims: one is to accompany the traveller and alert him to things to look out for; the other, more difficult to achieve, is to appeal to the armchair reader and inspire him to go out and explore. To be successful it has to be personal. 'I like a guidebook to be to some extent a diary', Piper wrote in his preface to the second edition of *Oxfordshire*, 'with a diary's prejudices and superficialities and perhaps some of its vividness'. This sort of approach was quite original. Inspired to some extent by John Betjeman's *Cornwall* and *Devon* – in Piper's view the revised *Cornwall* was 'the model *Shell Guide* of all time' – he had the advantage over his friend in being an artist who was able to use pictures (especially photographs) as well as words to convey atmosphere. Superficially viewed Oxfordshire had nothing very much to commend it. There were few beauty spots – 'nothing about which Oxfordshire inhabitants can get unbearably sentimental.' But this lack of excitement was something that appealed to Piper, who has always hankered after what Henry James called 'unmitigated England'. 'Though I like churches to be special', he says, 'I like country to be ordinary'. He therefore almost went out of his way to play down the grand set pieces like Blenheim Palace and even the best-known examples of the Cotswold picturesque like Burford, concentrating instead on small, significant and often humorous detail – a limestone wall, a blanket mill, a collection of advertisements nailed to a tree, a cottage doorway with washing hung on the line, a decaying tombstone in long grass. The very first picture in the guide was of an old Cotswold Manor House with a board stuck on the wall announcing 'Site for Super Cinema'; on the opposite page a corner of a neglected old walled garden by a stream with straggling espalier, wooden barrel and cracked cold frame. Next, a gamekeeper's gibbet on a wall; dead flowers on a marble chip grave and then a magnificent double-spread photograph of thunderclouds looming over the village of Shilton. 'If that picture comes out', Piper remembers telling Myfanwy, 'we'll make our fortune.'

It is hard to imagine how original such photographs were in their day. The traditional illustrations in guide books were at the time mostly supplied by agencies or they consisted of what Betjeman called – after the doyen of topographical photographers – 'Dixon Scott', the kind of picture postcard scenery in which the view has been framed by an arch of foliage in the foreground. Many years later, when Piper had taken over the editorship of the *Shell Guides*, he wrote in a preface: 'The pictures in these guides are not chosen for their popular holiday appeal, nor as advertisements for the places and buildings they show. The special character of a village or a house or a stretch of country is what, in the end, is exciting and memorable about it and this character may be brought out not only by camera angles and quality of negative and print but by cloud or lack of it, in fact by many different effects of lighting, mood, weather and season. These considerations have influenced the choice of pictures more than the demand for conventional compositions in sharp focus and perpetual sunshine.'

Accompanying these pictures and drawings was a written gazetteer which showed the same attention to pointful detail, using a few vivid phrases to describe the feel of villages – a difficult thing to do but one which Piper has always been supremely good at. Here he is on Ewelme:

'Ewelme is a picture-book village and is residential as well as workaday. It is in a gulley with a Chiltern-foot clear stream that widens into watercress beds. Church is a careful and elaborate fifteenth-century building, justly celebrated for its design and contents, including Chaucer and Suffolk tombs, especially that of Alice, Duchess of Suffolk, Chaucer's granddaughter, 1477, which has great delicacy of detail. Many brasses also. The roof, the stately font cover, the pale old wooden screen and the early nineteenth-century poppy-head pews are good things. The Mothers' Union blue drawing-room carpets, the clumsy electric fittings and some other internal touchings-up are not. Jerome K. Jerome is buried in the churchyard. Almshouses, with a court, of early brick, and a school beside them are near the church. Benson aerodrome is too near for quiet comfort.'

Myfanwy Piper went with her husband on his forays into Oxfordshire and contributed a brief essay to the guide on 'Deserted Places' showing that she is as good a descriptive writer as her husband: 'Oxfordshire is the place for vanished magnificence. Go by the back road to Oxford through Watlington and Cowley and you will pass on your way, near Stadhampton, the huge wide-set stone posts of Ascott House. Behind them a double lime avenue nearly a hundred yards wide leads to where the house of the Dormer family once was – burnt down before it was lived in, in 1662, and never rebuilt. From the road the tufted grass is not broken by ditches and

tumps and the holes of ancient foundations, but leads boldly away to nothing. So the great scale of the avenue and posts remains undestroyed, as if the house that ought to be there has been taken up temporarily into a cloud. At the top and behind the trees are two neat octagonal buildings, one on each side. But if you enter the grounds from the fields at the back you come on the whole paraphernalia of ruined sites; mounds and twisted trees, paths that end in desolation, and the flagged and weedy stuffiness of ancient fishponds.'

Oxon, as it was titled in typical Betjeman style, was to be followed by *Shropshire*, the first collaboration between Betjeman and Piper. (Although this was written in 1939 it was not published until after the war.) Shropshire needed doing and neither of them knew it at all well. They drove up to Shrewsbury in Piper's car and stayed at the Prince Rupert hotel, conveniently situated near St Mary's church where Betjeman was able to attend Communion daily. All in all they made about five separate journeys to Shropshire. 'It was marvellous going with Mr Piper for the first time', Betjeman says. 'It was like going to Brazil or somewhere. It was also frightfully funny. He always related people to buildings. He liked speculating about vicars and architects.' They spent much of their time visiting churches. 'We always thought looking at a village meant looking at the church.' Piper took numerous photographs as well as making drawings and sketches. 'He drew absolutely certainly with a quill pen', Betjeman remembers, 'and you could tell at once from the line whether it was decayed or Victorian . . . I don't think I've ever felt so confident as I did with Mr Piper. I remember once in Salop I suddenly lost my temper and then I felt I had wounded a tame animal.' (This loss of temper may well have been caused by Piper's unremitting energy. He remembers Betjeman complaining, 'I can't do more than ten churches a day, old boy.')

It was at Much Wenlock that he got his Betjeman nickname of 'Mr Piper'. They called at the hotel for tea and were told to sit in a Hardyesque waiting-room. Finally a waitress came in and said in a strong North Country accent, 'Will you two men come forward please'. When they sat down Betjeman started talking in a similar accent, pretending to be a business executive and referring solemnly to his colleague as 'Mr Piper'. The name stuck.

It is impossible to distinguish Betjeman from Piper in the Shell *Shropshire*. They observe and write as one person. Neither is primarily interested in the Shropshire scenery – the beauties of Wenlock Edge and the Long Mynd – though proper acknowledgement is made to

both. The book is first and foremost about churches. Betjeman and Piper made a church their starting-off point, and then looked at the village and the scenery in which it was set. More often than not the church was a disappointment, having been ruined by the Victorians, though some, like Petton, were striking 'in spite of restorations and beautifyings in 1871 and 1896'. Occasionally there was a surprise, for example Tong, which 'even now causes one to gasp at its effigies and its woodwork, It is possible in an evening light to imagine the effigies rising from these slabs and peopling the church and giving it a look of delightful and exaggerated venerability such as one sees in a Victorian engraving.'

Betjeman wrote a long description of the town of Shrewsbury. 'It is unfortunate', he noted, 'but not to be wondered at that the only books written about the town of Shrewsbury do not notice anything later than Cromwell, except Auden's *Shrewsbury*.' He soon put this to rights, singling out buildings like the Eye, Ear and Throat Hospital by Alfred Waterhouse (1881).

Piper was drawn to the 'attractively untidy' early nineteenth-century industrial scenery, much of it in a state of decay, which was to be found to the east of Shrewsbury. At Coalport, once famous for its pottery, he noted: 'A few shattered brownish-red brick workshops, a kiln or two, are all that remain of the potteries and early industry. Some sheds are now used for making rubber mats out of old motor tyres. Here and there, too, are rows of cottages. The progress up the gorge to Ironbridge on a sunset evening is unforgettably beautiful and desolate.'

As always where Betjeman and Piper were concerned, there was an appealing combination of frivolity, a profound knowledge of architecture and a reverence, based on strong religious faith, for old churches. 'It is surprising', the gazetteer notes, 'how many prominent but indifferent architects of the last seventy years have been employed in the town of Ellesmere.' At Hengoed, the authors observe, 'There is an orthopaedic hospital which is also a training school for masseuses and medical gymnasts'; while at Chelmarsh, 'On the occasion of our visit in May 1939, the incumbent was kind enough to show us a reputed burial mark of a monk's heart high up in the east wall of the chancel.'

Some Shell readers might have wondered what to make of the entry under Ludford: 'On the occasion of our visit in May 1939 the sacred well of St Julian (under a lead cover by the churchyard well) proved efficacious in a case of influenza.'

Such tomfoolery was no doubt intended, on Betjeman's part at least, to jolt the more solemn type of

33 and 34 Jackfield by Ironbridge, Shropshire 1979
*In the brick, tile and china area of the Severn Valley.
The church, by Sir Arthur Blomfield, is built of local
materials.*

35 [opposite] The Vestry, Brightwell Baldwin,
Oxfordshire
Illustration for John Betjeman's poem
'Diary of a Church Mouse'

reader who would not expect an architectural guidebook to include jokes, let alone those of an irreverent tendency. But only a superficial reader could object. What comes over, as in all the Betjeman-Piper collaborations, is a deep affection not just for churches as objects of aesthetic beauty, but for the Christian religion and the Church of England in particular. It was no accident that a few months after their visits to Shropshire John and Myfanwy Piper were confirmed as members of the Church of England. Betjeman, typically, disclaims any part in the conversion of his friend. ('It was probably looking at all those Norman fonts', he says.) But it was impossible for someone of Piper's sensitivity to be long in Betjeman's company without falling under the spell of his personality, and without coming to share in his religious vision:

'No love that in a family dwells,
　　No carolling in frosty air,
Nor all the steeple-shaking bells
　　Can with this single Truth compare
That God was Man in Palestine
　　And lives to-day in Bread and Wine.

As to the frivolity, Mervyn Horder tells me: 'I have the most agreeable memories of evenings spent at Fawley at the end of these early topographical expeditions. The preparation of Myfanwy's incomparable supper usually took place to the sound of American musical comedy numbers and Mozart's piano concertos; John played both by ear with enormous élan occasionally rescued and redirected by me with the music at a second piano. The music carried on after supper, with the addition of solo hymn-singing by Myfanwy, till the end of the day when we gathered on sofas round a huge log fire and settled into half an hour of Church Consequences, a game of unknown origin I have never played anywhere else.

'Each player writes down a single line about a church – as it might be – *Poor old Terrington St Clements, sinking in the marshes fast* – his neighbour then adds a rhyming line plus a line of his own which *his* neighbour has to amplify in the same way, and so on. After some twelve lines the poems are brought to an end with the single final line necessary, and read out. The results were most curious.

'I remember the two Pipers, Betjeman and Lancaster as the most spirited practitioners of this game – with John Summerson and Jim Richards sometimes joining in. The topics ranged as widely as possible over every likely and unlikely aspect of British church life: churches, churchyards, incumbents, curates, organists, cleaners, diocesan authorities, liturgy, heating and lighting systems,

children's corners; to say nothing of the private lives, marital affairs and inmost thoughts of all concerned. The churches chosen for the game might be either real or notional, and I think pious parishioners from the first class might have been astonished at the rather *outré* peccadillos attributed in these ruthless rhymes to their church officials . . .

'Being a novice myself in matters of church architecture, I found, when each evening was over, I had to do a lot of surreptitious work with reference books to discover the meaning of such terms as pyx, aumbry, baldacchino, and so on, so that I could use them with the necessary confidence next time we played. I have often since wished I had quietly picked up and stowed away the best of these sheets of instant doggerel, which after all included, in his own handwriting, some of the more extravagant sallies of our beloved Poet Laureate; but of course at that age one never thinks of stowing anything away.'

The Pipers can recall one complete 'consequence':

When they called in Sir Gilbert at Reading, St Chad's,
He took the whole building away,
And erected instead, which was one of his fads,
A marquee which was blessed the next day.
When the weather was wet it was empty of course,
But when it was fine it was thronged,
And the smell of the grass made the worshippers hoarse,
And liturgical rites were all wronged.

John Betjeman remembers only a fragment referring to the parish of Millbrook in Bedfordshire:

Believe me Canon Cotton
The acoustics here are rotten.

Shropshire was the beginning of a partnership which did more than to teach Englishmen to love their churches and their Church than anything or anyone else in modern times. It is a sign of their success that it is now hard to imagine the indifference that to begin with greeted their efforts. Betjeman was treated as a poseur and an anti-quarian while Piper was thought in advanced artistic circles to have betrayed the modern movement by devoting himself to provincial tasks. One critic referred to 'a waspish pair, consisting of a writer of funny verses and odds and ends, and an austere, would-be latterday Cotman'. Even in the fifties it was a struggle for Betjeman to find a publisher for what became *Collins Guide to English Parish Churches* (illustrated by Piper), a book that marked the culmination of their efforts.

In the meantime there were to be other collaborations, including more guidebooks. One of the most successful was Betjeman's *Poems in the Porch* (1955) which brought out the humour, in verse and line, always so important a part of the collaboration. *First and Last Loves* (1952) reprinted the articles on Nonconformist architecture first published in the 'Archie' before the war, and Piper provided drawings based on his photographs.

Later, in a monograph published by Penguin in 1944, Betjeman was to sum up why he admired his friend 'Mr Piper' so much: 'He has never been tempted by fashion; nor by money, often as he has wanted it in the past. He has refused to listen to flattery, and, if he is now in a position to sell everything he draws or paints, that is an accidental coming together of popular taste and John Piper. I think it unlikely that he will be disturbed if, in ten years' time, his work ceases to be bought. He will continue working without a stop, getting up early in the morning and going on until late at night; when daylight fades, lighting an Aladdin lamp and preparing canvases by its light or working on those parts of a picture which do not involve colour.'

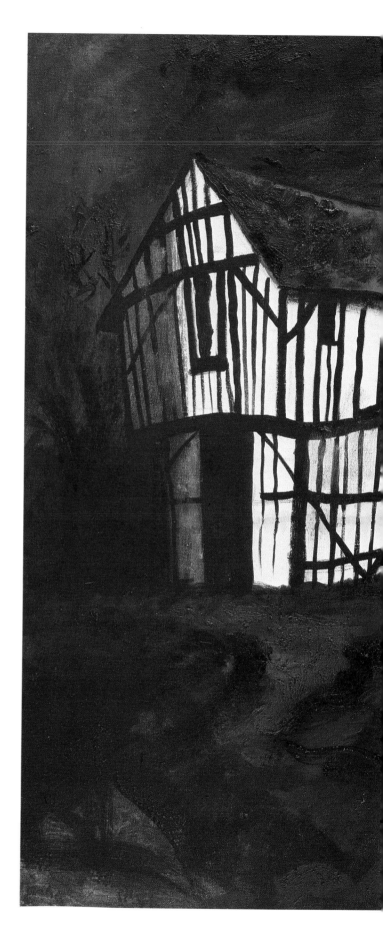

52

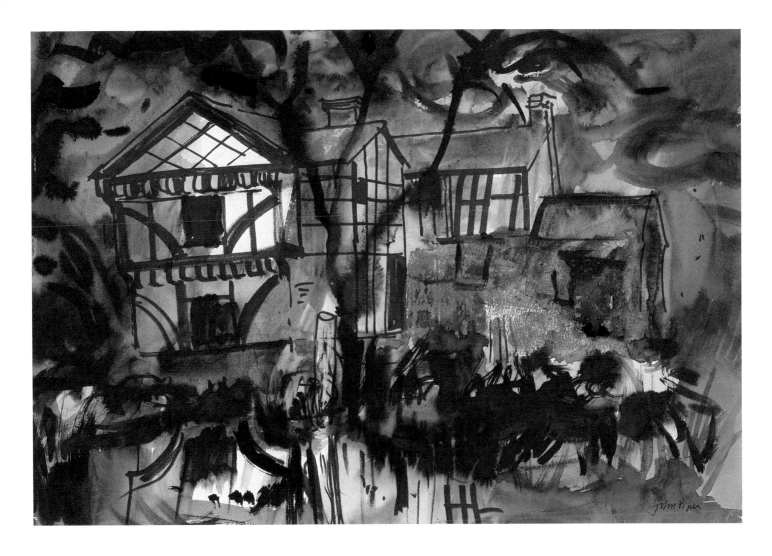

36 [pages 50/51] Lower Brockhampton I, Bromyard, Herefordshire 1981

37 Stokesay Castle I, Shropshire 1981

38 Upton Court, Little Hereford, Herefordshire 1981

39 Lower Court, Kinsham, Herefordshire 1981

Half-timber was my first love in the world of English domestic architecture. Much bad English landscape art has been produced under the influence of it, though I still find Mrs Allingham's Victorian watercolours of thatched and timber-framed cottages with flowery gardens appealing, as I do Anne Hathaway's cottage itself (even as reconstituted to face the twentieth century). When I was young three volumes in a series called Old Cottages and Farmhouses *(one for Surrey, one for Kent and Sussex, one for the Cotswolds) appeared. They were handsomely bound and full of excellent photographs taken with a big plate camera, mostly under cloudy skies but in perfect focus, by*

*W. Galsworthy Davie. The texts were by distinguished architects of the Lutyens and Jekyll period – E. Guy Dawber and W. Curtis Green, who adorned their texts with careful pen and ink sketches of hood-moulds and other details. These, and the whole exercise, were clearly the product of a dedication to the subject and became an absorbing hobby which in fact influenced their own creative professional work. (*Kent and Sussex *in this series has recently been re-issued in paperback, well reproduced from the original, though in smaller format, by Rochester Press, 1981.)*

As a boy, I longed to live in a timber-framed house with an over-sailing upper storey, and brick chimneys set diagonally, in pairs, and with stone slabs or irregularly-weathered tiles on the roof. I grew out of it, but to this day when I visit Stokesay, or the beautiful Lutyenized Lloyd family home at Great Dixter in Northiam, or that much sketched cottage at Bignor under the South Downs, or those great banquets of half timber one gets in Cheshire and Staffordshire and Shropshire and Herefordshire, I still feel a youthful stirring of excitement and wonder. J.P.

Brighton Aquatints

One of John Betjeman's passions, which he passed on to John Piper, was for collecting old topographical guide-books, especially those of the eighteenth century, illustrated with aquatints. They both went over to Dublin before the war where they could be bought for a few pounds. The best-known were those of Rev William Gilpin (1724–1804) who travelled round England and Scotland on horseback and published his account in a series of *Tours*. Piper was inspired by the aquatint illustrations in these books and as a result took lessons at the engraving department of the Royal College of Art, then housed in the Victoria and Albert Museum. The lessons cost ten guineas.

This new interest resulted in the publication of *Brighton Aquatints* in 1939, with a foreword by Lord Alfred Douglas. There were twelve aquatints in all, each illustrating a different aspect of the town and reflecting what Piper called its 'seaside nursery gaiety'.

'The great yellow and white façade of Brighton', he wrote, 'is ranged along the Parade, to face the incoming breakers. The piers, the fishing boats pulled up on the shingle, the band stands and shelters, the Georgian and Victorian and Edwardian hotels and lodging houses all act up. The bow windows and porticoes, the wide pediments and barge-boarded bays of Regency Square, the great Black Rock and Brunswick Square curves and sweeps, the late Victorian yellow brick at the far end of Hove – all these keep up the seaside spirit. They make thousands of people remember Brighton and long to return to it; they are the proper background for popular English seaside life.'

Even Victorian architects, Piper wrote, 'let themselves go in Brighton; the air and the clients were encouraging'. One aquatint showed the Brighton pavilion: 'It has been called all kinds of rude names by generations of residents and visitors, but most people start by laughing and later develop a great affection for it. It is at once acutely vulgar and extremely sensitive'. Also in the book were two churches, St Bartholomew's and the Chapel of St George, Kemp Town (he used a *New Statesman* leader page photo-engraved as 'collage' to suggest the colour and texture of its stucco and yellow brick walls); Brunswick Terrace, Regency Square, and Bedford Square, opening onto the promenade at Hove. ('On a misty October morning the beauty and shapes and colours in Bedford Square take the breath away. The yellow and and grey houses appear through the faint yellow-grey mist; the sea begins to sparkle with prickly sunlight beyond the fanciful bandstand on the the promenade – even the Brighton Corporation lamp-standard has a suitable gaiety.')

Brighton Aquatints did more than anything to put Piper on the map. ('After that I became one of the boys', he says). Osbert Sitwell wrote a full-page review of the book in the *Listener*: '*Brighton Aquatints* is a charming book, beautifully produced, and Mr Piper has called the tune to exactly the right note. His drawings are sensitive in an unusual way, and manifest all the quality, the ease and speed, of beautiful handwriting. He shows, especially, a rare aptitude for the rendering of architectural surfaces and manages to convey atmosphere with the strictest economy of means, though not of art.'

This article was immediately followed by Piper's first exhibition at the prestigious and go ahead Leicester Galleries. The show was well received and sold out.

Brighton Aquatints was published in two editions, one of them limited to only fifty copies in which the prints were coloured by hand. (One of these, *Brighton from the Station Yard*, was hand-painted in all fifty copies by John Betjeman).

Mervyn Horder was then Chairman of Duckworth, the publishers of *Brighton Aquatints*. He now proposed a sequel on Stowe, the eighteenth-century mansion, near Buckingham, and former residence of the Dukes of Buckingham. Since 1926 the building had been a public school, and the headmaster, the famous J. F. Roxburgh, was, as it happened, another admirer of *Brighton Aquatints*. He gave Piper written permission to come and go whenever he pleased. Though the promised book failed for years to materialise, Stowe proved to be one of Piper's favourite places. He made many visits there during the war, often in the company of his publisher Mervyn Horder who remembers sitting in a swirling snowstorm passing paints to the artist as he worked on regardless. What Piper particularly likes about Stowe is not so much the house itself as the follies and grottoes which are dotted around the park, and of course the park, laid out by Capability Brown and others. It is filled with a variety of fanciful buildings – pavilions by Vanburgh, little temples and monuments designed by William Kent, each one set in a carefully arranged background. The Congreve monument, crowned by the figure of a monkey looking at itself in a mirror, is a favourite Piper subject.

Since 1937, when he first visited it, he also made regular trips to Stourhead in Wiltshire. This handsome house, looking out on the downs, was built for Henry Hoare in 1724, and though Piper once sketched it from the road, he has never actually been inside it. Again, the

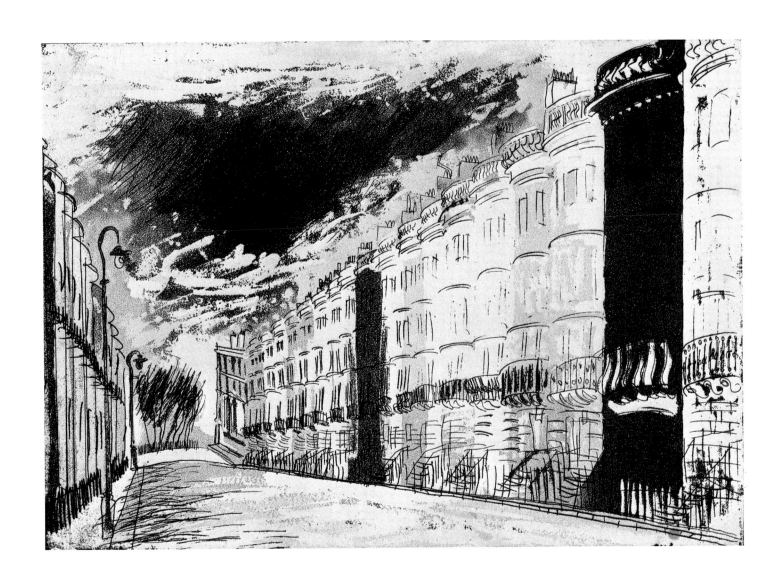

40 Brighton Street, Sussex 1939

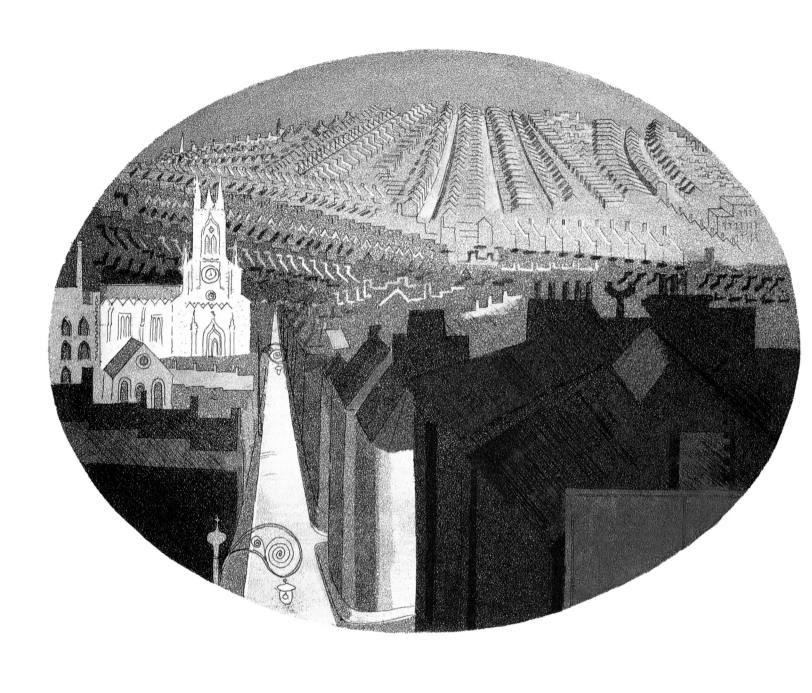

41 Brighton from the station yard 1939
Coloured by John Betjeman

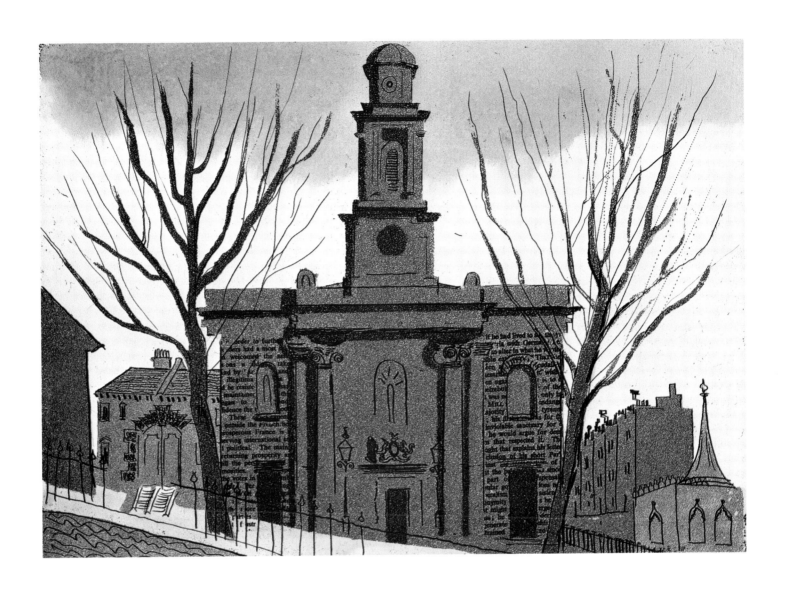

42 St George Kemptown, Brighton, Sussex 1939

glory of Stourhead is its park. It is not on such a grand scale as Stowe but then, as Piper points out, Stowe has been 'rather wrecked' by the twentieth-century additions of Clough Williams-Ellis and the bits and pieces that have naturally accumulated since the house was turned into a school. Dutch elm disease, too, has led to the destruction of its beautiful avenues.

By comparison, Stourhead garden is completely unspoiled. It was laid out separately from the house by Capability Brown and designed for walks offering a succession of pleasing views. Here again there is a variety of miniature classical buildings – the Temple of Flora, a Gothic cottage, a famous grotto with its inscription by Alexander Pope. All these are dotted about a lake and framed by a collection of exotic trees and shrubs. Piper writes in the Wiltshire *Shell Guide*: 'The undulating flanks of the lake with its dells and declivities, and the use of trees with dark-coloured foliage, have resulted in a natural looking landscape that is totally English and totally original.'

43 Stowe, Buckinghamshire *c.* 1975
Bridge and one of the Boycott Pavilions

44 Stowe, Buckinghamshire *c.* 1975
The House from the south; the lake; the Temple of Concord

45 Stowe, Buckinghamshire
The Shell Grotto and the
Congreve Monument

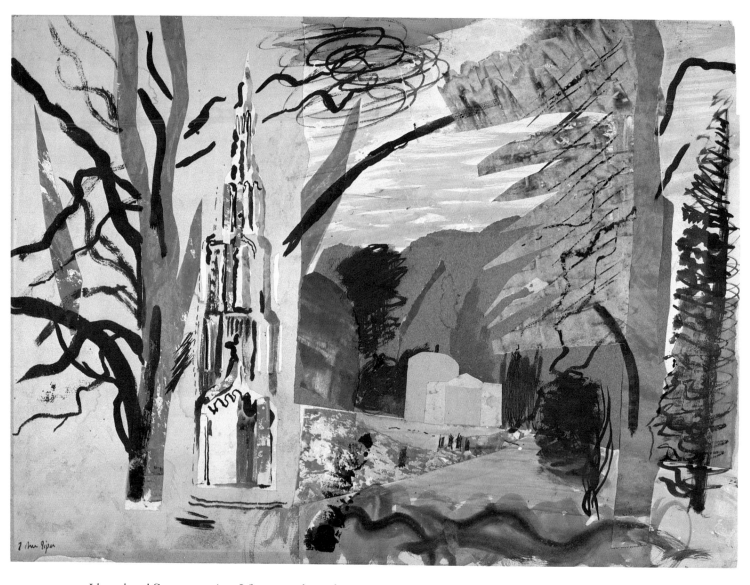

I have loved Stowe ever since I first went there when I was
about twenty. After Brighton Aquatints, and after the war,
when Mervyn Horder of Duckworths and I were talking of
a possible aquatint sequel we hit on Stowe as a good subject
and I have worked there at intervals ever since and on many
occasions. The results are not likely now to appear in
aquatint form, though a number of plates were engraved,
some proofed (one is reproduced on page 59) and all were
later lost, and no doubt destroyed. But the drawings
survived, and are being prepared for publication by
Hurtwood Press in association with the Tate Gallery.

I hope my happy days at Stowe will continue. There is no
end to the things one can paint there, and dream about.
'Architecturally', Mark Girouard has written, 'it is an
epitome, almost a museum of Georgian styles; where else can
one savour Vanbrugh, Kent and Gibbs, and move to and fro
from Baroque to Palladian, and Gothic to Neo-Classical, so
effortlessly and enjoyably within a few square miles?' J.P.

46 Stourhead, Wiltshire 1940
Bristol High Cross and Pantheon

47 Stourhead, Wiltshire 1981
The Temple of Flora, Bridge and Temple of the Sun

48 The south gateway, Holkham Hall, Norfolk c. 1975

49 Entrance to Fonthill, Wiltshire 1940

50 Seaton Delaval, Northumberland
A large romantic ruin in open landscape standing by the sea

51 Castle Howard, Yorkshire

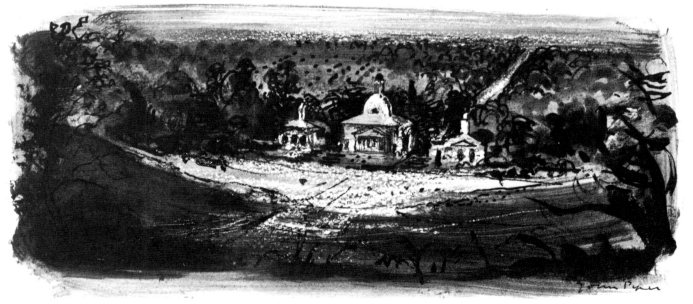

52 [opposite] Mereworth Castle, Kent 1953

53 Windsor Castle, Berkshire 1942
The Round Tower. Eton College in the background

54 Windsor Castle, Berkshire 1942
The Approach from the High Street

55 Windsor Castle, Berkshire 1942
The Great Courtyard

56 Hovingham Hall, Yorkshire 1944

57 Hovingham village, Yorkshire 1944

70

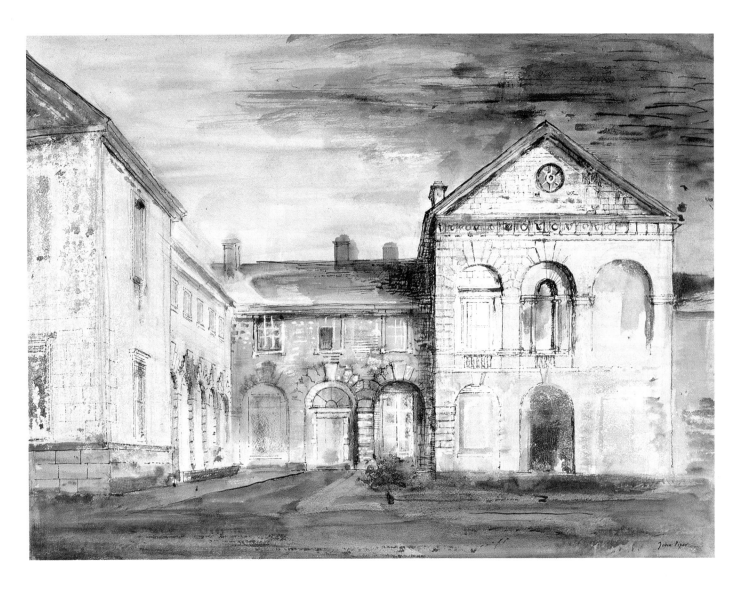

58 Blythburgh, Suffolk *c.* 1957

59 Mildenhall, Wiltshire *c.* 1950

Both illustrations are from *Collins guide to English parish churches*

Wartime

At the beginning of the war Kenneth Clark persuaded the government to set up the War Artists scheme, whereby artists were seconded from the armed services and given the job of commemorating the war in pictures. Clark's aim, which he did not specify at the time, was not only to provide work for artists but also, so far as possible, to prevent them from being killed. Piper, who had already been accepted by the RAF and was due to report at the photographic interpretation centre at Medmenham, was now released. He was involved in two main areas. One was the painting of bomb damage. The other was the 'Recording Britain' project, organised by Clark and the Pilgrim Trust which aimed to preserve a record of buildings which might well be destroyed in the war. Piper made several drawings for the four books which were later published by the Trust, mainly in Berkshire and Buckinghamshire, including some notable drawings of the Tithe Barn at Great Coxwell (Berkshire), a huge cathedral-like building which William Morris greatly admired.

At that time, in addition to his war work, Kenneth Clark was Surveyor of the King's Pictures. While he was waiting for the War Artists scheme to come into operation, he secured a commission for Piper from Queen Elizabeth (now the Queen Mother) to do twelve paintings of Windsor Castle. When a further delay occurred she commissioned another twelve. The commission led to Piper's now famous encounter with George VI. A shy man with no great interest in painting, he found it hard to think of what to say as he thumbed through the sketches, almost all of which featured the sombre skies of this period. 'You've been pretty unlucky with the weather, Mr Piper,' the King eventually remarked.

The outbreak of the war intensified Piper's love of England and especially its old churches. The early wartime period saw some of his best painting. He painted the church at Hamsey near Lewes with 'its old plaster and the Royal Arms over the chancel arch and the monuments.' He also painted the untouched Georgian interior at Mildenhall, near Marlborough. Surprising as it now seems, such Georgian churches were despised by guidebook writers, though Betjeman's *Shell Guides* were doing their best to put things right. Piper wrote at this time, 'Complete Georgian churches, with their pews and galleries, are as rare as they are beautiful. At Mildenhall there is a wonderful late Georgian interior. The box pews are of excellent workmanship, so is the panelling. There is a symmetrical arrangement of furniture in the

nave with a pulpit on each side of the chancel arch and an organ in the west gallery. Clear glass in the windows lets in the daylight to heighten the rich brown of the pews against the white-plastered stonework. The commandment board behind the altar, with its Gothic frame, takes part in a symphonic slow movement of tones. The colour as a whole is that of an old fiddle.'

Piper urged his readers to go out and explore such things for themselves. 'Evacuated gallery and museum goers', he wrote in the *Spectator* (8 December 1939), 'feeling rather lost in muddy December lanes, would do well to comfort themselves by visiting some country churches and discovering some of the unexpected and unlabelled beauties that almost every church in England has to show.'

Typically, he had been exploring a rural backwater, the borders of Bedfordshire and North Buckinghamshire, and looking at churches, some of which were neglected and ignored. Wavendon, according to the guidebook, was 'over-restored' in 1848 but, Piper noted, 'the work was so well conceived and executed that it has hardly been touched since, and the church presents a rich and lovely Victorian interior. It is Romantic and mysterious ... Medieval prejudice might call the glass at Wavendon gimcrack, but looking at it without prejudice one can usefully compare it with the glass of the fourteenth-century and note its additions of charming melodrama.'

Nearby, at Hulcote, he found a church 'built entirely in Elizabeth's reign, a rarity. It has many simple excellencies, not least of which is its colour, ochre and grey, with some dark scrolls made on its pinkish doors by the contemporary ironwork. (Here the incumbent, till he retired this year, drove round his parish in a horse-drawn vehicle.)'

Piper has always been very keen on church monuments, especially those of the seventeenth and eighteenth centuries. 'At neighbouring Simpson', he wrote, 'in a well kept church, there is a monument in dark grey and white marble by J. Bacon R.A. 1789 of slim and lovely proportions. There are more good monuments at Toddington, a few miles away, though they are in corners, uncared for, amid an atmosphere of recumbent effigies and erect brooms and brushes.'

The church at Hartwell near Aylesbury was in danger of falling down – it is now only a shell – 'but there was surprise and delight at Lidlington, seven miles from Bedford. As the door of the old, almost ruinous church swung open the cold December light revealed a damp grey floor from which rose a forest of box pews, dominated at one end by the pulpit and clerk's desk, and at

60 Lidlington, Bedfordshire 1939

61 North Moreton, Berkshire 1939

Both are illustrations from *The Listener*

the other by a gallery, the colour ranging from steel-grey through pink to faded yellow – the colour of many Cotman watercolours. And what a subject for Cotman: Ivy crawls through the broken windows. The tower is too unstable for the bell to be rung . . .'

It is notable that Piper, neither here nor elsewhere, regards it as his special duty to plead for the restoration of churches like Lidlington (now demolished). The spectacle of ruin and decay appeals to the true Romantic partly because such things are inevitable. They are a necessary reminder of the transience of all human endeavours and therefore not a subject particularly for indignation nor sentimentality. The apt phrase 'pleasing decay', coined by de Cronin Hastings as the title for an article by Piper in the 'Archie', suggests a state of affairs somewhere between newness and ruin. Pleasing decay was to be found where old buildings had neither been fussed over and restored in such a way that their character had been lost, nor had they been totally abandoned. Piper likes old buildings to serve a purpose even if it is only to provide a shelter for cattle. A favourite text of his was in Ruskin's *Modern Painters*:

'For instance I cannot find words to express the intense pleasure I have always in first finding myself, after some prolonged stay in England, at the foot of the old tower of Calais church. The large neglect, the novel unsightliness of it; the record of its years written so visibly yet without sign of weakness or decay; its stern wasteness and gloom, eaten away by the Channel winds, and over-grown with the bitter sea-grasses; its slates and tiles all shaken and rent, and yet not falling; its desert of brick-work full of bolts and holes and ugly fissures and yet strong like a bare brown rock; its carelessness of what anyone thinks or feels about it, putting forth no claim, having no beauty or desirableness, pride nor grace; yet neither asking for pity; not, as ruins are, useless and piteous, feebly or fondly garrulous of better days; but useful still, going through its own daily work – as some old fisherman beaten grey by storm, yet drawing his daily nets; so it stands, with no complaint about its past youth, in blanched and meagre massiveness and serviceableness, gathering human souls together underneath it; the sound of its bells for prayer still rolling through its rents; and the grey peak of it seen far across the sea, principal of the three that rise above the waste of surfy sand and hillocked shore – the lighthouse for life, and the belfry for labour and this for patience and praise.'

Consciously or not, during the early wartime period, Piper was very much involved with ruins of various kinds. In 1941 he painted a series of pictures of ruined cottages. One of these at Deane, Hampshire, he describes in a diary which he kept intermittently during the war years:

'28 Dec 1941. South of Kingsclere rise one of those Southern and Wessex walls of bare down. From the ridge the ground falls more gently southwards, riddled with shallow valleys, patched with blown coppices. Off the tarred road go metalled but not motor metalled lanes, often with wide grass verges. The grass is washed and rinsed of its colour. Thin grey clouds sag and loop above hedgerows drifted with old man's beard. There are leafless hazel copses, new plough (the richest colour in the view that is otherwise grey to amber with a tinge of sodden green) a tractor at work here and there, cows on the ridge: a whole landscape that seems dry even when it's saturated with December damp. Here and there we come upon patches of vegetation which are survivals of the ancient order – commons, pieces of open down or scrub, or virgin woodland. These have been left like islands in the rising sea of cultivation; they are like old houses in the heart of a busy town, the relics of a past age'. There were thorns and junipers on the uplands, oaks and some beech and ash and sycamore on the lower ground. And so it is still, but the arable land flows in and rolls between the now infrequently surviving patches.

'In the valley – south again – by the railway an acre or so of ground with a derelict cottage is half screened from the lane by a wall of hawthorns. Dried madder-coloured nettles push up from bleached, matted grass . . . There is a yew or so in the dead garden, a broken apple tree or so, and against the south wall a December periwinkle in flower. The cottage is of brick and flint – a double cottage with a flat, lean-to porch to the south, shading the two front doors. Exposed laths on top of this porch have a few loose tiles, broken and ready to slide. There is a saturated mat of thatch, parti-coloured in areas of brown, ochre, grey and black; an all over colour of watered umber. Forms are at once folded and angular, with the double shape of the structural beams and the conglomerate straw. Irregular black holes of windows; powder-blue walls and crumbled plaster appear in the gloom through these.

'The late afternoon sun of mid-winter makes a wave of colour wash over ground, building, yews, thorns, and distant ploughland and down; dark, scarcely-lit colour. A wild and wet light in the December evening.'

During the war Piper also returned to the huge ruined abbeys of Yorkshire which he had first visited when he

62 Hartwell Church, Buckinghamshire 1939

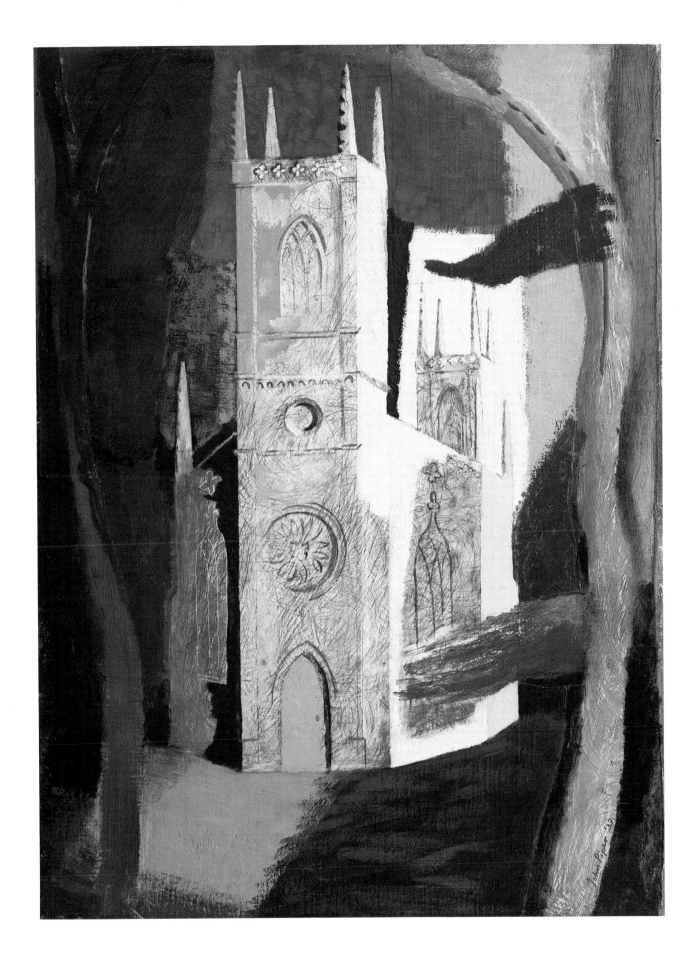

75

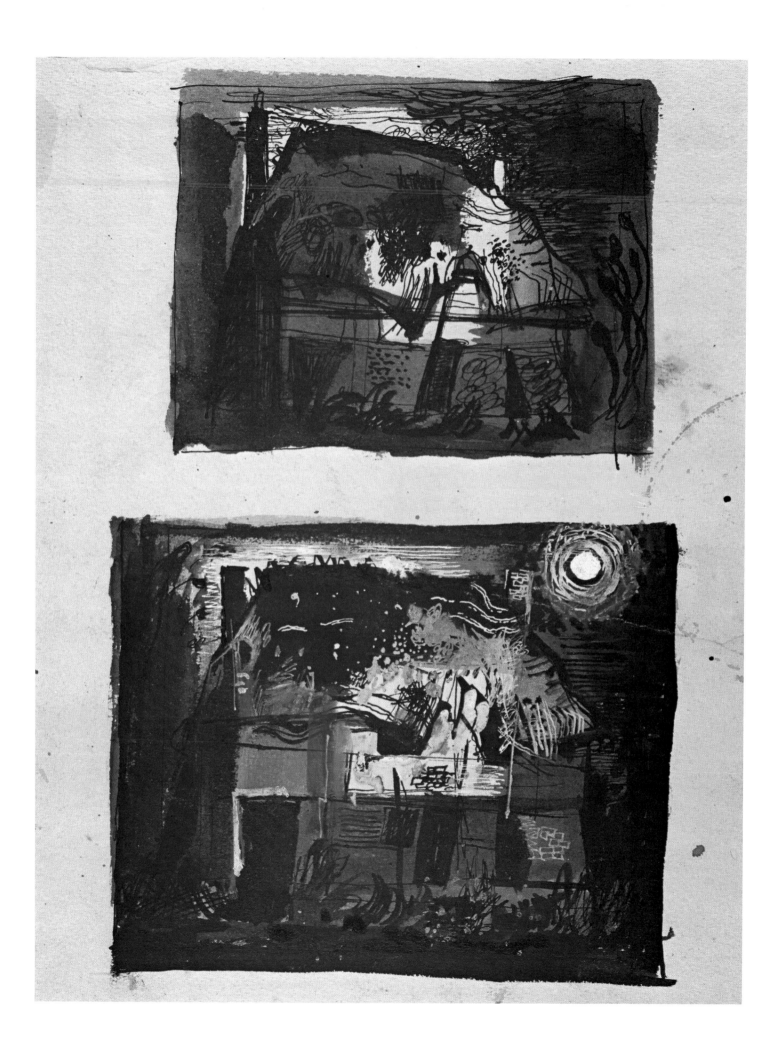

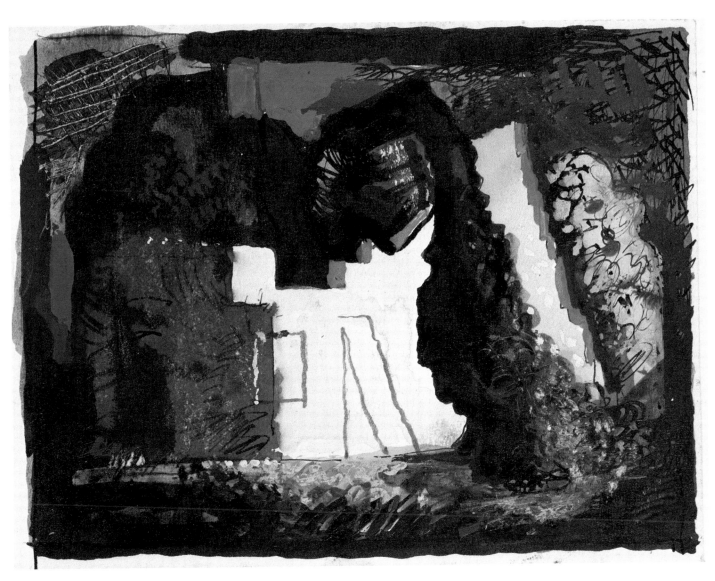

was a boy. He was drawn in particular to Byland, the Cistercian abbey completed in 1200, now surviving only in fragments, and made a number of paintings as well as a very striking aquatint in which the abbey's west front with its haunting semi-circular broken window and one surviving turret always loom large. Though Piper was interested in these fragments partly as abstract shapes he was also intensely aware of the place the medieval ruins occupied in Romantic tradition and the long line of artists like Turner and Cotman who had been there before him. It was only regrettable that in the present day the ruins should be fenced about and surrounded by cast-iron notice-boards – the grass between the masonry neatly rolled and mowed.

A more satisfactory ruin which had not been tidied up at that time was Valle Crucis Abbey near Llangollen in North Wales. Visiting it during the war, he noted: 'Decay of Valle Crucis Abbey sensibly unarrested. In its present condition one of the best of ruins. Not taken over by Office of Works. Ash trees sprout from stonework. Rain dribbles from broken fourteenth-century tracery. Caretaker Owen plants nasturtiums along under the walls. No other decorations or diggings up and little mowing. Not much altered since use as a farm. Decaying stairs, broken roofs, iron gates in rooms – one fireplace with fine floreated cross for a lintel. Well of clear water in the precincts for penny dropping. Father Ignatius tried to entice caretaker Owen away to Llanthony to become a monk. Fishpond that used to reflect E. front for Girtin and Turner broke its banks thirty years ago and is now rush-grown depression. Full grown and overgrown trees saturate the area between abbey and hillside. Wartime desertion complete, except for evacuee caravans by the river.'

63 Ruined cottages, Stadhampton, Oxfordshire *c.* 1942

64 Ruin at Stockbridge Mill, Hampshire 1942

Knowlton

66 Horton Tower, Dorset 1942

65 [previous page] Ruins of Knowlton, Dorset, within an early encampment

67 Wiggenhall St Peter, Norfolk 1974
Against the Ouse embankment

Wissenhall St. Peter 24 X 74

68 [previous page] Byland Abbey, Yorkshire 1940

69 [above] Binham Abbey, Norfolk 1981

84

70 Llanthony Priory, Monmouthshire 1941
*In a hollow of the Black Mountains in Wales, near the
Welsh border. Usually known as Llanthony Abbey, because
since the nineteen twenties the Abbey Hotel has occupied part
of it. A twelfth-century foundation that seems to have been
deserted in the thirteenth century, the ruined buildings are
still largely unrestored. Long may they remain so.* J.P.

86

Coventry

Very different were the 'instant ruins' which had been made by German bombers since the war began in earnest in 1940. As a war artist one of Piper's main tasks was to record bomb damage, whenever possible immediately after the raids. This involved flying visits to Bath, London, Bristol and Coventry. In 1940 he went to Coventry, later recording his impressions for the *Architectural Review*:

'Roads blocked, warehouses still burning. Not a pall of smoke, but a thin fog of smoke and steam like a concentration of the blighted November weather with that strange new smell that this war has produced – mixture of the smells of saturated burnt timber and brick dust with the emanation from cellars and hidden places. The ruined cathedral a grey, meal-coloured stack in the foggy close; redder as one came nearer, and still hot and wet from fire and water; finally presenting itself as a series of gaunt, red-grey façades, stretching eastwards from the dusty but erect tower and spire. Outline of the walls against the steamy sky a series of ragged loops. Windows empty, but for oddly poised fragments of tracery, with spikes of blackened glass embedded in them. Walls flaked and pitted, as if they had been under water for a hundred years. Crackle of glass underfoot. Inside the shell of the walls, hardly a trace of woodwork among the tumbled pile of masonry, stuck with rusted iron stays.'

Elsewhere in the centre of the city he noted 'a city-stained, smoke-dried medieval church among burnt and blown-up warehouses. The church itself burnt out. Fifteenth-century windows sliced vertically in half. Plaster scored and scarified, disclosing flaked stone courses behind it. The bells, that had become red-hot before their supports gave way, lying on the ground by the west door, Tower standing – an enormous hollow chimney.'

71 [opposite] Coventry Cathedral, Warwickshire, November 15 1940

72 Church of the Holy Innocents, Knowle, Bristol, Avon 1940

73 St Bride's Church, Fleet Street, London 1940
Illustrations from *Architectural Review*

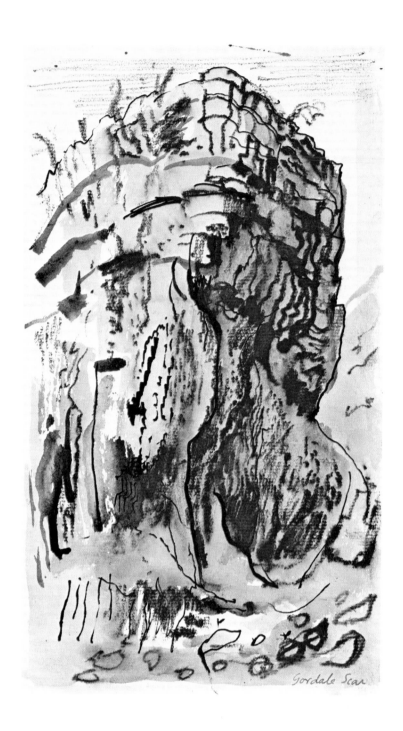

74 Gordale Scar, Malham, Yorkshire 1941

Geoffrey Grigson

Once the war began in earnest Fawley Bottom became something of a refuge for London friends, escaping from the blitz and its effects. Osbert Lancaster, whose flat had been bombed, was one evacuee. Almost immediately he sat down and began to draw cartoons. Osbert and his wife Karen became close friends of the Pipers and later bought a house nearby at Henley. In 1951 he and Piper designed together the Grand Vista for the Festival of Britain's Pleasure Gardens in Battersea Fun Fair.

Another frequent wartime visitor to Fawley Bottom was Geoffrey Grigson, the poet and critic. Piper first met him, through Henry Moore, in the early thirties ('A nice chap, you'd like him,' Moore said to Grigson). Born in 1905, the son of a Cornish canon, Grigson had worked on the *Morning Post* and founded *New Verse* in 1933. He is a man of many parts, reflecting the interests and enthusiasms of an old-fashioned clergyman; poet, critic, anthologist and naturalist. Grigson who has played his part in any number of literary feuds, is also a connoisseur of little-known poets and artists and has a profound knowledge of English topography and all its artistic and literary associations. He is the champion of Samuel Palmer and Gerard Manley Hopkins, and the author of books on wildflowers. Apart from Betjeman and Piper no one in modern times has done more to educate the English to value their heritage.

For over ten years (1939–50) he and Piper were close friends, though later they fell out. Grigson, like Richards and Betjeman before him, became a Piper travelling companion, walking, bicycling and exploring in England and Wales. In the meantime they corresponded at length, introducing one another to new sights discovered and places explored. In an undated letter to Piper from Parracombe in North Devon, sent during the war, Grigson describes the scene in terms which convey very well the nature of their friendship:

'I've liked this place more than any I've ever seen on any coast, I think – the way the cliffs vary, are broken, are different heights and colours, are wooded and sheer with these vast hills behind. Tell me on Wednesday how much you know of it. The superbest combination of valley and mufflings of wood ending in sea and rocks (the rocks of the Valley of Rocks) is from Croscombe Barton. Also a great many Class I, well preserved lime kilns, even on the scarcely accessible beaches. Good ones at Woody Bay and Heddon's Mouth. Rector at Martinhoe, named Ansorge – he's worth seeing. Rather

stiff and pompous and bearded, a botanist, and an amateur pianist who plays Haydn and Mozart to himself – no wife. And his lavatory is broken. "Quite easy, quite easy, just lift up the lid, plunge your hand in the water, and pull smartly. Quite easy. Handle broken." Age about 45, and steadily retreating from the world, tho I returned *Jude the Obscure* for him to Malcolm Elwin, lazy, blond, revolting, bearded, fat, anaemic and rather nice, who writes lives, e.g. of Landor and lives with a very attractive, gentle, good-hearted mother of two girls. "Not married, not married; I must warn you of that. But I must say much happier than many homes in my parish, much happier…"

'Flowers v. late, owing to the north-facing cliffs; aubretia wild, as well as clumps everywhere of Japanese knotweed; and mimulus on the streams. Children need keeping away from 600-foot precipices beside roads. Much periwinkle; pink-flowering currant against old walls. Hedges planted with beech trees. Many buzzards. Curlews on the moor behind the cliffs and great heath fires browning the sky.

'Gainsborough, Coleridge, Hazlitt, Palmer, E. Phillipps Oppenheim all absolutely justified for liking this area…

'I've forgotten a goodish cliff waterfall on Hollow Brook, about 22 visible feet high, in a cliff hollow of grey stone and grey oaks curved round like hands and clumps of gorse. As for the violet shadows down in the big valleys and the shafts of sunlight and white choppy waves on deep, lead coloured seas under scarlet and grey cliffs, with bright patches of dead bracken and dark brown oaks and so forth; you might do worse than try Killington on Ed and Clarissa; or the rather smart and ugly Hunter's Inn, which is reasonably near the beach on a level and near Trentishoe Church, with its gallery etc (which I haven't seen I'm afraid).'

Caves and waterfalls had a fascination for Piper and Grigson and they even thought of doing a book together on the subject. In 1939 the year of their first meeting, inspired by another eighteenth-century guidebook, *Views of the Caves near Ingleton, Gordale Scar and Malham Cove in Yorkshire* by William Westall, a friend of Wordsworth, Piper and Grigson made an expedition to Yorkshire. Grigson was expecially interested in the painter James Ward (1769–1859) whose massive painting of Gordale Scar is familiar to visitors to the Tate Gallery. He also wanted to find a rare wild plant, the mountain avens. They travelled to Yorkshire by train – 'Going north in the train from Leeds', Piper wrote, 'through Saltaire and Skipton, the country begins to open up towards the fells that eventually become mountains, and looks dry and bare until at some point in the journey the train

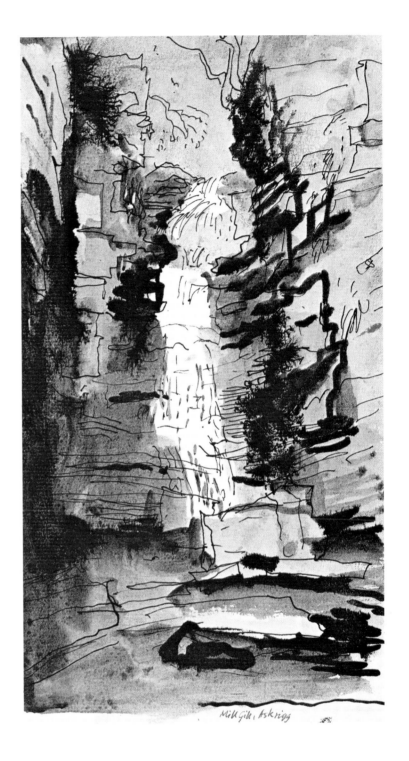

75 Mill Gill, Askrigg, Yorkshire 1941

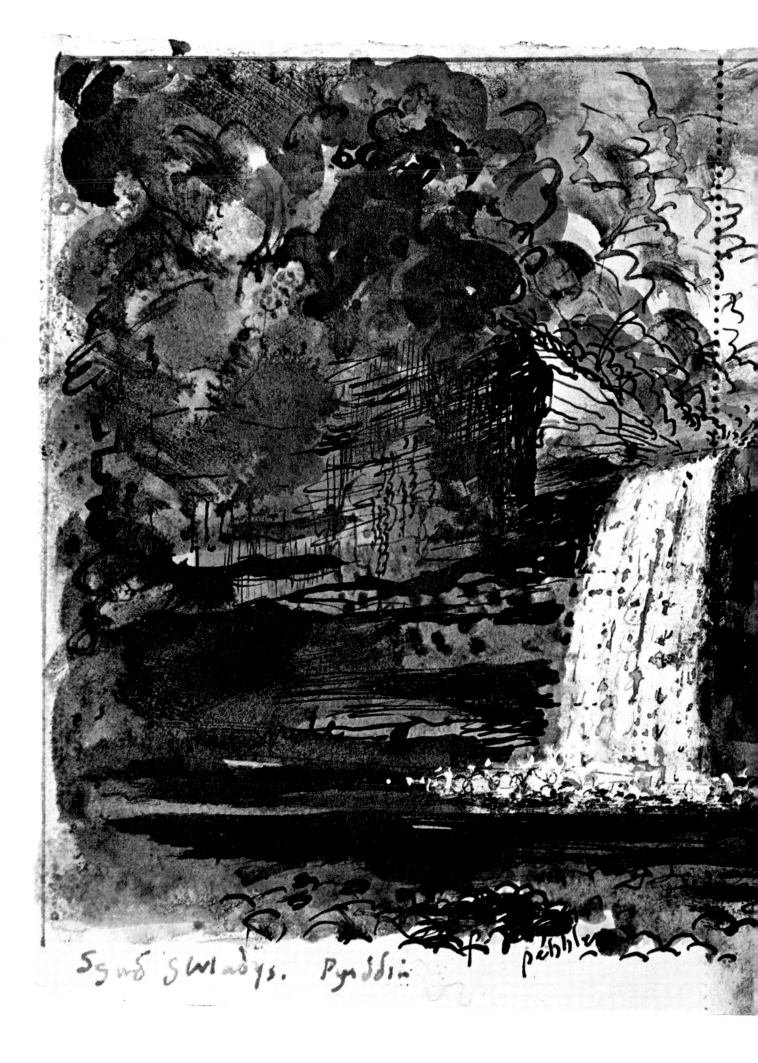

Sgwd Gwladys. Pyrddin pebbly

Crooked Aniel Purssden

stops and you hear the familiar necessary sound of running water that gives the region life and character. Stone walls thread the lower grounds and in the sheltered places ash, sycamore and rowan sprout patchily by the streams'.

They got off the train at Bell Busk station and walked the five miles to Malham where they stayed at the Buck Inn and visited Malham Cove and Gordale Scar which had exercised so strong an effect of awe and terror on the tourists of the Romantic period – 'Today', Piper noted, 'no terror. Larking hikers plug stones at the stream, feeling at home in the theatrical scenery, their voices echoing oddly among the cliffs as the large drops that still descend from the sweating heights begin to mingle with a summer's afternoon drizzle'.

Piper painted Gordale Scar as well as Weathercote cave, with its dramatic waterfall. He and Grigson trekked across the moors to Yordas Cave. 'On the Lancashire – Westmorland border', Piper wrote, 'there is a valley that is very little known and full of beauty and limestone curiosity. The way to approach it is from the heights above Dentdale, from where the shallow valley-beginnings are evident beside the lowest flanks of long, dark Gragareth mountain, hilly banks folding in here and there, so that the view is alternately obscured and revealed. The open moor is featureless but friendly, with sheep and bracken against a strange ground colour of brilliant yellow fungus. Suddenly, after an hour's walk, the valley's character alters and the stream begins to descend a narrow gorge. At the final approach to the gorge a natural gargoyle stretches its bird-man form out over the water, and hollows and puddles and larger pools are scooped out of the limestone. There follow on the stream's course a series of roofless caverns, with small waterfalls dropping into dark pools, the stream bed between these caverns, and often in them, being dry. The falls are overhung with rowans and ash, not trees and coarse grass, and the stones in the dry stream bed are of rare beauty – one side of them flat and the other rounded, they are curded and marbled in cream, pink and slate colour, or are streaked in grey and green, or in orange and brown grey. Lower down the valley still, the caverns become deeper and bolder, and at a

sudden twist in the valley's course, at Easegill Kirk, where the gorge becomes profound and narrow, the rock shapes suddenly become wildly dreamlike and fantastic, and subsidiary caverns wind into the blackness on the gorge's sides. In the near-silence, just broken by the sound of dropping water, it is possible to imagine the sound of mumbling voices and easy to feel the truth of Wordsworth's

". . . rocks that muttered close upon our ears
Black drizzling crags that spake by the wayside. . ."

Below Easegill Kirk the stream becomes a river and flows out into the pastoral valley that opens into the Lune plain by Leck, towards Kirkby Lonsdale.'

Piper and Grigson also made an expedition to the Neath Valley in search of caves and waterfalls. The inspiration for this was a rare eighteenth-century guide-book *Guide to the Beauties of Glyn Neath* (1835) by William Young illustrated with aquatints. In 1943 the two friends travelled to Cornwall, cycling round the countryside looking at churches and Holy Wells. Cornwall had been, before the war, a favourite Piper place. He had first visited it as a young man, renting cottages at Gunwalloe near Porthleven and later at Zennor. He and Myfanwy also took a cottage at Pendeen. After the war Wales took over as the place to get away from it all.

Piper made detailed notes of his Cornish impressions: 'July 5 1943 Talland. Tangle of seaweed on the beach; tangle of hedgeflowers in the banks. The pinkish, short, round-leafed seaweed, and the vivid green ribbon-like kind – both, held up to the sun, show an enriched stained glass light. The pink has an inner tree-like veining in darker tone. Clouds on hills. Warm drizzle and clammy air. Hedge flowers dangling uncut in deep lane. Tansy, burdock, hemp agrimony, sea-pea, mugwort, profuse bedstraw – dimmed rich colours and thick pale tones.

'Uphill to church in high terraced churchyard, long-grassed with slate tombstones. Lichen on pale Cornish granite; grows slowly at first, but finally takes with vigour, producing whites, pale Naples, blue-greys in round overlapping spots and scabs. Good effect of sound holes in belfry, east side; quatrefoils, spades, diamonds, loopholes, date (1834) and so on all pierced in thick slabs of slate. Interior dark and spacious in late, cloud darkened twilight. (Subdued detail of dark old bench ends, and lack of detail in Cornish window tracery.)

'Farm opposite with palest blue-washed wall and wet slates reflecting sky of identical colour and tone. Barn on left, and yard with stream, straw and dung of good levels and curves.

'On the way back, white edges to waves and pink

76 [pages 90/91] Sgwyd Gwladys, Pyrddin, Vale of Neath 1942

77 [opposite] Crooked Anvil, Pyrddin, Vale of Neath 1942

78 Trecarrel Chapel, Lezant, Cornwall 1943

79 Botallack Chapel, Near Fowey, Cornwall 1943

80 Yatton Chapel, Herefordshire 1944

rocks visible in growing dark; honeysuckle and bedstraw smells, and other sweet wafts and breaths.'

At this period Piper did a series of paintings as well as a number of aquatints of 'farmyard chapels'. including one at Yatton in Herefordshire and another at Chisbury in Wiltshire. At one time he even thought of doing a book on the subject. Such places were especially good examples of 'pleasing decay', old buildings put to a different use. On 20 July 1943 he and Grigson cycled to Bodinnick where there was another such medieval chapel now used as a cow byre:

'... very pale grey green in embowered surroundings. Pointed north door, with Cornish spiral corbels – sienna and madder straw and dung flooring the entrance ... Ivy on S. side climbing to roof and bellcot. Ash trees, pale whitey-green, thistles, nettles and burdocks prone and reddening in front. Some fresh green burdock leaves in foreground. General effect white to dark grey with rich brown and grey green tingeing, with dark bowering of trees and ivy. Delicious lane-avenue behind with waste

grass, this leading above to ripening wheatfield towards hilltop, with view of estuary. Cornish drizzle now and again.'

Another abandoned chapel which he painted was at Trecarrel, about five miles from Launceston. Grigson and Piper visited it on 29 July 1943. Piper noted:

'Farm buildings with medieval remains, perfect in rare and once common relationship of old and new. Cattle, barns, farm roads, wood piles, using or neighboured by old buildings and old walls. Medieval doorheads, mouldings and other fragments here and there – used to decorate the top of a well-head, built with newer walls, lying in grass and nettles. The whole well-placed among old trees in a dip, approached only by remote flower-starred lanes of East Cornwall. Deep valley of the river Inny to the south, with river and hill scenery, with wooded hill shoulders like the Welsh border country (Radnor etc). Ruins of hall of manor house – remains rather – of exquisite colour, greys, pale, stained with yellow lichen. Interior used as a store, drying place etc, earth floor, good beamed ceiling. Darkness penetrated by lights from open door, cracks and crevices. Windows largely blocked with slate slabs. Chapel across the yard. Stone floor, traceried windows intact without glass. Spreading ash tree with twisting bole at corner. Muddy roads; washing hanging out.'

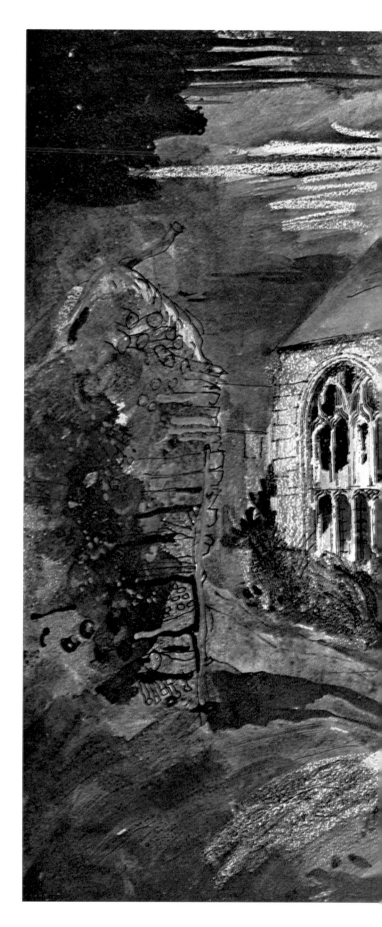

81 Trecarrel Hall, Lezant, Cornwall 1943

Derbyshire Domains

Throughout the war years Piper made several visits to Renishaw, the Sitwell home in Derbyshire. As already mentioned, Sir Osbert Sitwell had been one of the greatest admirers of *Brighton Aquatints*, and in 1942 when he began work on his 5-volume autobiography he commissioned Piper to illustrate it.

Although Piper's name is associated in some minds with paintings of large country houses he has never been especially attracted to them as subjects, though he has carried out a number of commissions from various aristocrats from time to time. Renishaw is one of the few such houses for which he has a great affection.

The house has an intensely Romantic history. The core was built in 1625 when the Sitwells first established an ironworks nearby. During the Civil War the house, then garrisoned with Royalist troops, was fortified with battlements. Sitwell Sitwell (1771–1811), a typical eighteenth-century squire famous for his harriers and fighting cocks, made a number of extensions. He himself designed a Gothic temple and an archway on the drive. In 1808 a ballroom was added and a ball held in honour of the Prince Regent. Sitwell Sitwell was given a baronetcy. But his grandson, Sir Reresby, let things slip and after his death in 1862 the house was closed. Then thanks to the discovery of coal in Renishaw Park, his widow retrieved the family fortunes and with her young son George, moved back in.

Sir George Sitwell (1860–1943), who designed the magnificent gardens, was made famous by his three children, Edith, Osbert and Sacheverell. He was snobbish and slightly mad, obsessed by his family and the need to preserve its wealth; his wife Ida was vain, hysterical and spendthrift. In 1915 she was sent to Holloway prison for three months when Sir George refused to pay off the debts she had incurred to a crooked money-lender. Their two eldest children, Edith and Osbert, spent a miserable childhood and neither really recovered from their early traumas, spending much of their subsequent lives in pointless feuds, as though seeking to avenge themselves in some obscure way on their parents. It is not surprising that Renishaw is still to this day troubled by ghosts.

In 1925, to the relief of his children, Sir George Sitwell retired to Castello di Montegufone, the huge Tuscan castle which he had bought in 1909 while on a visit to Italy, leaving Osbert, to be joined by Edith in 1939, living at Renishaw, busy with his writing in the large and draughty house. Piper was charmed by the atmosphere and by his host who was as cultivated, well-mannered and amusing as his father was not. The young Sitwells had always been great patrons of artists. It was Sacheverell who had 'discovered' William Walton when he was still an undergraduate at Oxford and had taken him into their home. Later Edith Sitwell prided herself as the first poet to acclaim Dylan Thomas. Sitwell houses were always filled with writers and artists.

For Piper, Renishaw with its huge log fires and old retainers unaffected by the call-up was his first introduction to the agreeable atmosphere of cultured upper-class life and the best kind of literary gossip. ('The Sitwells were renowned for rancour. But I found nothing but affection in the house'). He had a standing invitation to come whenever he liked and found the house a welcome sanctuary from his work as a war artist. Once the Griller String Quartet turned up wearing military uniform and gave a concert to an audience of three, Osbert and Edith Sitwell and John Piper. In May 1942 he first met Evelyn Waugh who was also staying at Renishaw. (Waugh, who may have had Piper partly in mind as Charles Ryder, the painter hero of *Brideshead Revisited*, later asked him to illustrate the manuscript of his novel with imaginary landscapes as a present for his wife Laura, but Piper, who likes commissions to be specific, declined.)

'I believe', Osbert Sitwell wrote in a preface to an exhibition of Piper's Derbyshire paintings held at the Leicester Gallery in 1945, 'that in the part of the world in which my family has long been settled, the portion of Derbyshire which abuts on Yorkshire and Nottinghamshire, Mr Piper has found a territory peculiarly suited to his sombre yet fiery genius. Not only does he portray for us the great castles and halls of this lurid but beautiful region as they look, but his landscapes, too, are imbued with the very spirit of a countryside that knows no rest from work, and that throbs with a strange dual life: for, under the age-old surface processes of farming, forestry and the like, runs the cramped subterranean existence of the mines. Here, in this hilly land of slag-heaps and chimneys, is a vividness not to be found in the tamer districts of the South, and, in spite of the revolutions of industry, a strong sense of continuity persists. Thus in his roofscapes – to coin a new word for a new kind of picture – the artist shows us the battlemented lines, so characteristic, where every church, even, and every wall, had to have its fortifications; for hardly a decade went by between the time when Robin Hood ranged the forest and that day, some five hundred years later, when the Young Pretender reached Derby as the farthest point on his projected way south, without such defences having to be manned. These battlements splinter with their

82 Bolsover Castle, Derbyshire

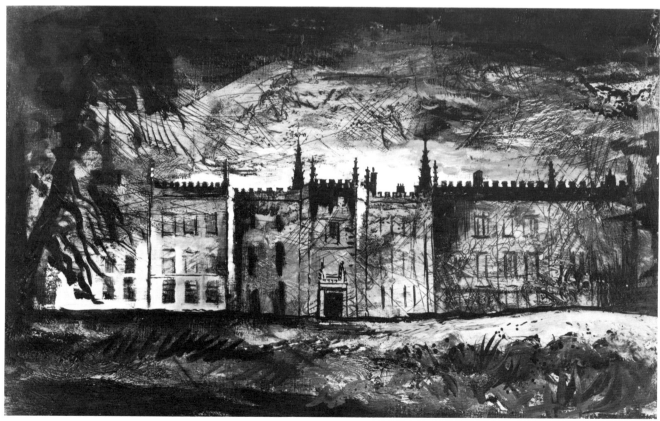

ancient glory the black clouds and golden lights that come so naturally to this painter's brush, and in the landscapes he renders precisely the darkness and illuminated splendour of the countryside, its curious and lovely melancholy and the occasional rage of it.'

A large painting, dominating the 1945 exhibition, was called *Derbyshire Domains*. It showed, in addition to Renishaw, Sutton Scarsdale (the ruined house of the Earls of Scarsdale later saved by Osbert Sitwell, who bought it and prevented its destruction); Barlborough, an Elizabethan hall near Renishaw; Hardwick Hall, built in 1590 with its great façade 'more glass than wall'; and Bolsover 'a hill top castle of the seventeenth-century by Smythson. Eccentrically planned, with details that are at once heavy and exquisite, it dominates a landscape fretted with collieries and ironworks'.

These vast and gloomy houses, perhaps partly because they echoed the sombre wartime mood, were perfect Piper subjects. He was especially stimulated by the dramatic effects of the weather. Osbert Sitwell described a visit to Hardwick which, as Piper sat down and began to draw, 'shone like a cliff of gold in the hot, clear, mellow sunshine of an early September afternoon but, then, Hey Presto! we were treated to every form of

83 [above] Derbyshire Domains 1945
left to right: Renishaw ballroom; Sutton Scarsdale;
Triumphal Arch, Renishaw; Renishaw Hall;
Barlborough; Hardwick; Bolsover

84 Renishaw Hall, Derbyshire
The north front

tenebrific effect, of celestial limelight dazzling and darkening through cloud slides. After ten minutes or so of this working towards a culmination, so intense and sombre and thick and inexplicable a gloom descended – for it was due neither to eclipse nor fog, though blacker than either, an atmosphere in fact, as if it was "the year's midnight and it is the day's" – that, unable to see the paper in front of him, Mr Piper was obliged to abandon drawing and return home – and this at three o'clock in the afternoon!'

Piper recorded some of his own impressions of the dramatic Derbyshire effects in a diary note for 15 November 1942:

'Day beginning with fog and ending with a nineteenth century sunset. Sun a fireball in the fog, and Renishaw rising from ground mist, only top storey visible. Blue trees round orange folly temple. A grey scabrous wreathing on the swimming pool and lake. (A young man here convinced it was a slimy uprising from the bottom.) Stationary swans. Burnt out grass, colourless. Midland refuse tips and blackened trees at their best in the disappearing mist.

'To Bolsover: as wonderful as could be, commanding the fog-soaked colliery sodden landscape. The riding school pale in its hilltop light: ruined gate and blown trees at end of terrace dark. Buildings greenish and Naples and pale grey rather ochre or pink.... To Sutton Scarsdale, through Arkwrightstown. Curious slightly suburban atmosphere of Sutton Scarsdale, owing probably to its last business-man (colliery manager) owner. Elders rioting in de-leafed condition. Dark, reddish, pinkish, but not rich in colour and not light and pale and sky-ridden like Bolsover. Becoming very ruinous.'

85 Hardwick Hall, Derbyshire
'More Glass than Wall'

Snowdonia

In 1946 the Pipers spent a long summer in Snowdonia and the following year began to visit a cottage in Nant Ffrancon ('Beaver Valley', in English). Three years later they rented a farmhouse above Llyn Ogwen. It was called Bodesi and was only available in the winter. In this period Piper made a series of drawings and paintings of the mountains which marked a new departure for him. For the first time he was studying and painting pure landscape devoid of any buildings; and it was not landscape which could be described as 'ordinary', the sort of landscape to which he had hitherto been drawn, but intensely dramatic and even sensational. This new experience was exciting. 'I felt then that I was seeing the mountains for the first time', he wrote, 'and seeing them as nobody had seen them before. This was partly due to the feeling of release after the confining of the war, partly to a "spurt" in my capacity to observe more clearly at this particular time. Each rock lying in the grass had a positive personality: for the first time I saw the bones and the structure and the "lie" of mountains, living with them and climbing them as I was, lying on them in the sun and getting soaked with rain in their cloud cover and enclosed in their improbable, private rock-world in fog.'

The resulting pictures are amongst Piper's most successful and his close involvement with the landscape and the changing effects of the weather is clear from some notes he made at the time:

'Nov 16 [45] 7.30 pm Cold gale from the S.E. blowing down the valley. Light from a watery misty moon strong; thin, horizontal, furry-edged clouds above Tryfan and Glyders. Wind whistling and slanging.

'Nant Ffrancon Jan 24 [46] Sunrise rosy pink. Glyders and Tryfan under snow, down the level of Idwal but not lower. High up in the sky, yellowish rose-coloured mackerel clouds; lower, rich yellow pink flock-clouds, and lower still – immediately above Tryfan and the Glyders – curled meal-grey helm clouds. Pink reflection on snow in the east-facing mountains (Foel Goch, Y Garn). Snow blowing off in smoke-like tufts and curls. (This followed later in the day, about 2 pm, by rising gale with drizzling rain, which developed into a blizzard at night.)

'Glyder Fawr, Glyder Fach Aug 18 [46] Mist blowing

86 Rocks in Nant Ffrancon, North Wales 1950

across; during the morning, peak of Snowdon out once only – for 5 seconds, Llanfaes visibility about 15–20 yards. Curious feeling in presence of giant pale boulders, coffin-slab and trunk shaped, disappearing at close range into grey invisibility. The affectionate nature of the mountain (compared with Snowdon and the Carnedds) not changed by the lonely closed-in sensation induced by the mist; though the rock strewn flat top becomes more than ever like a friendly cemetery belonging to an enormous and untidy race of men.

'Sept 6 [46] 8 pm (after weeks of rain) Looking across valley to East, a fern frond of white cloud rising from pale blue sky and large, isolated bronzed-grey clouds moving rapidly across the valley and disappearing behind the darkening olive bank of Braich-tu-du and below the fern frond.

'To S., small patches of rich orange light moving across dark grey and green of Tryfan and the Glyders. Above the mountains, heavy pink-stained grey clouds. To N, over the sea, low grey clouds in a bank, its top lighted yellow and with a kiss curl like an inverted breaking wave. Above this, very pale blue with slender bars of orange-yellow in zenith.'

A regular visitor to Nant Ffrancon was the engraver Reynolds Stone. He joined Piper in exploring Snowdonia and for some time the two men worked on a new guide-book together which was to have been illustrated by Piper's drawings and also engravings made by Stone, in the manner of the old guidebooks, from Piper's original drawings. Unfortunately the book was never finished, though the engravings were later published as illustrations to a text, *The Mountains*, by the Welsh poet R.S. Thomas. All the same, Piper with his usual thoroughness, read a great many books and made extensive notes of different aspects of the area.

Once again his initial interest had been aroused by his precursors. Before the war, in a second-hand bookshop in Hereford, he bought a copy of Pugh's *Cambria Depicta* which had hand-coloured aquatints and some engravings bound in by a previous owner. He visited the sites and read a number of other books including Pennant's *Tour to North Wales* and Ramsay's *Old Glaciers of Switzerland and Wales.*

As in Yorkshire and elsewhere he was following in the footsteps of the old Romantic artists. In the case of Snowdonia Richard Wilson (1714–1782) was the pioneer. 'There are only three ideal views in the mountainous country of North Wales,' Piper wrote, 'and Richard Wilson painted all of them several times ... An intimate knowledge of the Welsh mountains increases one's respect for Wilson's performance greatly.'

87 Nant Ffrancon, North Wales 1950

106

Other artists had made the mistake of drawing the ideal views naturalistically. 'If this is done the result looks nothing like the real thing. The scale is gone; the colour is vague and impersonal, dull and impressionist colour, and the rocks are shapeless. It is impossible to draw this landscape superficially without the result looking primly and obviously superficial, because it is impossible to draw it without a calculating, stalking, inventive vision. Rock outcrops and terraces indicate a direction of line which seems to be immediately contradicted by grass covered slopes at the side of them. It is only when the light changes and the sun comes out from low cloud at sunset perhaps, that the general shape of the whole hillside is disclosed as agreeing with the terraced strata indications of the exposed rocks. And as to colour, it is no use to accept the momentary appearance of any part of the landscape as a revelation of itself. A mountain lake is black as the cloud blows over to hide the mountain peak behind it, and white or palest grey as the cloud wind comes across from the same cloud to serrate the water surface with ripples.'

The same change of light affected the colour of the rocks: '"Grey" is not only an over-simple and over-vulgar answer to the sum, but a wrong one. The rocks can only look grey in a leaden light and then do not, commonly. Against mountain grass or scree, against peaty patches near tarns, on convex slopes, in dark corners – the same kind of rock can look utterly different; and changes equally violently in colour according to the light and time of year. The rocks are often mirrors for the sky, sometimes antagonistic to the sky's colour; they can react to a shower of rain like dried pebbles with the wash of a rising tide on them, or having grown half-waterproof coats of lichen, change very little in wet weather.

'In an early November sunset about 4 o'clock on the Western slopes of Y Garn and Foel Goch isolated rocks in the darkening grass were a rich magenta colour, and the same rocks can look as white as a newly born sheep, or pinkish or greenish. The range of tone in the rocks is from black to white – blackest moss patches them often, and the white lichen common near the Atlantic seaboard too. On top of the Glyders, in places, the richest chrome yellow and chrome orange lichens are prominent. In the Llyn Llydaw region towards Glaslyn there are copper-coloured rocks lying in confusion. In Cwm Glas the glaciated rocks lie in the shape of enormous half-shut fans, and black and deep-grown moss scrawls wildly-drawn patterns over a main whitish-grey design, which is closed and skirted by rich green grass.'

Piper also made a study of the stone walls that he found in the area and this led to a number of paintings on the same theme done in Snowdonia and neighbouring Anglesey. 'Walls made largely of the igneous rock of the Snowdon area,' he wrote, 'are not nearly so neat as the limestone walls of Gloucestershire or Northants or Oxford nor the Sarsen walls of Wiltshire, nor even as the Pennine or Cornish walls. Frost-split fragments of the hard rock preserve their points and angularities against weather, and only in the walls which have been built largely of stone that was lying in the open for thousands of years before it was appropriated is there much neatness. In the higher places a dark greyish-green colour prevails in the walls, and they are given local peculiarity by the intermixture of slate waste on which the big flat-sided stones in the centre part of the wall are often bedded, the slate resting on and holding together a number of small stones below them, and acting as a tie.

'In the lower places, especially in sheltered parts of the valleys, the walls are richly mossed, and small-leaved ivy is thrown over them here and there, its stalks, self-coloured brownish grey like some of the stones, knotting in the crevices. Where neither moss nor ivy grows, the stones are lichen-speckled in these lower places and grey seaweed-like lichen grows profusely, as well as the flat grey stain-like ones and the Naples, ochre and chrome yellow ones – and through the whole with its further clothing, and especially skirting, of harebells, blackberry sprays, foxgloves, bedstraw and ferns, glisten starry points of quartz, which grow little lichen and less moss.'

88 Anglesey Walls: Llanddona, Penmon, North Wales

89 Cwm Idwal, North Wales 1950

90 Rocks on Glyder Fawr, North Wales 1945–6

91 Tryfan, North Wales 1945–6

92 Bethesda, North Wales 1944

Romney Marsh

In 1947 Piper was commissioned to write and illustrate a book on Romney Marsh for the King Penguin series edited by Nikolaus Pevsner. Since his boyhood, when he first went on a cycling holiday with his friend Frank Milward, the Marsh has been one of his favourite parts of England. A neat triangle of flat land between Rye, Dungeness and Hythe, it is, like the Isle of Portland, a lonely and rather desolate area which has at first sight little to commend it. There is nothing sensational to see; no beauty spots. But, like Portland, it is on closer knowledge an intensely Romantic place, full of atmosphere. The Marsh is covered with military rubble, a reminder that it was always regarded as the most likely place for an invasion of England from the continent. Piper noted 'the dark blots of the Martello Towers along the east marsh coast from Hythe away past Littlestone, the Military Canal, and the remains of twentieth century war activity – rusty wire in hedgerows, radar masts and an occasional crows nest look out on the coast.' As a painter he was especially sensitive to the colours: 'There is extraordinary richness of summer vegetation, the grass is lush and the dykes and banks, when uncut, are thick with reeds and waterplants. In winter the reeds still blow in the dykes, showing a pale-yellow flank of close stalks with feathery crowns of grey or purple-black fronds, and there are pea-stacks, built on a tripod of sticks for aeration, as well as the many dyke-side potato and swede clamps. The fences are mostly made of three long split-oak or elm rails joining stout posts, the whole low and sturdy, and they grow an emerald lichen that at first sight seems to dust, and finally screens the pale grey wood. They are an important feature in marsh colour and very often the palest objects in the view. They look excellent against the blackthorn hedges in winter when these are dark purple-brown, and against the oranges and reds of massed willow branches. The levels themselves are often paler than the sky ... The most frequent and the most characteristic views in the Marsh have foregrounds of pale warmth, distances of misted trees and low hills, and intervening low levels in pale light.'

And then of course there were the churches, amongst the finest in England. 'In the marsh', Piper writes, 'you are seldom out of sight of a church'. He drew and painted all of them for his King Penguin book on Romney Marsh and has returned to paint many of them since: Old Romney 'an irregular buttressed structure in fields neighboured by a large dark yew'; Ivychurch 'large, clerestoried and regularly planned'; Brookland

93 Royal Military Canal, Kent 1981

Ruckage 8 VII 81 John Piper

Snargate

94 Newchurch, Romney Marsh, Kent 1946

95 Snargate, Romney Marsh, Kent 1946

96 Ivychurch, Romney Marsh, Kent 1982

97 Interior of Ivychurch, Romney Marsh, Kent 1982

with its detached bell tower; and little Fairfield, isolated in a field near Appledore like a Noah's Ark. Piper started work on *Romney Marsh* in 1947 and it was eventually published in 1950. The little book brought together all sides of his genius – it contained his drawings and paintings, a descriptive text and detailed architectural notes on the churches; and though it was all done on a miniature scale in keeping with the rest of the series, it put over the atmosphere of Romney Marsh better than any more lavish volume might have done.

Once again Piper was back to one of his earliest loves – the neglected seashore. He ignored the more picturesque Martello Towers at Hythe and the Dymchurch wall (painted so many times by his great friend Paul Nash) and returned instead to Dungeness, the wilderness of shingle, now wrecked by a gigantic nuclear power station, which he had once compared to an oversized nursery floor littered with coastguard cottages, huts, stores, lighthouses and flagpoles.

'Coastal gaiety' was an expression he had used in his essay on the Nautical Style published in the *Architectural Review*, and Piper was quick to appreciate the humorous side of Romney Marsh. With the encouragement of his friend William Plomer he even made a collection of the names of seaside bungalows in the Greatstone area: *Hove To, Windy Cot, Midships, Galleons, Owl's Retreat, Per Mart* (Percy Martha perhaps), *Mount Nod, Cooparoo, Linga Longa, Sea Spray, Sea Close, Sea Wynd, Minarest, Thistledome* (This'll do me), *Twix Us, Emohruo* (Our Home backwards), *Ecnamor* (Romance backwards), *Nelande* (Edna Len backwards).

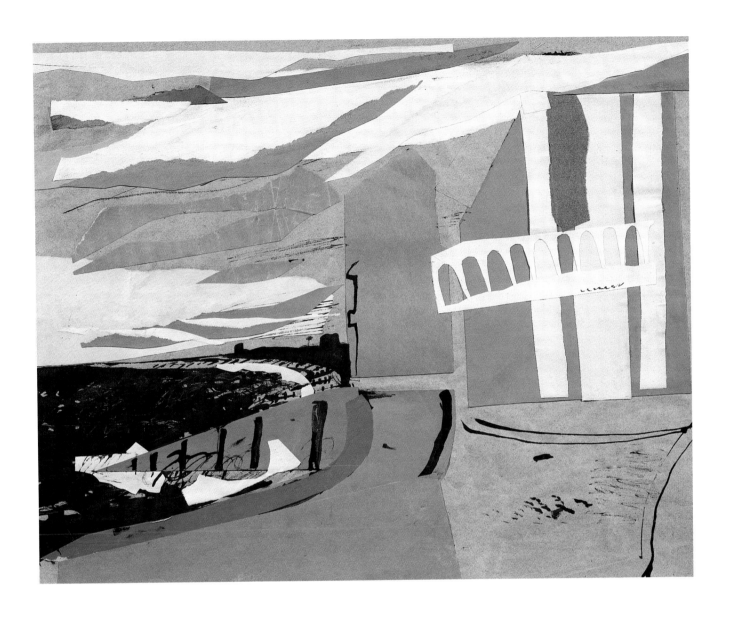

98 Dungeness, Kent 1947

99 Littlestone-on-Sea, Romney Marsh, Kent 1936

Monuments

At different times in his career Piper has tended to do a number of paintings on the same theme. In this post-war period, during which he was working on the Romney Marsh book as well as in Snowdonia, he painted several pictures of church monuments. The classical monuments of the seventeenth and eighteenth centuries which include the work of masters like Roubilliac, Scheemaker and Rysbrack were not thought much of during the thirties. Like Georgian churches and Non-conformist chapels they tended to be ignored by the writers of guidebooks. One of the innovations of the Piper and Betjeman guides was the emphasis given to these overlooked masterpieces. This interest coincided with the work of Katherine Esdaile, author of *English Monumental Sculpture since the Renaissance* (1927), and other pioneering books. She contributed a list of all the best church monuments to Piper's *Oxfordshire*. The book also had photographs by Piper of a number of examples like the Lichfield monument at Spelsbury.

During the period '46 to '50 Piper also did a number of oil paintings of monuments including those at Exton, Rutland (the work of Nollekens and Grinling Gibbons); Ockham in Surrey, the King monuments, Redgrave (Suffolk), Boxted (Suffolk) and Lydiard Tregoze (Wilt-shire). 'I thought they made such beautiful compositions of lights and darks', he says. A favourite church was at Croome d'Abitot, Worcestershire, an eighteenth-century Gothick building erected for the Coventry family by Capability Brown and with an interior designed by Robert Adam. The church is really a mausoleum for the Coventrys – though 'Provision is also made . . . for the worship of God' (Betjeman's *Collins Guide*) – and contains several beautiful monuments including one by Grinling Gibbons. In 1958 Piper revisited the church with BBC film maker John Read and sketched the striking seventeenth-century tomb of Margaret Coventry, later using it as the subject of an aquatint.

In 1951 the *Shell Guides* were published again, and the Betjeman/Piper *Shropshire* appeared. The Guides had been discontinued during the war and meanwhile Piper and Betjeman had become involved in a new guidebook project with their publishing friend John Murray. Three guidebooks were produced, *Buckinghamshire* (1948), *Berkshire* (1949), both by Betjeman and Piper, and *Lancashire* (1955) by Peter Fleetwood Hesketh; but in the difficult post-war period, the books proved too expensive to produce and Murray reluctantly abandoned

100 [previous page] The Coventry Monuments, Croome D'Abitot, Worcestershire 1953

101 [above] Monument by Grinling Gibbons, Exton Church, Rutland *c.* 1970

the scheme. The *Shell Guides* continued as before but as the years passed Betjeman's interest began to wane and Piper found himself playing more and more of an active role, especially with the choice of pictures, until eventually in 1962 he became joint editor of the Guides along with Betjeman. Then in 1967 Betjeman picked a quarrel with Shell when the company withdrew what they considered a defamatory reference to the Norwich Union Building Society from Juliet Smith's Northamptonshire *Guide*. There was a major public row and Betjeman resigned: 'I remember feeling despondent walking down the embankment and wondering whether it had been worth it, having all those jokes with typography.'

Piper now took over the editorship – an immense task but one for which he was exceptionally well fitted, as the work was what he had been doing all his life, ever since he first started cycling round Britain as a boy. He had too what Betjeman lacked, an iron determination to see a thing through; though in the case of the Guides the task was an endless one, like painting the Forth Bridge. After a few years the information in the books was out of date, and they had to be revised.

As well as being the overall editor Piper contributed drawings and quantities of photographs. In two cases he stepped in also as writer. Following the death of Pennethorne Hughes he took over the job of completing the unfinished text of *Kent* (1969), which also contains some of his most successful photographs. He also collaborated with the architect J. H. Cheetham on the third edition of *Wiltshire*, published in 1968.

The first Wiltshire *Shell Guide* appeared in 1935. Edited by the travel writer Robert Byron it was one of the best of the early guides. A second edition with a revised gazetteer by David Verey was brought out in 1956. Piper's interest in Wiltshire went back to his boyhood when he had joined the Wiltshire Archaeological Society and experienced for the first time the strange atmosphere of the downland, at once wild and homely, and the pull of the prehistoric sites which had been felt by so many painters and early antiquaries like John Aubrey – the 'tree-crowned barrows', the sarsen stones and Silbury Hill – 'dark and wonderfully shaped, like an inverted hand-turned wooden bowl.' Driving from Marlborough to Calne with Jim Richards in 1940 he noted that 'apart from a shack or so and the distant RAF depot, nothing has spoilt this area. It is still possible to see it as Gilpin saw it in 1798*: "Marlborough Down is one of those vast, dreary scenes, which our ancestors, in the dignity of a state of nature, chose as a

Observations on the Western parts of England.

repository of their dead. Nature, in scenes like these, seems only to have chalked out her designs. The ground is laid in, but left unfinished". Again: "the ground is spread, indeed, as the poet observes, *like the ocean*; but it is like the ocean after a storm, it is continually heaving in large swells ... By the rays of a setting sun the distant barrows are most conspicuously seen. Every little summit being tipped with a splendid light, while the plain is in shadow, is at that time easily distinguished."'

In 1940, Avebury had been recently restored by Alexander Keiller, and many of the monoliths, those which had not been destroyed or put to other uses, re-erected. 'Compared with the gaunt self-sufficiency of Stonehenge', Piper writes, 'Avebury has an inconsequent domesticity; the great ditch embraces the cottages of the modern village, stones that were once in precise and ritual positions stick up amongst village elms or, smashed to a suitable size, are embedded in the cottage walls themselves. Concrete posts mark the places of old stones and make up the Kennet avenue, one and a half miles long, that once approached the site from the south. They look like a vast game of archaeological chess.'

Stonehenge aroused more complicated emotions. Even in 1949 when Piper wrote a long article about it for the *Architectural Review*, its wild and remote character that had attracted Turner and Constable had gone for good: 'Larkhill Camp is a clearly visible eyesore and the custodian's chalet in a tasteless and dated "art" style flanks a car park; a turnstile revolves in the barbed-wire fence, and the Ladies and Gents is a good solid eye catcher in a single block, with notices close to the grass pointing to it.'

At the same time the various scientific theories that were put forward to explain the purpose of the stones tended, in Piper's view, to detract from the aesthetic and spiritual emotions which they ought to inspire in the beholder. He quoted with approval the view of William Long, a Wiltshire archaeologist, who wrote in 1876: 'Upon the mind of the thoughtful visitor two considerations can hardly fail to press, and with considerable force, as he recovers from the first astonishment; the one being the very sacred character of the place to those who had selected the spot, and raised upon it this remarkable structure: the other the (probably) long period during which it must have served as a *locus consecratus* to the surrounding people.'

'Two positive and loving yeses' – Piper commented.

Despite the trippers and the archaeologists Stonehenge was and is still in Piper's view 'one of the most beautiful man-made objects in Britain'.

He wrote: 'On a winter day, when small pools of

Photo by EP Stonehenge 7 V 81

102 [previous page] Stonehenge, Wiltshire 1981

103 [above] Barrow on Salisbury Plain,
Wiltshire *c.* 1944

126

water lie in hollows of some of the fallen stones like sea-water in slabs of fallen cliff on a beach after the tide has gone out, and when sun and shadow alternate so that from a few points the sense that the stones stand firmly in circles is made plain and then, as the light changes, the sense of ruin or chaotic arrangement succeeds; and when from the trodden, re-turfed and re-trodden grass the stones rise dark grey with specklings of white lichen, and then again, in brightening light, sparkle with ochres and umbers and contradict their natures by becoming insubstantial – then it is still possible to recognise here a giant of visual drama and intensity.'

Lacock Abbey near Chippenham was another Wiltshire site which especially appealed to Piper. It is an ancient building which began life as an Augustinian Nunnery in the thirteenth century and was later added to in the 1750s in the style of the Gothic revival. By then the house was owned by the Talbot family and remained so until 1958, W. H. Fox-Talbot carrying out some of his early photographic experiments there in 1839.

Piper escaped from his work on the Bath war damage in 1942 to pay a visit to Lacock. He noted, on 17 March:

'Wiltshire upland elms and brown Avon behind Lacock Abbey. Lightings and blottings of March rain and sun. Sharp shadows on grey and ochre stone of Gothic hall of abbey. Village damply lit in open weather: shut and preserved looking with empty streets, well patted and pickled beams and smoothed medievalism. Blacksmith working; tractors backfiring in yards. Decent guest house (curry and prunes). Elm tree bottoms in the water by rustic bridge behind. Church has some odd 1910-looking very late Perp tracery in N. aisle. Beautiful glass in tracery lights of N. Chapel. Eliz. tombs here ugly. Note: Eliz. work peels and becomes textural in a thin scraggy way, as does Carpenter's Gothic, only more so.

'Military occupying Batsford-book large court of Abbey. LCC School in residence, and some paying guests. Miss Talbot efficient, with an office. Gothic hall has busts in niches, floriated canopies projecting. Skeleton death, man in a dunce's hat, full-length figures with small heads and swirled draperies, all in reddish plaster – terra cotta colour. Through Palladian dining room, down spiral stair, cloister – miniature Winchester – and nuns' chapter, frater, dorter, launder and so on. All very much as left by C. H. Talbot, enthusiastic FSA. Cobwebbed Cotman texture. Peeling yellow plaster, dampening stonework, trestle tables sagging under dusty fragments. 67 gallon Nuns cauldron, genuine Mechlin 1500 with a Birmingham look, stands on a plinth, black in one of the pale vaulted rooms.

'Cedars on the lawn. An urn transplanted to top an air-raid shelter. Lawn slopes below octagonal angle tower to brown river, but Gothic front the best.'

The following year Piper was back in Wiltshire, this time at Inglesham near Lechlade. This village has a tiny late Norman and Early English church which remained unrestored by the Victorians, thanks to the efforts of William Morris who lived nearby at Kelmscott and who helped to repair the church in 1888–9:

'The day [21 April 1943] spent drawing the south side of Inglesham church with little success. Strong sun, warm early, fading towards noon; rather blighting wind and grey clouds later. The stone and plaster rich ochre (iron-ore ochre) to grey, patched with browns and neutrals. Dove-grey and near white lichen, and some gold. General colour that of medium-cooked pastry (but very rough and matt, nowhere shiny) transforming to grey under cloudy sky. The colours milky. Also, like a faded gold-ochre velvet, greyish where rubbed.'

The little Wiltshire town of Devizes was one that has always held an appeal for Piper. The attraction like that of so many of his favourite places has lain in its ordinariness and lack of pretension. There was nothing special for the Medievalist, nothing much for the guidebook to mention – 'it has been allowed to grow and live a reasonable unhurried life without being maimed or killed by major disasters or unwanted developments'. Piper listed as its blessings: good minor architecture, magnificent museum (contents, not building), brewery and tobacco factory (sensible, small-scale manufacture for such a town), branch-line railway, good inns and bars, hotels that are not over Trust-worthy, fair churches and chapels, canal of handsome appearance, sensible plan, bracing air, good-looking inhabitants, cinemas (old fashioned and super, the super not ostentatious).

The disadvantages were: 'lack of second-hand book-shops, absence of short sylvan walks and the wind.'

(As this was written in 1944 it is not surprising that some of it is no longer valid. Today Devizes is not on the railway. On the other hand there is a second-hand book-shop. As a general description of the town, however, it remains a fair one).

Devizes retained its character because in Piper's view it had not fallen a prey to planning. But at the same time he sounded a warning: 'Devizes cannot possibly remain Devizes unless each house owner is allowed to paint his house any colour he likes, and let the whole sort itself into an arbitrary, informal jumble. If we are not allowed any unnecessary ornament in modern architecture let us keep some traces somewhere of informality and jumble; in the country, some weeds and wilderness between the

104 Lacock Abbey, Wiltshire 1940

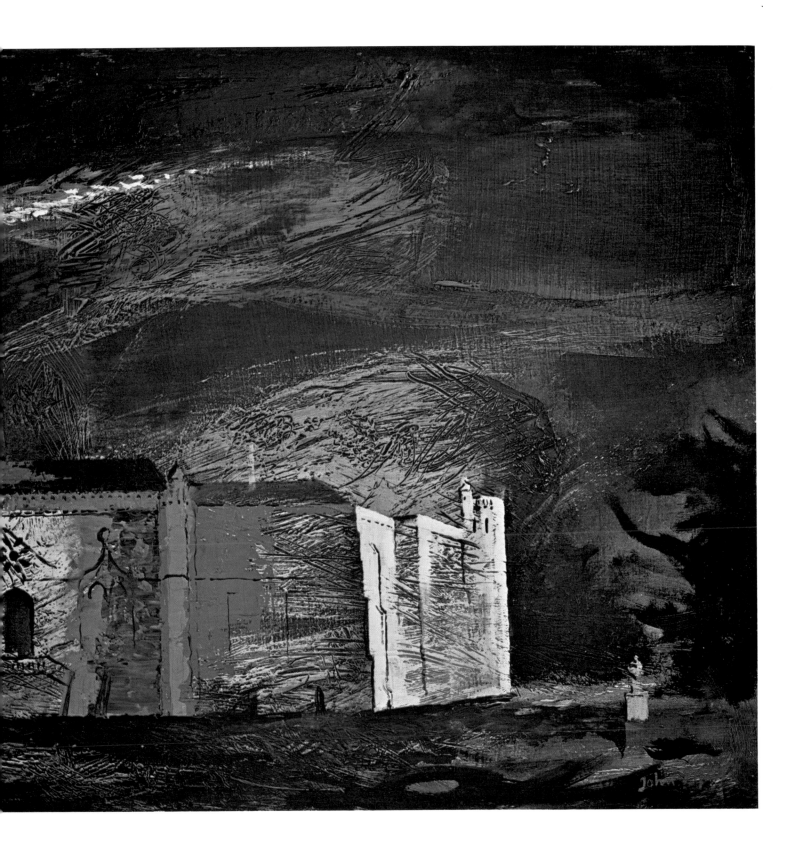

Within the image: ← New St: (4 houses distant) GR OCERS FO RTT BROTHERS OPTICIAN JEWELLER Lloyd's BANK Limited

105 Devizes, Wiltshire

The Little Brittox →

BURT

BURTS IRONMONGERS STORE County Tea Warehouse Milliner LUCAS Draper

National Parks with their rows of litter baskets, and in the town some possibility of nonsensical self-expression, hidden away behind Marks and Spencers and the Gaumont British. The Devizes Co-operative Society gave the Market Place a shock a few years ago with a smart modernistic shop with horizontal window bars and a square clock; but already it is beginning to take its place co-operatively, because there is still enough of a jumble to absorb it and make it look funny. If two more Co-operative Societies creep up side alleys into the market place the end will be in sight. Less good taste and less co-operation, that is the secret; more individuals doing more as they like, so long as they are not speculative builders or "chain" architects – these, and committees of all kinds, should be rendered powerless in architectural matters, forbidden to build a house or invest in a concrete mixer. It is our only hope.'

In 1981 Piper himself was able to contribute to the pleasant jumble of Devizes when the town's museum installed a stained glass window designed by him, illustrating a number of Wiltshire archaeological themes. It was an appropriate gesture from an artist who had earlier paid tribute to the museum and the tradition of the Wiltshire archaeologists that it maintained – 'the fading tradition of the specialist who is also a man of wide learning and culture, the man who can treat his subject scientifically without losing hold of the main romantic threads that connect it with life.'

106 Wiltshire: Cartoon for a stained glass window at Devizes Museum 1981
left to right: Woolly-headed thistle; part of Avebury Avenue; White Horse, Cherhill and iron-age fort; urns and amber necklace from the bronze age in the Museum collection; Devil's Den

South Wales

By the sixties the Pipers had tired of the Snowdonia rainfall, which is twice the national average. Myfanwy described 'day after day looking across the Nant Ffrancon Valley from the cottage . . . to the driving unpenetrable curtain, hearing the torrent behind us gathering stones and rubble to hurl at our backs, sweeping the water that flowed in at the back door out at the front, driving to Bangor for food and books and back, through seven, weary, sodden gates, day after day, week after week. . .'.

In 1961, they decided to move to South Wales for their holiday home. Piper became closely involved with the area. His visits to it had begun before the war, when he went on a camping holiday with his school-friend Frank Milward. Later he visited the Gower peninsula with Myfanwy where they went looking for Nonconformist chapels. A number of pictures date from 1939 when the Pipers stayed on a farm near Pontrhydfendigaid in Cardiganshire on the edge of 'the green desert of Wales', an area of undulating upland where nothing grows and where there are no roads. Piper did some paintings of the Teifi lakes and Strata Florida Abbey during this visit. The same year he visited Hafod for the first time.

Hafod (meaning 'a summer dwelling'), in the valley of the Ystwyth, was built by Colonel Thomas Johnes (1748–1816), MP for Radnorshire and Cardiganshire, translator of Froissart and Monstrelet and friend and patron of many artists and writers. In 1783 he began to build his Gothic mansion, surrounding it with a plantation of millions of trees. His architect was Baldwin of Bath, though Nash also had a hand in the designs and added a number of features, a suspension bridge over the river and the walled Adam and Eve garden. The house was gutted by fire in 1807. 'It destroyed the mansion', Grigson writes, 'destroyed "Thetis dipping Achilles in the Styx" by Banks, destroyed the antique bust of Isis in red granite, destroyed the "petrification found in the old bed of the Nile", destroyed furniture, tapestries, the Welsh manuscripts, the collection of medieval romances, the translations of Froissart printed on his own press by Colonel Johnes, destroyed all the rest of all the treasures of the great octagonal library with its copper dome, and its gallery carried on Doric pillars and variegated marble.'

107 Llyn Teifi, Cardiganshire 1982

The house was rebuilt with a number of additions, an Italianate tower at one end and a pagoda, reminiscent of Brighton pavilion, at the other. But then more fires and other disasters reduced the place to a state of what Piper called 'decrepit glory'. 'The most enchanted fortnight we have ever spent', Myfanwy Piper later described this 1939 visit to Hafod, 'On the terrace of the house which stood above the fast flowing amber Ystwyth (fishless, polluted by the leadmines further up) sheep detached themselves from the stonework. In the orangery a solitary geranium, rare and brilliant, was witness to the care of past years. The delicate octagonal gothic library looked empty and dishevelled, flanked by a huge unfinished campanile by the fashionable Italian architect Anthony Salvin from whose parapet and open roof trees and ferns appeared. Upon the ground lay fruit from the ice blue conifers, pale pink and green inside, like unripe pomegranates.

'Slowly we found it all. The now flowerless garden on a knoll, its entrance with the elegant slate steps hidden beneath a tunnel of laurel and rhododendron. The robin's grave, with its urn by Joseph Banks upon it, Samuel Rogers' epitaph for his friend Johnes's little daughter's pet, still decipherable.

'The Adam and Eve garden with its crude stone entrance; a cedar, a cypress, a decrepit box tree and, on the ground, in this crumbling Eden the remains of a stone serpent, and a stone hand holding stone flowers. Everywhere there was some new piece of invention, crumbling, moss grown, hidden in ferns and grass. A fine delicate single-span bridge; rustic arches; here a solid spout of water, falling for twelve feet into a rich deep brown basin, there a silver ribbon slithering down a shoulder about forty feet high to join the main stream which curved round another shoulder where the level, a narrow tunnel blasted through the cliff, allowed one to walk along and see the cascade through a rocky framework. The opalescent spray fell at our feet, making pools on the floor of the tunnel. All miniature, but in living scale with the valley in which it lay.'*

A Betjeman anthology, *English Scottish and Welsh Landscape Verse* (1944), is illustrated by Piper lithographs, a number of them Welsh scenes; one of them, Grongar Hill, near Llangathen in Carmarthenshire, is also the subject of a painting done in 1943. The hill, which has an iron age fort on the summit, was the subject of a poem by the Rev John Dyer (1700–1758):

See on the mountain's southern side,
Where the prospect opens wide,

*Hafod has now been completely destroyed.

Where the evening gilds the tide;
How close and small the hedges lie!
What streaks of meadows cross the eye!*

In the same area Piper also painted Dryslwyn Castle, another favourite site of Romantic poets and artists. A print of the Towey valley dates from 1947.

In the summer of 1961 he was exploring the country near Strumble Head in Pembrokeshire and came across a ruined cottage on the slope of Garn Fawr ('Big Cairn') a rocky outcrop crowned by the remains of an Iron Age fort just on the boundary of what is now the Pembrokeshire National Park. Below the cottage down a grassy walled-in lane was another cottage, also abandoned. The Pipers eventually bought both of them along with fourteen acres of land for £2000 and since then they have made regular visits. It is a kinder, sunnier country than Snowdonia; very fertile, made up of small fields bounded by stone walls and the coast, with its wonderful variety of beaches, caves and cliffs, never far away.

I was lucky enough to pay a visit to Garn Fawr in October 1981, driving with the Pipers from Cardiff on a clear cold day and reaching the cottage at about noon. It is a tiny single-storey building made of stone, white-washed with a pinkish tinge, and roofed with slurry, a mixture of slate and cement. Inside, the cottage is primitive but comfortable. There is only one real room which acts as sitting- and dining-room and the right half is roofed over with a platform, reached by a step-ladder, on which the Pipers sleep. A kitchen and bathroom have been added at the rear of the cottage. There is no electricity and no telephone. As dusk falls, Piper busies himself with trimming and lighting calor gas and Tilly lamps.

The other cottage, which acts as a studio and a spare bedroom, is further up the hill, across a field grazed by sheep, and here there is a water tank which the Pipers had made, fed from a spring higher up Garn Fawr. The stones which once made up the walls of the fort can still be seen. The view from the top (700 feet above sea level) is magnificent – the patchwork of little fields and farms stretching inland towards the Prescely mountains; south down the coastline to St David's Head; Strumble Head lighthouse to the North-west, with the snow-white Sealink ferry rounding the cape from Fishguard on its way to Rosslare. On a clear day, when conditions are right, you can even see Snowdonia, and the Wicklow Hills seventy miles away, to the south of Dublin.

*The poem in its original text has recently been published in an edition illustrated with lithographs by John Piper: John Dyer, *Grongar Hill*, illustrated and with a foreword by John Piper (The Stourton Press, London, 1982).

Down the road at Llangloffan is a Baptist Chapel dated 1862 and below, by a little green gate, a stream where believers are baptised by 'total immersion', one of two such places in the district. These Nonconformist chapels, mostly built in the nineteenth century, are a notable feature of the Welsh landscape. Piper has done more than anyone to restore their standing as beautiful specimens of architecture. In the thirties, like Romanesque carvings and Victorian churches, they were despised. The proportions were thought to be all wrong and their colour schemes vulgar and ostentatious. With the help of John Betjeman, Piper brought the chapels back into favour, travelling round Wales and England taking photographs and later making them the subjects of prints and paintings. He admires the bold shapes and colours, the unusual and modern-looking lettering – of which Llangloffan affords a striking example. Piper saw the chapels, Betjeman wrote, 'not as "amusing" or "remarkably hideous" subjects, but as additions to the landscape – a flash of colour and vigour in Welsh bleakness or English mellowness'. Each has some unusual feature, like Pontyglazier, near Whitechurch, with its clock painted over the door – the hands set for ever at five to twelve, a simple and striking reminder of the short time left for repentance.

A tour with Piper does not involve the indiscriminate visiting of every place of interest in the area but rather the selection of one or two special places which seem to sum up what a particular part of the country is all about. On the second day of my visit we drove through Fishguard and Newport up into the hilly country near Nevern, through lanes lined with small oak trees which remind Piper of France, to the prehistoric site of Pentre Ifan. It is a Stone Age burial chamber on a hillside with a view down to Cardigan Bay. It has a huge capstone over sixteen feet long and weighing at least sixteen tons which looks as if it is precariously balanced on the tips of three upright stones each seven and a half feet high. Like many prehistoric places there is a special atmosphere about Pentre Ifan and there are no trippers here to detract from the majesty of the site.

The second place chosen for me to see that day, after a drive through the Prescely mountains, was St David's Cathedral. One expects to see cathedrals from a long way off, towering on the skyline, but what is different about St David's is that it stands in a hollow and from a distance only the top of the tower is visible. The cathedral is built of purple-coloured stone with splashes of yellow and the floor slopes upwards towards the altar which gives it an unusual atmosphere. The nave has an elaborately carved wooden ceiling – 'of almost Arabian

108 [above] Hafod, Cardiganshire 1939

109 Hafod: Nash Folly and Ystwyth Gorge 1939

110 [page 138 above] Grongar Hill,
Carmarthenshire 1944
Illustration from *English, Scottish and Welsh
Landscape Verse*

111 [page 138 below] Grongar Hill, Carmarthenshire

112 [page 139] Grongar Hill, Carmarthenshire 1983
top to bottom: Dryslwyn Castle and Grongar Hill from
the south; Dryslwyn Castle and Grongar Hill in the
early morning; Dryslwyn Castle and Paxton's Tower
Illustration from John Dyer, *Grongar Hill*

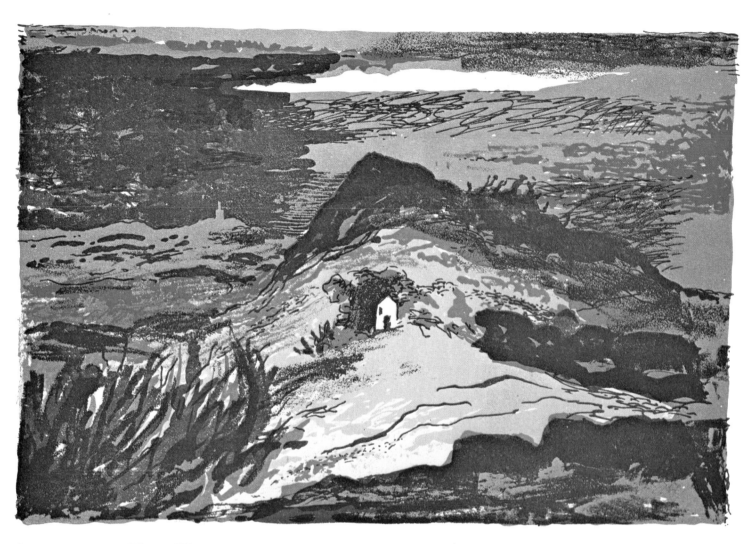
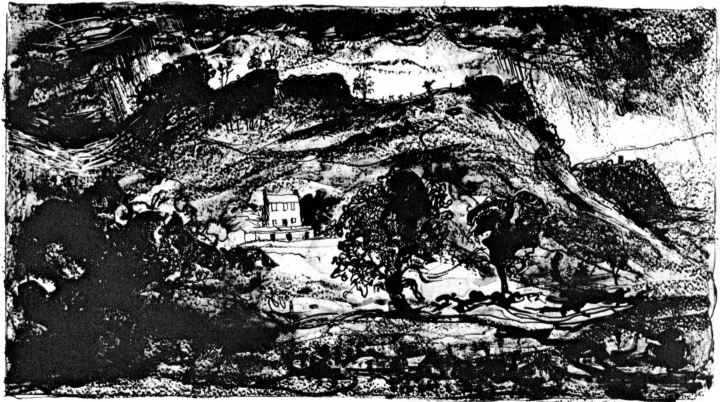

John Piper

113 [previous page] Llanfyrnach, Breconshire 1980

114 [above] Beetling Rock, Garn Fawr, Pembrokeshire 1981

115 [right] Garn Fawr, The Road to the South, Pembrokeshire 1980 *The Pipers' cottage is in the foreground*

116 [opposite above] Garn Fawr, Pembrokeshire 1970

117 [opposite below] Tretio, St David's, Pembrokeshire 1970

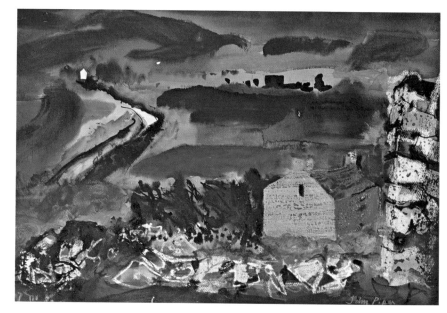

gorgeousness', as *Murray's Handbook* described it. The Pipers come here regularly for Holy Communion on Christmas Day and John takes great pleasure in kneeling at the altar rail, looking down at the medieval tiles on the floor – 'the best in the country'. He has painted the cathedral from the North, looking across the extensive ruins of the Bishop's Palace built in the fourteenth century, and the combination of the ruin and the carefully restored cathedral makes a fine panorama of rooftops and pinnacles.

There are plenty of ruined castles in this part of Wales and they have always attracted artists. We drove into a junkyard and then walked across a field to get what Piper considers to be the best view of Pembroke Castle. ('Richard Wilson knew all about it.') The castle, built by the Normans, towers above the River Pembroke, a massive citadel. Llawhaden, visible from the A40 near Haverfordwest, is another ruined castle which we visited. Built on a hill, the castle was once the residence of the Bishops of St David's. Below, on the banks of the river Cleddau, surrounded by yews and laurels, is the little church with its two turreted towers. There is also an old mill. The road goes off eastwards across an ancient bridge and from a distance you can look back and see the castle on the hill, half-hidden in the trees, and the church on the river bank.

Too many of Pembrokeshire's old castles have been, in Piper's view, excessively tidied up by the Ministry of Works. The romantic atmosphere is spoiled by the railings and neatly cut grass. An exception is Carew Castle, near Tenby, which is still in private hands. Carew is famous for its eleventh-century Cross which stands, thirteen feet high, beside the main road. The castle looks more homely than most and from the award-winning car park on the North bank of the river you can look across the river to the mullioned windows that in the words of Vyvyan Rees's *Shell Guide* 'mark the transition from the military to the domestic'. But what gives the place its character is the way the ruin has been left to be a ruin with ivy scrambling over the walls and brambles sprouting beneath. Piper sketched it from the North with Carew Cheriton church towering up in the fields beyond.

118 Tretio, Pembrokeshire 1970

119 [pages 146/147] Llandegigi Fawr, Pembrokeshire 1970

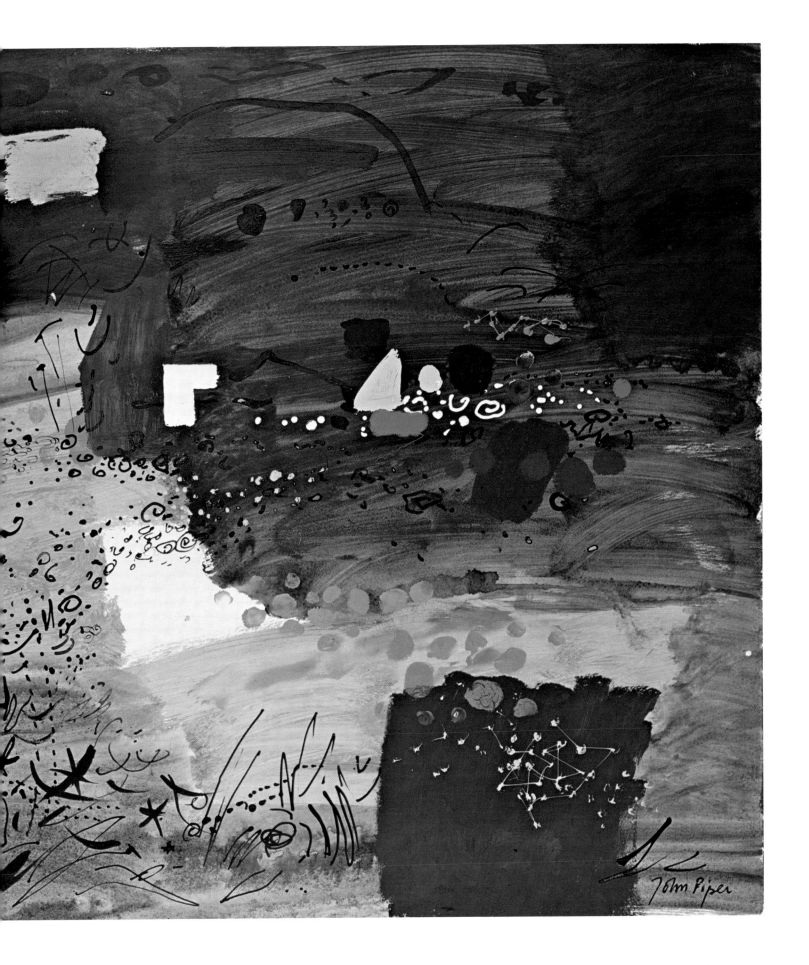

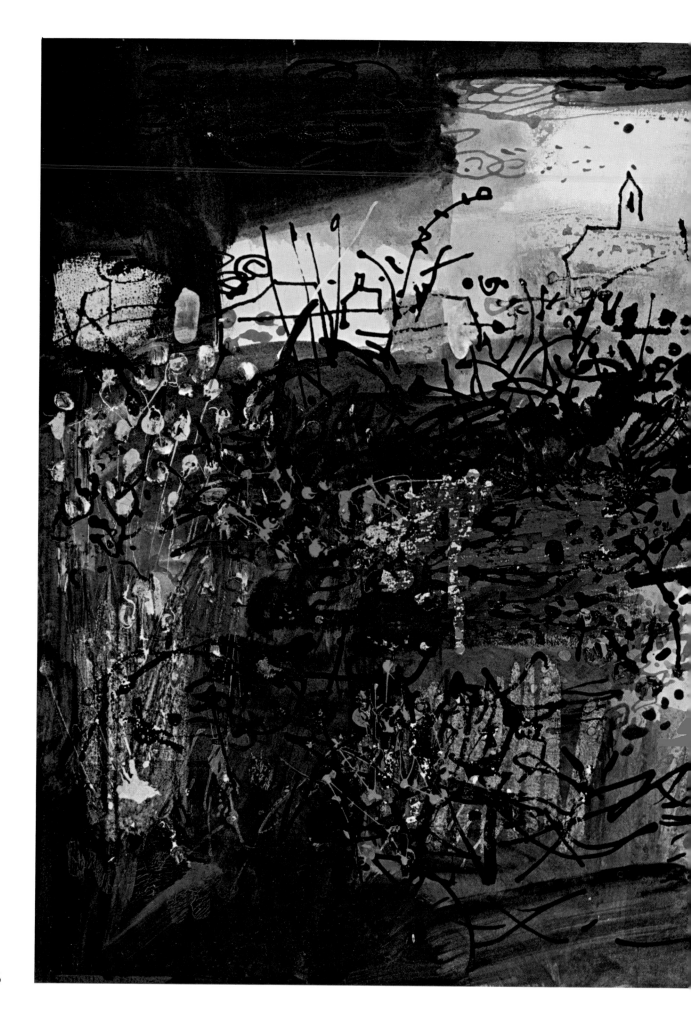

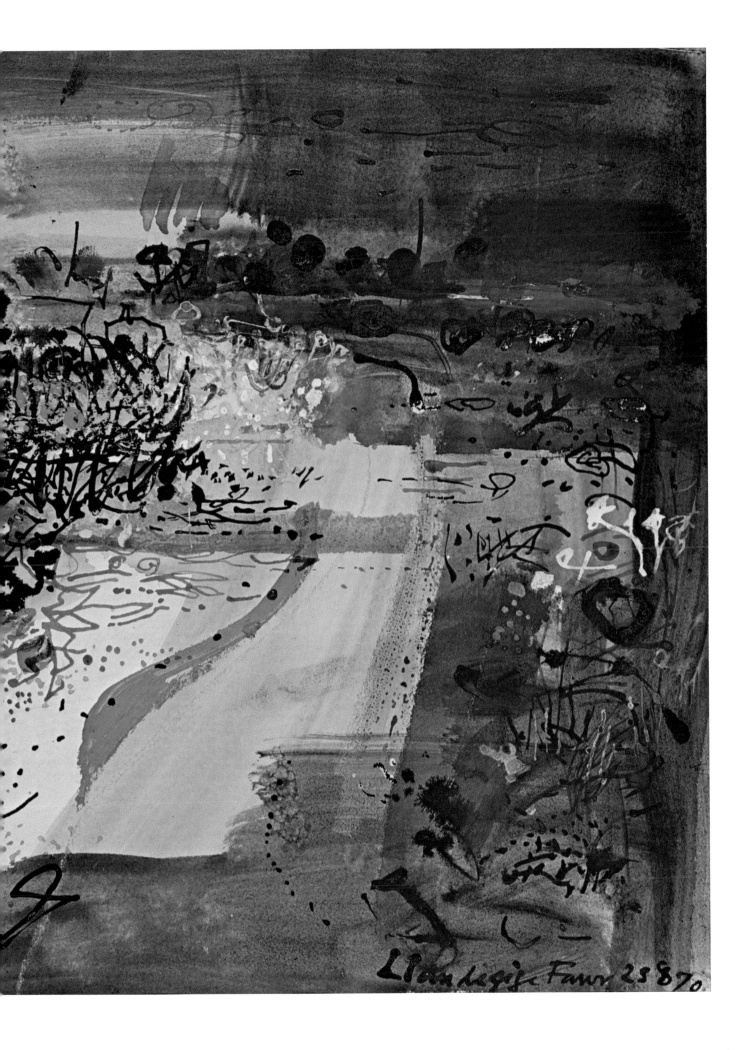

Llandégig Fawr 25 8 70

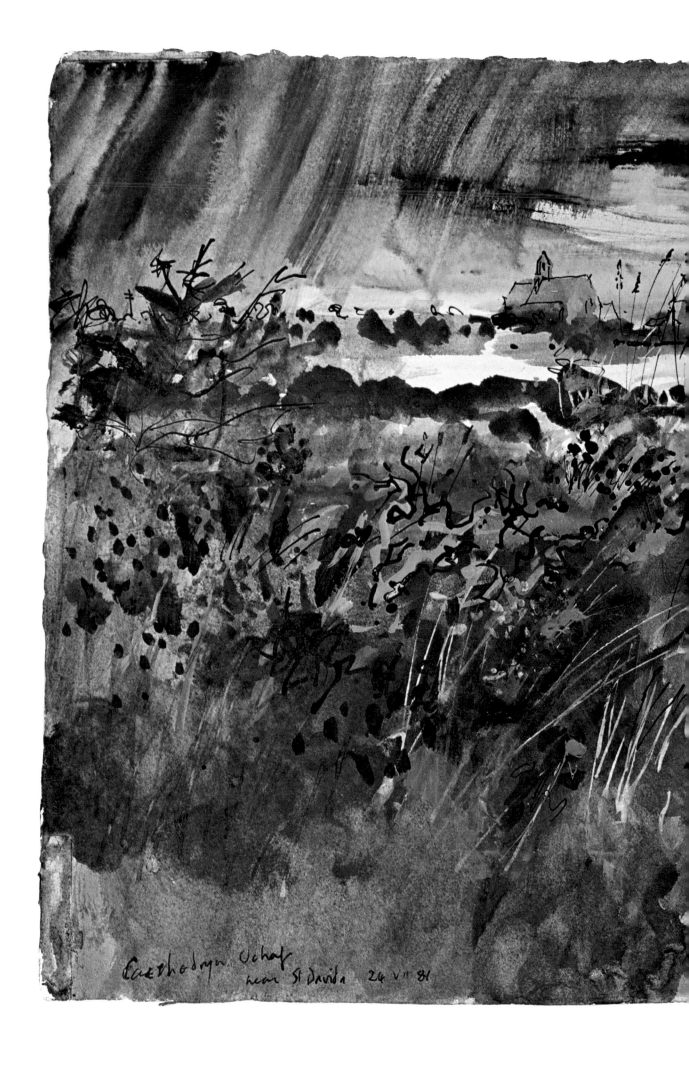

Caethodryn Uchaf
near St Davids 24 VII 81

John Piper.

120 [previous page] Caerhedwyn Uchaf III,
Pembrokeshire 1981

121 Chapel, Newtown, Montgomeryshire 1975

122 Tabor, Cross Hands, Carmarthenshire 1965

123 Bethesda, Merthyr Tydfil, Glamorgan *c.* 1970

23 viii 65

TABOR
BAPTIST CHAPEL
1872

Tabor
cross-house

Swansea
Carmarthen
main road

Colour note: Bethesda, Merthyr

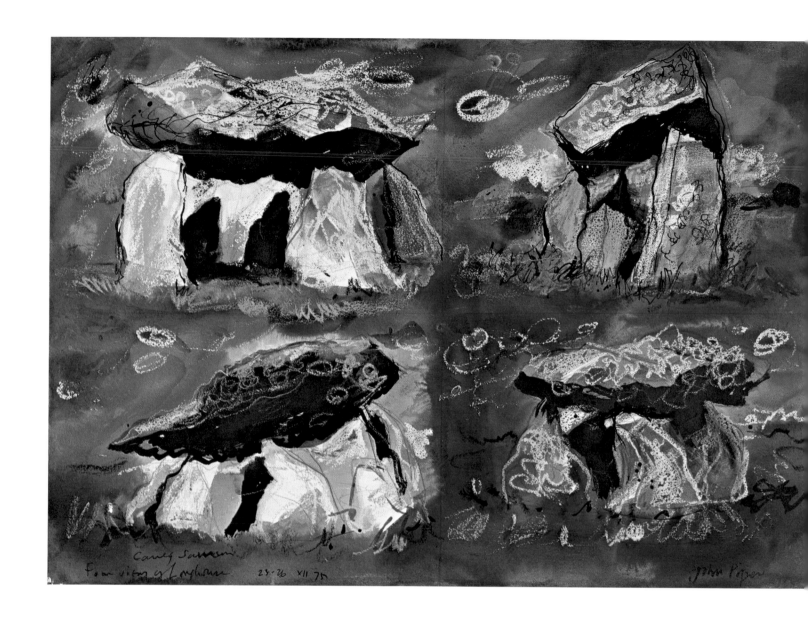

124 Carreg Sampson, Pembrokeshire 1975

125 Pentre Ifan, Prescelly Hills, Pembrokeshire *c.* 1975

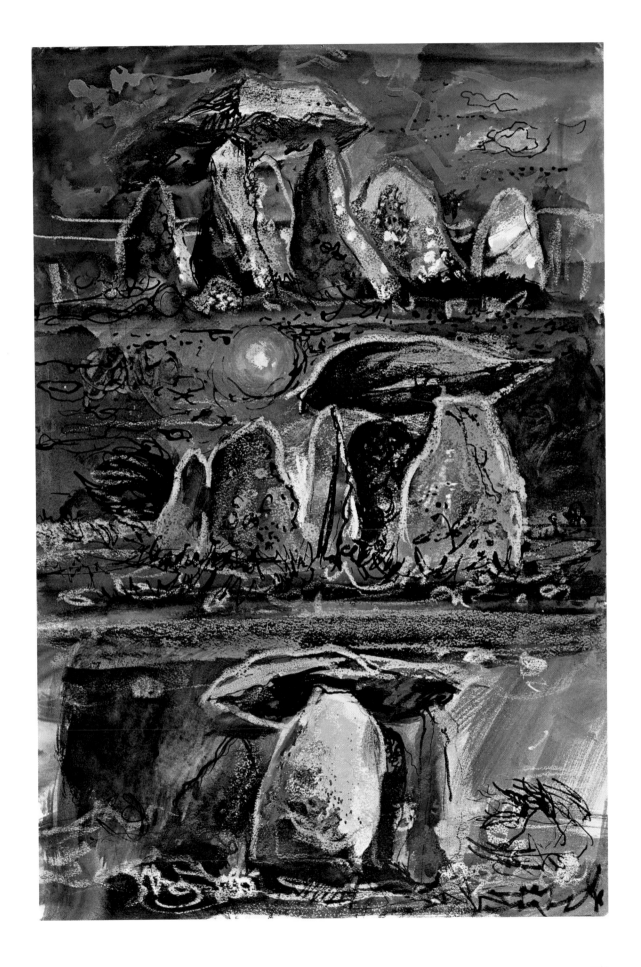

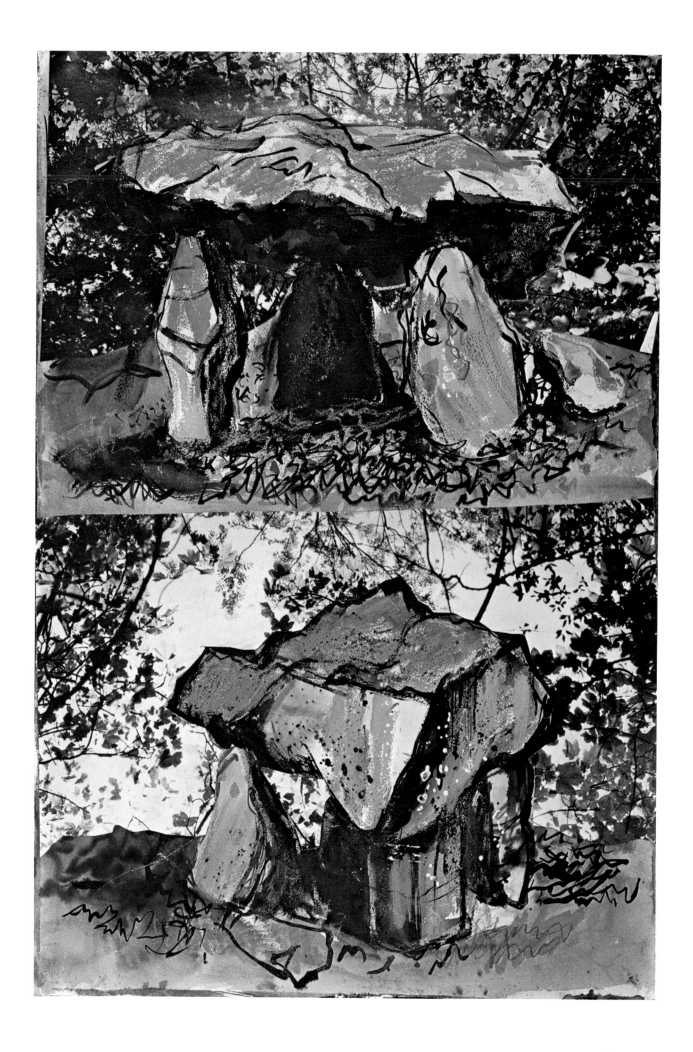

126 Dolmen near Login, Carmarthenshire 1977

127 Pen-lan, Moylgrove, Pembrokeshire 1977

128 [overleaf] St David's, Pembrokeshire 1980

129 Caernarvon Castle, North Wales 1969

THREE WELSH CASTLES
Today, castles are either whiskered ruins or tidied-up ruins: the latter are far more frequent. Pleasing decay is far less common than arrested decay. Caernarvon and Raglan are magnificent ruins that have been tidied. Carew, in Pembrokeshire has not, and is in much the same condition as it was in the early nineteenth century, when it was much sketched (like all other castles) by watercolour painters and engravers. It still sits beside the mill-pond of a tide-mill at the head of one of the many arms of the Milford Haven estuary. J.P.

130 Raglan Castle, Monmouthshire 1980

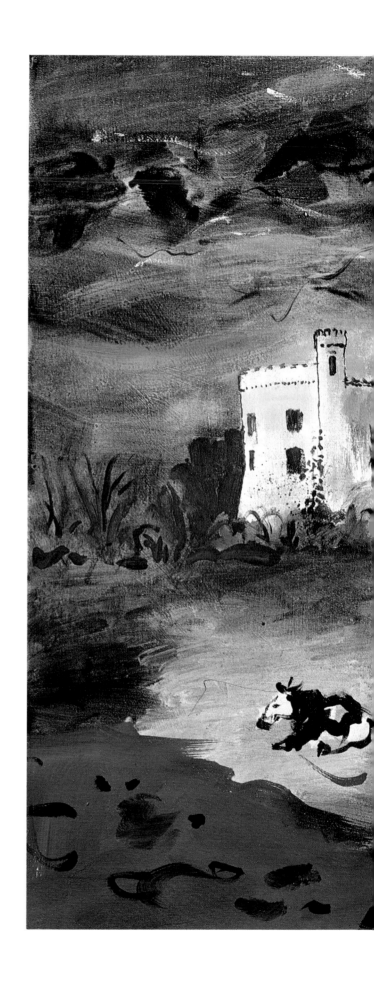

131 Carew Castle, Pembrokeshire

132 Newcastle Emlyn, Carmarthenshire 1981

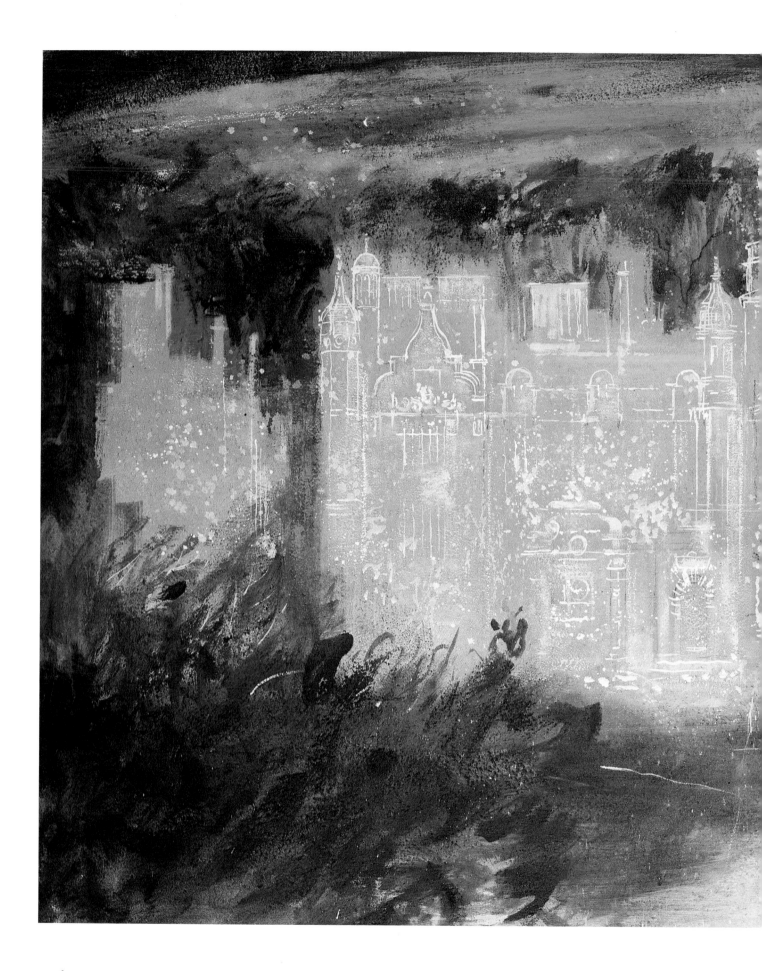

164

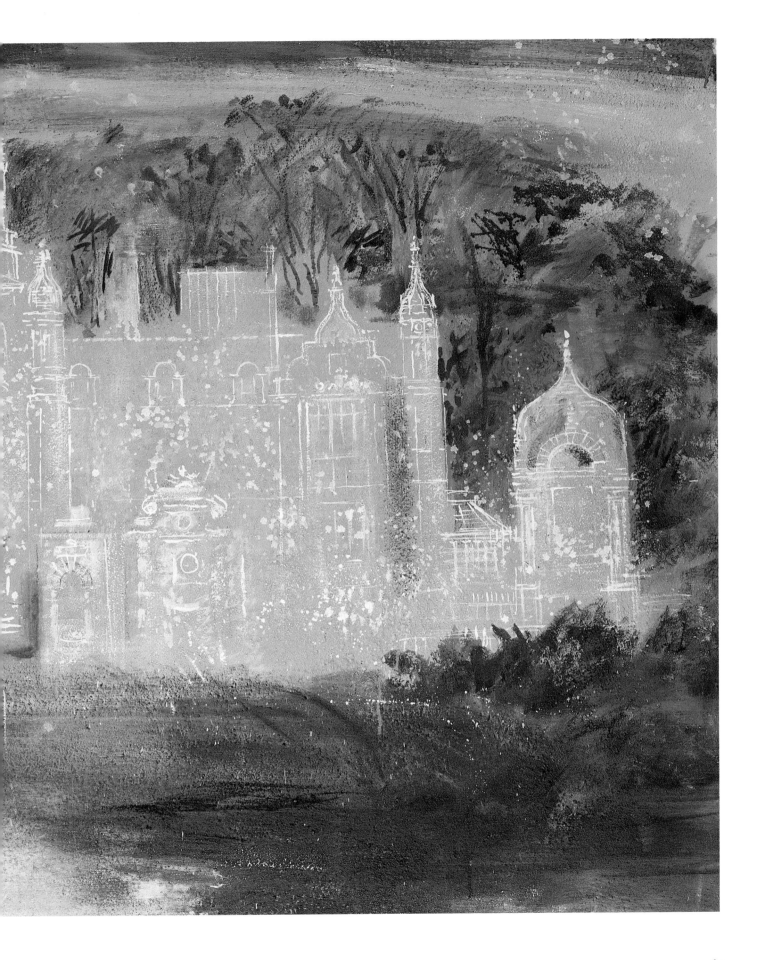

The Fens revisited. May 1980

The Pipers meet me at Grantham Station. Their Citroën is crammed with guidebooks, maps, photographic equipment, picnic food and drink. We drive to Harlaxton Manor, a few miles out of the town. Approached down a mile-long drive, it is a magnificent baroque pile dating from 1837, one of Piper's 'dream palaces'. He has made a series of paintings of such vast Victorian country houses – the others being Ettington Park, Wightwick Manor, Capesthorne, Milton Ernest, Shadwell Park, Kelham, Flintham and Waddesdon. Harlaxton has been bought and restored by the American University of Evansville and now, in May 1980, the huge ornate conservatory has just been reopened. The occasion is being marked by a Piper exhibition organised by the bursar of Harlaxton, Russell Read. Most of the paintings are of Lincolnshire churches and have been loaned by their owners. They are a reminder of Piper's huge contribution to the cause of conservation of old churches. In 1976 his old friend Henry Thorold, author of three *Shell Guides*, asked him if he had a painting of a Lincolnshire church which could be used to illustrate a book for fund-raising. 'I'll come and spend a night with you', Piper replied, 'and paint any church you like, and give the picture to the Trust to sell'. In the event he painted eight churches and these pictures were sold, the proceeds going to the Lincolnshire Old Churches Trust. Here at this Harlaxton exhibition Piper has again donated a painting to help pay for the restoration of the conservatory.

Outside, the magnificent driveway stretches into the spring fields and cherry blossom. We set off for Boston. 'In the fens the churches sail past like ships at sea' – one proud Piper owner has had this motto printed on the mount of his painting. Is it a quotation from an article in the *Architectural Review*? Piper cannot remember but he approves of the spirit of the text. It seems to describe quite well what he likes about this flat Lincolnshire landscape that we are now driving through – the huge green expanse, like Romney Marsh without the sheep, stretching towards the unseen mud flats and the sea, with the spires and towers of churches looming up on the horizon. At frequent intervals we stop for Piper to take a photograph or do a sketch. He is especially keen on the view of Bassingthorpe, a tiny hamlet on the

133 [previous page] Harlaxton Manor, Lincolnshire 1977

134 Royal Holloway College, Egham, Surrey 1978

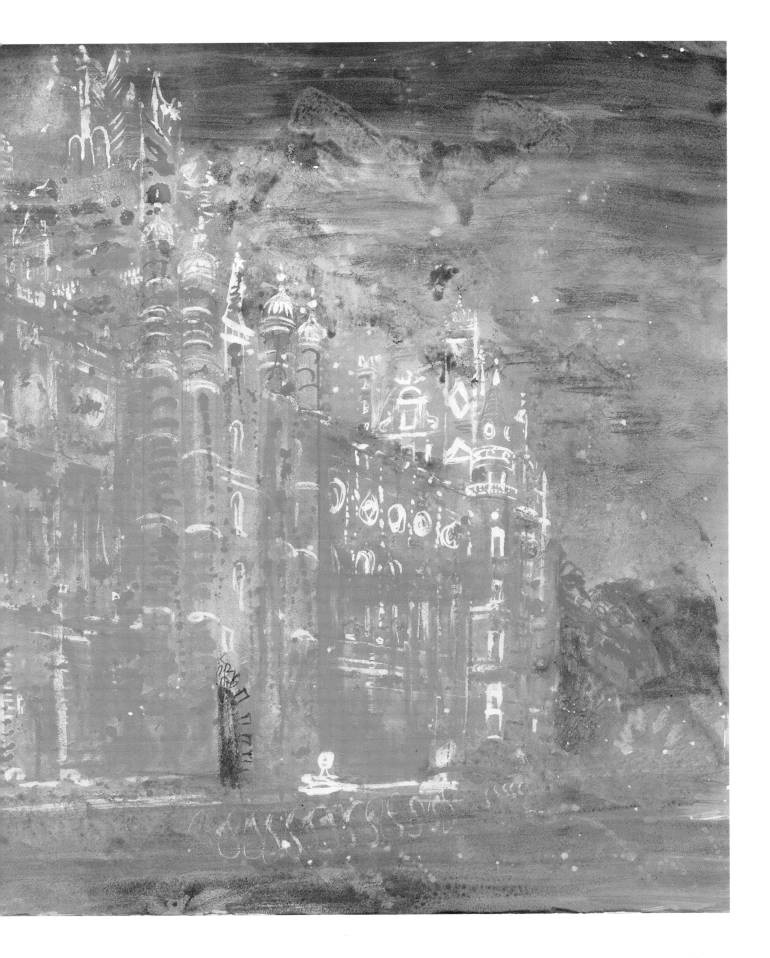

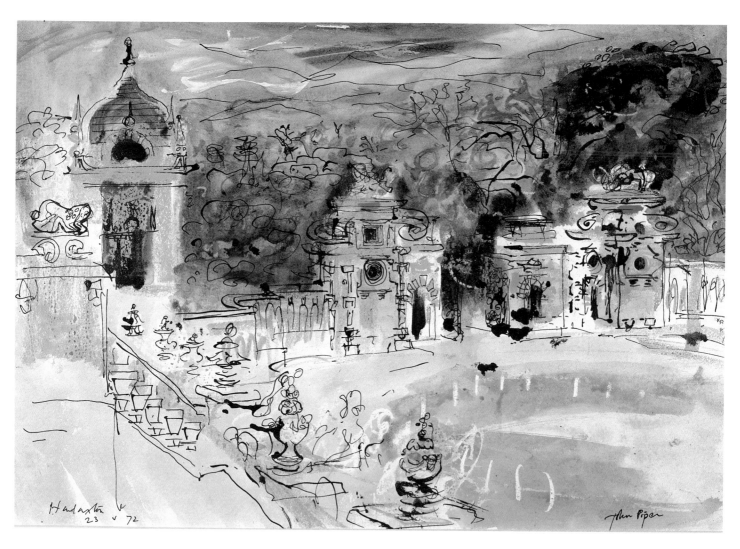

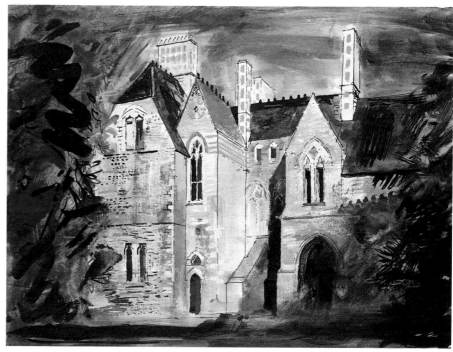

brow of a hill with the road running between the church and the surviving fragment of an Elizabethan manor house. 'This would be a good place to end up', Piper says.

BOSTON 9 MILES says the signpost and already at this great distance the 'stump' (Church tower) is visible – 'a distinguished bulk on the skyline'. Piper explains that Boston is short for Botolphstone – St Botolph being the patron saint of travellers. 'You will always find St Botolph where roads begin. Places like Aldgate in the City or Swyncombe in Oxfordshire on the Icknield way.' The Boston tower, tallest in England, also acted as a navigational aid for sailors. We stop in Boston to admire the church at close quarters. There is a fun-fair going on in the town square and, with the hot sun, the open-air market, the blaring music and the crowds of people, the atmosphere is continental. Myfanwy buys picnic things in a back street.

We now head for Wisbech, stopping first at Gedney Church and then Fleet. Both are represented in the Harlaxton exhibition and Gedney has been used in the past as an example of 'pleasing decay'. Terrington St Clement is the next call, painted by Piper in 1975. While Myfanwy fetches the key from the newsagent's shop – 'Local Man's Heart in Latest Transplant' says the poster outside – Piper mounts his tripod to photograph the west end of the church in the evening light. Then we are off to Walpole St Peter. 'John B. says it's the best church in England', Piper says, as we drive through the narrow Norfolk lanes. 'I'm not sure I agree with him, though it

135 [opposite above] Entrance to
Harlaxton Manor, Lincolnshire
1972

136 [opposite below] Milton Ernest,
Bedfordshire 1977.
Architect: William Butterfield

137 Green Man 1980

138 [right] Bassingthorpe, Lincolnshire 1980

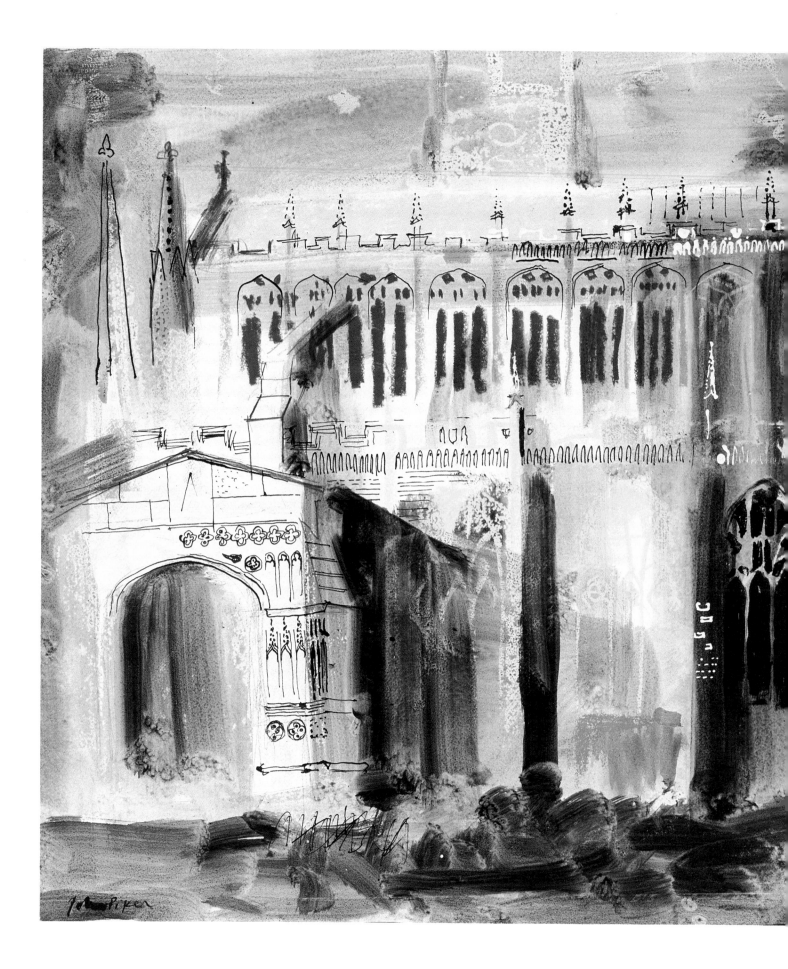

is pretty good I must say.' Approaching the south door we have to stoop to get through an archway at the east end. In the churchyard a huge copper beech is bursting into leaf. Although it is six, the church is still open. Inside, one can see at once what Betjeman means – the pews, brass candelabra, plain glass windows. 'It's really a combination of architecture and furnishing – all the original woodwork, no stained glass by the Victorians, decked windows and a spaciousness everywhere, everything unspoilt. No silly taste exercised on it. It's only a question of accepting it for what it is and heating and looking after it.'

Still Piper personally prefers the church of West Walton which we drive to next. It is a more isolated and romantic place, and there is plenty of 'pleasing decay' about the massive Early English tower – separated from the church like many towers in this part of England, the builders fearing land subsidence on the damp Fenland soil. Swallows swoop in and out of the archway where they are nesting. It is my turn to fetch the key from the vicarage. The village is quiet. A motorist parked outside the church is listening to Linguaphone cassettes. When I get back with the key Piper is sketching the south side of the church. 'It never fails to get me', he says, as we enter the plain white interior with its cluster of Purbeck marble pillars and fading painted texts on the wall of the nave. 'Very plain and marvellous: It's like a superior Romney Marsh church'. What he likes most is the contrasting textures of plaster, glass and brick.

139 Terrington St Clement, Norfolk 1974

140 [above] West Walton, Norfolk 1980

171

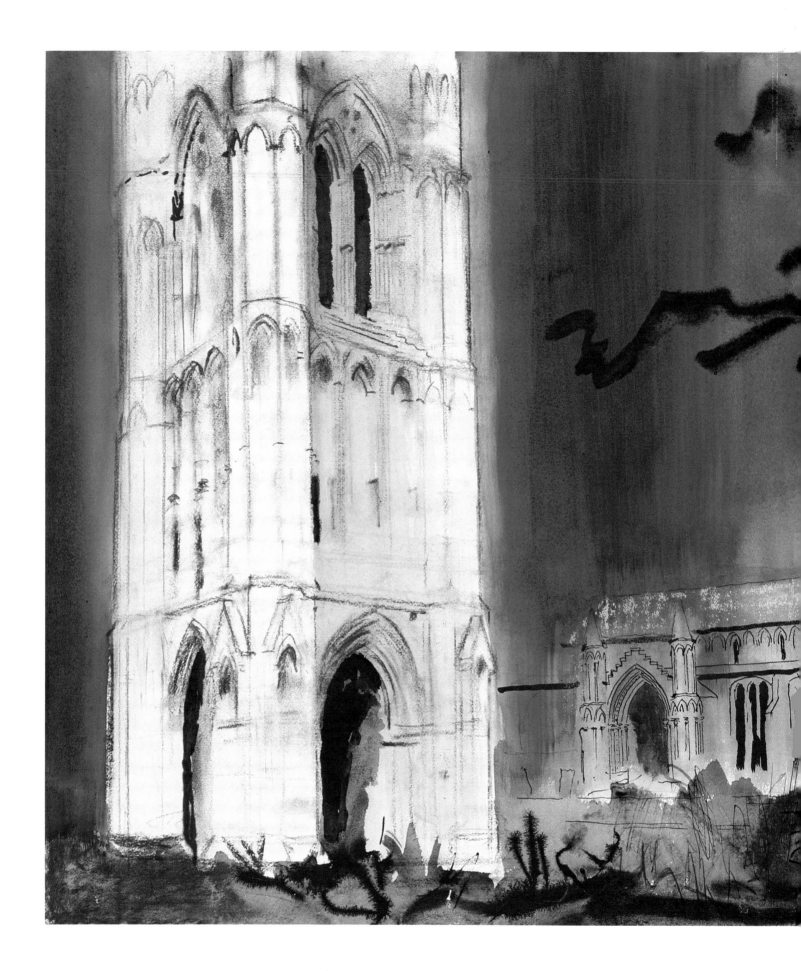

At West Walton, as elsewhere on our tour, we are following in the footsteps of another artist, John Sell Cotman (1782–1842). Cotman, Piper tells us, in his *British Romantic Artists*, was one of the greatest of water-colourists, 'much obsessed' – like himself – 'with old churches and ruins'. In 1811 Cotman set out from his native Norwich to illustrate 'all the ornamented antiquities of Norfolk', the result being a series of famous engravings, including one of West Walton tower.

'Most country churches', Piper writes, 'were then at an extreme of picturesque beauty. Ready to drop like over-ripe fruit, they were in an exquisite state of decay. In almost every village church a derelict wicket gate opened onto a porch strewn with straw, and a creaking door led into a nave full of worn grey box pews. Clear glass windows let in the sunlight that streamed over the faded umbers, ochres and greys of the walls, furniture and floor, and the whole scene was enriched by splashes of brilliant colour provided by tattered cushions and hangings.'

What Piper wrote of Cotman's work could be applied as well to his own – 'These drawings dwell on three facts: the beauty of texture of decaying stonework and woodwork; the clear light of East Anglia, and (in the exterior views) the wholeness, the oneness – like a good piece of sculpture – of each church in its relation to its landscape. The archaeologist and the topographical draughtsman had not been struck by this last point. Cotman was; and his drawings are still alive and real in consequence.'

Piper has done as much as anyone to rehabilitate Cotman as a great English artist. Neglected in his lifetime, he was attacked ferociously by the art critics of the Bloomsbury period, in particular Roger Fry. Fry, the principal spokesman for post-Impressionism, was so influential in his day that he could fill the Queen's Hall – as big as the Festival Hall – for his lectures on Art. Writing in 1934, Fry dismissed Cotman as 'very over-rated', an artist whose paintings were prized by 'a certain type of cultured people who fail to see its underlying sentimental vulgarity'. To Piper such an attack seemed almost like blasphemy against one of the greatest spirits of the Romantic movement. So far from being a senti-mentalist, Cotman was a melancholy visionary who found in old ruins and deserted places – 'chapels that had been turned into cow byres' – not only a feeling, like Wordsworth's – 'that there hath passed away a glory

141 West Walton, Norfolk 1980

from the earth' – but a more personal relevance. 'He saw', Piper wrote in 1942 'a desecrated chapel or a decrepit brick wall toppling above long grass as a symbol full of meaning. For he saw in such things the symbolic flames of his own life.'

We are booked into the White Lion at Wisbech. The town comes as a revelation to me with its long unspoiled rows of mostly eighteenth-century houses lining each bank of the River Teme. After dinner we walk in the twilight down the South Brink admiring the slightly superior houses on the north. 'I last came here thirty-five years ago', Piper says, 'with Jim Richards. I drew all those houses and Jim photographed them. They don't seem to have changed at all. I was a tremendous chauffeur in those days. Richards was a bit grumpy and there were long periods of silence. But he wasn't difficult to get on with.'

Sunday May 11. Another wonderful day. Church bells ringing. We drive back to West Walton so that Piper can photograph it in the morning light and then set off towards Ely, stopping to buy bedding plants at a roadside nursery. Myfanwy objects to the purchase of cineraria but Piper prevails and a box of them is added to the pile of luggage at the back of the Citroën. Ely Cathedral is visible on the horizon – 'Like a great ship tugging at its moorings' (John Betjeman). We arrive just before noon. The Communion service is still going on so we take a stroll round the building. 'Ely is more like a French cathedral than anywhere else, I think', says Piper. 'The surroundings are slightly scruffy. And it's so nice and remote and distant with no big town surrounding it.' He heads for the prior's door on the south side of the building, a wonderful piece of Romanesque art with a tympanum showing Christ in majesty flanked by two angels. This type of bold twelfth-century art has exercised a great influence on his own painting and especially his stained glass. 'Christ is always clean-shaven in Romanesque', Piper explains, 'and notice the frieze of feet at the bottom – turning away from Christ.'

Upstairs in the cathedral there is a museum of stained glass, the exhibits being gathered together by Piper's friend, Martin Harrison. Its main interest to the layman like me is to show that stained glass was not something that died out after the Reformation and was revived by the Victorians but is a continuing tradition which was kept up in the seventeenth and eighteenth centuries. There is a tendency now to decry Victorian stained glass and one bishop wanted to remove the windows in Ely cathedral. Piper was among those to protest. 'They could be awfully good, the Victorians.' He also greatly admires the exhibit in the museum by William de Morgan.

Piper himself is represented here with his cartoon for a memorial window in Nettlebed Church, Oxon., in memory of his friend and neighbour, the writer Peter Fleming. He had already done one window for the church which Fleming admired, and after his death his widow Celia Johnson had the idea of commissioning another window in memory of her husband. Piper's original idea was a Tree of Life, and then Celia Johnson said, 'Of course he was very fond of birds – even though he did shoot an awful lot of them.' So birds were added to the design, including an owl – a reference to Fleming's *Spectator* pseudonym of 'Strix'. The result is one of Piper's most successful designs.

While Piper is examining some of the examples of modern glass, an American lady tourist approaches him, asking, 'Do you like stained glass?' 'Yes, I do', says Piper. The American lady explains that she doesn't care for the modern non-representational work. She expects to see scenes from the Bible. Piper explains that the aim of the modern artists is not so much to show explicit Biblical scenes as to 'create a Biblical atmosphere'. The American lady looks thoughtful.

We leave the Cathedral by the west door, passing over an elaborate maze set in the floor – 'John B. would love that. He would spend the rest of the day tottering round it.'

After another picnic in the flat farmland we drive on towards Crowland, stopping at Bury church where Piper sketches a 'foliate head' carved on the lectern – a Green Man with leaves growing out of his mouth. This figure was a common medieval symbol, often carved on capitals, a pagan symbol of resurrection which later gave its name to countless pubs. Piper has done a number of paintings and prints using this motif. Crowland has a ruined abbey, also etched by Cotman, and a unique triangular bridge standing in the road guarded by a figure of Christ holding up the world. The next stop is Stamford. 'Stay awhile amid its ancient charm', says the roadside board erected by the local council. Stamford is another example of a town which has escaped the developers. The Pipers are especially fond of it and often stay at the George Hotel. Piper drives us to a spot on the outskirts where he promises a surprise – the Norman priory of St Leonard. This is a genuine example of 'pleasing decay', standing in a field and overgrown with ivy. The little church is used as a barn by a local farmer. Piper sets up his tripod amid the nettles and docks.

Then we're off again. One can't help noticing Piper's extraordinary energy. There is no let up. Indeed he recalls almost ruefully how in the old days Betjeman used to hold him up by insisting on finding somewhere

142 Cley-next-the-Sea, Norfolk 1973

to have tea during their explorations. We stop at Wansford – 'one of our old haunts' – to admire the beautiful sixteenth-century bridge over the Nene and then drive on in the evening sunlight to Fotheringhay Church – 'almost a cathedral overlooking the Nene water meadows' – and finally to Oundle where we are booked into the Talbot, a pleasant old inn with public school boys in suits being wined and dined by their parents.

After dinner we walk up to Oundle School chapel, where at the east end there are three Piper windows commissioned from the Worshipful Company of Grocers, Governors of Oundle School, in 1956. It was Piper's first stained glass commission and he took a great deal of time over it. Each of the windows represents three aspects of God: shepherd, king and judge; Christ, the way, the truth and the life; and wine, water and bread. The scheme was suggested to Piper by his old Epsom friend, Father Victor Kenna. The windows are a welcome burst of colour in an otherwise drab and rather nondescript building. Outside Piper is pleased to see that a statue by Lady Hilton Young of her son Peter – now Sir Peter Scott – has been removed from its place at the south door of the chapel. The statue, now surrounded by rose bushes at some distance from the building, shows the young Peter entirely nude with his right hand upraised as if asking to be excused. It bears the enigmatic inscription 'Here am I. Send me.' I can remember another cast of this statue at my own prep school, West Downs, Winchester, where Scott went before going to Oundle. Walking back to the hotel we note the slightly melancholy atmosphere that public schools have – perhaps because they provoke unhappy memories of one's own schooldays.

143 Long Sutton, Lincolnshire 1981

144 Prior's Door, Ely Cathedral, Cambridgeshire 1982

List of illustrations

All pictures are in private collections unless otherwise stated. Dimensions, where known, are given in inches and centimetres, height before width.

John Piper, photograph by Bill Brandt 1945

1 [Frontispiece] Scotney Castle, Kent *c.* 1972
Ink and watercolour, 23 x 15½ (58.4 x 39.4)

2 Looking towards Snape Maltings, Slaughden, Aldeburgh, Suffolk 1975
Ink and watercolour

3 Withy Bed, Earl Stonham, Suffolk 1974
Watercolour, 15¾ x 23 (38.8 x 58.5)

4 Fawley Bottom Farmhouse, Buckinghamshire 1980
Mixed media, 14½ x 21½ (36.8 x 54.6)

5 Farm at Fawley Bottom, Buckinghamshire 1982
Mixed media, 15½ x 22 (39.4 x 55.8)

6 Six Somerset Towers 1980
Mixed media

7 Two Suffolk Towers: Alpheton and Stansfield 1969
Oil, 48 x 48 (122 x 122)

8 Wymondham Church from the west, Norfolk 1965
Mixed media

9 Two Suffolk Towers: Brundish and Lavenham 1969
Ink and watercolour

10 Rose Cottage, Rye Harbour, Sussex 1931
Gouache and pencil, 14 x 18¼ (35.5 x 46.5)

11 Dungeness, Kent 1936
Collage and gouache, 19¾ x 15¼ (50.2 x 38.7)

12 Newhaven, Sussex *c.* 1936
Collage, 15¼ x 18½ (38.7 x 47)

13 Newhaven Harbour and Cliff, Sussex 1936
Collage and ink, 15 x 18½ (38.1 x 47)

14 Seaford, Sussex *c.* 1936
Ink, 15¾ x 21 (40 x 53.3)

15 Beach Huts, Kent 1933
Collage and watercolour, 15 x 17½ (38.1 x 44.4)

16 Portland, Dorset 1933
Ink and watercolour, 10¾ x 15 (27.3 x 38.1)

17 Portland, Dorset 1981
Watercolour and mixed media, 15½ x 22½ (39.4 x 57.3)

18 Portland, Dorset 1942
Ink and watercolour, 4½ x 6 (11.4 x 15.2)

19 Chesil Beach, Dorset 1934
Ink, 10¾ x 15 (27.3 x 38.1)

20 St George Reforne, Easton, Portland, Dorset 1954
Ink, 9¾ x 14¼ (24.8 x 36.2)

21 St George Reforne, Easton, Portland, Dorset 1954
Lithograph, 19½ x 25 (49.6 x 63.6)

22 Detail of gravestone, St George Reforne Churchyard, Easton, Portland, Dorset 1954
Gouache, 8 x 10½ (20.3 x 26.6)

23 Local craftsmanship in stone, St George Reforne Church, Easton, Portland, Dorset 1954
Illustration from John Piper 'Portland Stone – Portland Colours', *Ambassador*, No. 6, 1954

24 Corbels, East Riding, Yorkshire. Illustration from John Piper 'England's Early Sculptors', *Architectural Review*, May 1939

25 Detail of the font, Toller Fratrum, Dorset 1936
Screenprint from a photograph
Stones and Bones, Kelpra Editions, 1978

26 Romanesque tympanum with hanging lamp, Rowlstone, Herefordshire 1952 Print, 20 x 27 (50.8 x 68.5)

27 The font, Avington, Berkshire 1952
Mixed media, 27 x 21½ (68.6 x 54.6)
The Arts Council of Great Britain

28 Holdgate, Shropshire 1973
Mixed media

29 Between Reading and Newbury. Illustration from John Piper, 'London to Bath, a topographical and critical survey of the Bath Road', *Architectural Review*, May 1939

30 Piper's mother's house, St Martin's Avenue, Epsom, Surrey
Book jacket for J. M. Richards *The Castles on the Ground*, Architectural Press, 1946

31 Italianate houses at Reading, Berkshire 1939
Illustration from John Betjeman 'The Seeing Eye or How to Like Everything', *Architectural Review*, October 1939

32 Adderbury, Oxfordshire *c.* 1975
Ink and watercolour

33 Jackfield by Ironbridge, Shropshire 1979
Gouache, 22½ x 30¾ (57.1 x 78.1)

34 Jackfield, Shropshire. Illustration from John Piper and John Betjeman, *A Shell Guide to Shropshire*, Faber 1951

35 The Vestry, Brightwell Baldwin, Oxfordshire
Illustration for John Betjeman's poem 'Diary of a Church Mouse'. John Betjeman, *Church Poems*, John Murray, 1981

36 Lower Brockhampton I, Bromyard, Herefordshire 1981
Oil, 34 x 44 (86.4 x 111.8)

37 Stokesay Castle I, Shropshire 1981
Watercolour and mixed media, 22½ x 31 (57.2 x 78.7)

38 Upton Court, Little Hereford, Herefordshire 1981
Watercolour and mixed media, 15¾ x 22¾ (40 x 57.8)

39 Lower Court, Kinsham, Herefordshire 1981
Watercolour and mixed media, 15¼ x 22½ (38.7 x 57)

40 Brighton Street, Sussex
Aquatint, 7¼ x 11 (19.7 x 28) Prepared for but not included in John Piper, *Brighton Aquatints*, Duckworth, 1939.

41 Brighton from the station yard (Coloured by John Betjeman)
Aquatint, 8 x 10¾ (20.3 x 27.3)
Illustration from *Brighton Aquatints, op. cit.*

42 St George Kemptown, Brighton, Sussex
Aquatint, 8 x 10¾ (20.3 x 27.3)
Illustration from *Brighton Aquatints, op. cit.*

43 Stowe, Buckinghamshire *c.* 1975
Bridge and one of the Boycott Pavilions
Mixed media, 22½ x 31 (57.1 x 78.8)

44 Stowe, Buckinghamshire *c.* 1975
The House from the south; the lake; the Temple of Concord
Aquatint, 8½ x 6½ (21.6 x 16.5)

45 Stowe, Buckinghamshire
The Shell Grotto and the Congreve Monument
Mixed media, 22½ x 31 (57.1 x 78.8)

46 Stourhead, Wiltshire 1940
Bristol High Cross and Pantheon
Collage and watercolour, 16½ x 22 (41.9 x 55.9)

47 Stourhead, Wiltshire 1981
The Temple of Flora, Bridge and Temple of the Sun
Watercolour and mixed media, 23 x 31 (58.5 x 78.7)

48 The south gateway, Holkham Hall, Norfolk *c.* 1975
Mixed media, 22¾ x 30¾ (58 x 78.1)

49 Entrance to Fonthill, Wiltshire 1940
Oil, 20 x 30 (50.8 x 76.2)

50 Seaton Delaval, Northumberland
Ink and watercolour record sketch of the oil painting in the Tate Gallery, London, 7 x 8½ (17.8 x 21.6)

51 Castle Howard, Yorkshire
Ink and watercolour record sketch, 6¼ x 7¾ (15.9 x 19.7)

52 Mereworth Castle, Kent 1953
Ink and chalk, 11½ x 8½ (29.2 x 21.6)

53 Windsor Castle, Berkshire 1942
Ink and watercolour, 16 x 21 (40.6 x 53.3)

54 Windsor Castle, Berkshire 1942
Ink and watercolour, $15\frac{1}{2}$ x 21 (39.4 x 53.3)

55 Windsor Castle, Berkshire 1942
Ink and watercolour, $20\frac{3}{4}$ x 29 (52.8 x 73.8)

56 Hovingham Hall, Yorkshire 1944
Watercolour, 21 x 28 (53.3 x 71.7)

57 Hovingham village, Yorkshire 1944
Watercolour, 16 x 19 (40.6 x 48.2)

58 Blythburgh, Suffolk *c.* 1957
Illustration from *Collins Guide to English Parish Churches*,
John Betjeman, ed. 1958

59 Mildenhall, Wiltshire *c.* 1950
Illustration from *Collins Guide to English Parish Churches, op. cit*

60 Lidlington, Bedfordshire 1939
Illustration from John Piper 'Grey Tower and Panelled Pew',
The Listener, 1 February 1940

61 North Moreton, Berkshire 1939
Illustration from John Piper, 'Grey Tower and Panelled Pew',
op. cit.

62 Hartwell Church, Buckinghamshire 1939
Oil, 22 x 16 (55.8 x 40.7) *Usher Gallery, Lincoln*

63 Ruined cottages, Stadhampton, Oxfordshire *c.* 1942
Mixed media, $9\frac{1}{4}$ x 6 (23.5 x 15.2)

64 Ruin at Stockbridge Mill, Hampshire 1942
Mixed media, 3 x $4\frac{1}{4}$ (7.6 x 10.8)

65 Ruins of Knowlton, Dorset, within an early encampment
Mixed media, $4\frac{3}{4}$ x $6\frac{1}{2}$ (12.1 x 16.5)

66 Horton Tower, Dorset 1942
Mixed media, 9 x $10\frac{1}{2}$ (22.8 x 26.7)

67 Wiggenhall St Peter, Norfolk 1974
Mixed media, 11 x 8 (27.9 x 20.3)

68 Byland Abbey, Yorkshire 1940
Aquatint, hand coloured, 7 x $10\frac{3}{4}$ (17.8 x 27.3)

69 Binham Abbey, Norfolk 1981
Oil, 34 x 44 (86.4 x 111.8)

70 Llanthony Priory, Monmouthshire 1941
Oil, 12 x 16 (30.5 x 40.6)

71 Coventry Cathedral, Warwickshire,
November 15 1940
Oil, 30 x 25 (76.2 x 63.5) *City of Manchester Galleries*

72 Church of the Holy Innocents, Knowle, Bristol, Avon 1940
Illustration from John Piper, 'The Architecture of
Destruction', *Architectural Review*, July 1941

73 St Bride's Church, Fleet Street, London 1940
Illustration from John Piper, 'The Architecture of
Destruction', *Architectural Review*, July 1941

74 Gordale Scar, Malham, Yorkshire 1941
Ink and wash, $9\frac{1}{2}$ x 6 (24.1 x 15.2)

75 Mill Gill, Askrigg, Yorkshire 1941
Ink and wash, 9 x $5\frac{1}{4}$ (22.8 x 13.3)

76 Sgwyd Gwladys, Pyrddin, Vale of Neath 1942
Ink and wash, 6 x $9\frac{1}{4}$ (15.2 x 23.5)

77 Crooked Anvil, Pyrddin, Vale of Neath 1942
Ink and wash, $9\frac{3}{4}$ x 6 (24.8 x 15.2)

78 Trecarrel Chapel, Lezant, Cornwall 1943
Aquatint, 7 x 10 (17.8 x 24.8)

79 Botallack Chapel, Near Fowey, Cornwall 1943
Aquatint, $7\frac{1}{4}$ x $10\frac{3}{4}$ (19.6 x 27.3)

80 Yatton Chapel, Herefordshire 1944
Aquatint, $5\frac{1}{2}$ x $7\frac{1}{4}$ (14 x 18.4)

81 Trecarrel Hall, Lezant, Cornwall 1943
Watercolour and chalk

82 Bolsover Castle, Derbyshire 1944
Oil

83 Derbyshire Domains 1945
Oil

84 Renishaw Hall, Derbyshire
Oil

85 Hardwick Hall, Derbyshire
Gouache and ink

86 Rocks in Nant Ffrancon, North Wales 1950
Screen print, $12\frac{1}{2}$ x $11\frac{1}{4}$ (31.7 x 28.5)

87 Nant Ffrancon, North Wales 1950
Oil, $24\frac{3}{4}$ x $29\frac{1}{2}$ (62.8 x 75)

88 Anglesey Walls: Llanddona, Penmon, North Wales
Mixed media, 14 x $10\frac{1}{2}$ (35.8 x 26.7)

89 Cwm Idwal, North Wales 1950
Watercolour, $8\frac{1}{4}$ x 11 (20.9 x 28)

90 Rocks on Glyder Fawr, North Wales 1945–6
Mixed media, 11 x 9 (28 x 22.8)

91 Tryfan, North Wales 1945–6
Ink and wash, 11 x 9 (27.9 x 22.8)

92 Bethesda, North Wales 1944
Ink and watercolour, $8\frac{1}{4}$ x 11 (21 x 27.9)

93 Royal Military Canal, Kent 1981
Watercolour and mixed media, $15\frac{1}{4}$ x $22\frac{1}{2}$ (38.8 x 57.2)

94 Newchurch, Romney Marsh, Kent 1946
Watercolour and ink

95 Snargate, Romney Marsh, Kent 1946
Ink, 7 x $9\frac{1}{2}$ (17.8 x 24.1)

96 Ivychurch, Romney Marsh, Kent 1982
Mixed media, 18 x 25 (45.7 x 63.5)

97 Interior of Ivychurch, Romney Marsh, Kent 1982
Ink and watercolour, $19\frac{3}{4}$ x $26\frac{1}{2}$ (50.1 x 67.3)

98 Dungeness, Kent 1947
Oil, 6 x 8 (15.2 x 20.3)

99 Littlestone-on-Sea, Romney Marsh, Kent 1936
Collage and ink, $14\frac{1}{8}$ x $18\frac{3}{4}$ (35.8 x 47.6)
The Tate Gallery, London

100 The Coventry Monuments, Croome D'Abitot,
Worcestershire 1953
Mixed media, $9\frac{1}{4}$ x 14 (23.5 x 35.5)

101 Monument by Grinling Gibbons, Exton Church, Rutland *c.* 1970
Ink and wash, $12\frac{1}{2}$ x $11\frac{1}{4}$ (31.8 x 36.2)

102 Stonehenge, Wiltshire 1981
Ink and wash, from a photograph by Edward Piper, $15\frac{1}{2}$ x $22\frac{1}{2}$
(39.4 x 57.1)

103 Barrow on Salisbury Plain, Wiltshire *c.* 1944
Collage and watercolour, $15\frac{1}{4}$ x $17\frac{3}{4}$ (38.7 x 45)

104 Lacock Abbey, Wiltshire 1940
Oil, 20 x 40 (50.8 x 101.6)

105 Devizes, Wiltshire
Gouache and collage, $11\frac{1}{2}$ x 30 (29.2 x 76.2)

106 Wiltshire: Cartoon for a stained glass window at Devizes
Museum 1981 Mixed media, 38 x 48

107 Llyn Teifi, Cardiganshire 1982
Watercolour, each $15\frac{1}{4}$ x $22\frac{1}{2}$ (38.7 x 57.1)

108 Hafod, Cardiganshire 1939

109 Hafod: Nash Folly and Ystwyth Gorge 1939
Oil, $10\frac{1}{2}$ x $14\frac{1}{2}$ (26 x 36.8)

110 Grongar Hill, Carmarthenshire 1944
Illustration from *English, Scottish and Welsh Landscape Verse*,
John Betjeman & Geoffrey Taylor, eds. 1944

111 Grongar Hill, Carmarthenshire
Lithograph

112 Grongar Hill, Carmarthenshire 1983
Lithographs, each 3 x 6 (7.6 x 15.2)
Illustration from John Dyer, *Grongar Hill*, Stourton Press, 1982

113 Llanfyrnach, Breconshire 1980
Watercolour and mixed media, 16 x 22½ (40 x 57.2)
114 Beetling Rock, Garn Fawr, Pembrokeshire 1981
Watercolour and mixed media, 15 x 22 (38 x 56)
115 Garn Fawr, The Road to the South, Pembrokeshire 1980
Watercolour and mixed media
116 Garn Fawr, Pembrokeshire 1970
Ink and watercolour, 14½ x 22½ (36.8 x 57.2)
117 Tretio, St David's, Pembrokeshire 1970
Ink and watercolour
118 Tretio, Pembrokeshire 1970
Gouache, 15 x 22 (38.1 x 55.9)
119 Llandegigi Fawr, Pembrokeshire 1970
Watercolour and mixed media
120 Caerhedwyn Uchaf III, Pembrokeshire 1981
Watercolour and mixed media, 15½ x 22½ (39.3 x 57.1)
121 Chapel, Newtown, Mongomeryshire 1975
Watercolour, 15 x 22¾ (38.1 x 57.8)
122 Tabor, Cross Hands, Carmarthenshire 1965
Watercolour and chalk, 15 x 22 (38.1 x 55.9)
123 Bethesda, Merthyr Tydfil, Glamorgan c. 1970
Collage and watercolour, 15¼ x 23¼ (38.7 x 59)
124 Carreg Sampson, Pembrokeshire 1975
Watercolour and chalk, 15¼ x 22½ (38.7 x 57.1)
125 Pentre Ifan, Prescelly Hills, Pembrokeshire c. 1975
Watercolour and chalk, 22¾ x 15¼ (57.8 x 38.7)
126 Dolmen near Login, Carmarthenshire 1977
Screenprint from photograph with watercolour
Stones and Bones, Kelpra Editions, 1978
127 Pen-lan, Moylgrove, Pembrokeshire 1977
Watercolour, chalk and ink, 20 x 25 (50.8 x 63.5)
128 St David's, Pembrokeshire 1980
Gouache, 35½ x 48 (90.2 x 121.9)
129 Caernarvon Castle, North Wales 1969
Print made for the investiture of HRH The Prince of Wales
130 Raglan Castle, Monmouthshire 1980
Gouache, 22¾ x 31 (57.8 x 79)
131 Carew Castle, Pembrokeshire
Watercolour
132 Newcastle Emlyn, Carmarthenshire 1981
Oil
133 Harlaxton Manor, Lincolnshire 1977
Oil, 42 x 72 (106.8 x 182.9)
134 Royal Holloway College, Egham, Surrey 1978
Mixed media, 27¾ x 37 (70.5 x 94)
135 Entrance to Harlaxton Manor, Lincolnshire 1972
Ink and watercolour, 15½ x 22½ (39.3 x 57.1)
136 Milton Ernest, Bedfordshire 1977
Watercolour, 22¼ x 30 (56.5 x 76.2)
137 Green Man 1980
Pencil, sketchbook
138 Bassingthorpe, Lincolnshire 1980
Ink, sketchbook
139 Terrington St Clement, Norfolk 1974
Watercolour
140 West Walton, Norfolk 1980
Ink, sketchbook
141 West Walton, Norfolk 1980
Watercolour and mixed media, 22½ x 31 (57 x 78.7)
141 Cley-next-the-Sea, Norfolk 1973
Watercolour
143 Long Sutton, Lincolnshire 1981
Oil, 28 x 36 (71.1 x 91.5)
144 Prior's Door, Ely Cathedral, Cambridgeshire 1982
Mixed media
Endpapers: front and back, Brighton, Sussex 1939
Ink, each 15¾ x 20¾ (40 x 52.8)

Short bibliography

The following books and articles by John Piper are referred to, or quoted from, in the text.

BOOKS

Shell Guide to Oxfordshire. Batsford, 1938. Rev. edn, Faber, 1953
Brighton Aquatints. Duckworth, 1939
British Romantic Artists. Collins, 1942
Buildings and Prospects. A collection of magazine articles mainly from the *Architectural Review (see below)*, 1948
Romney Marsh. King Penguin, 1950
With John Betjeman
Murray's Architectural Guide to Buckinghamshire. John Murray, 1948
Murray's Architectural Guide to Berkshire. John Murray, 1949
Shell Guide to Shropshire. Faber, 1951
With J. H. Cheetham
Shell Guide to Wiltshire, rev. edn, Faber, 1968

ARTICLES

The Ambassador, 'Portland Stone', No. 6, 1954
The Architectural Review
'England's Early Sculptors', October 1936
'The Nautical Style', January 1938
'London to Bath, A Topographical and Critical Survey of the Bath Road' (with J. M. Richards), May 1939
'Decrepit Glory', June 1940
'The Architecture of Destruction', July 1941
'Towers in the Fens', November 1940
'Pleasing Decay', September 1947
'Re-assessment Stonehenge', September 1949
The Cornhill Magazine, Letter from Devizes, November 1944
Country Goers Heritage, 'John Piper's Notebook', 1945
The Geographical Magazine
'Gordale Scar and the Caves', December 1942
International Textiles
'The Colour of English Country Houses', No. 8, 1944
The Listener
'English Sea Pictures', 28 July 1938
'Grey Tower and Panelled Pew', 1 February 1940
'Bath, Edinburgh and Art Historians', 1 July 1948
The Spectator, 'Country Church Visiting', 8 December 1939

Introduction to '*The Mountains*' by R. S. Thomas.
Chilmark Press, 1969

ACKNOWLEDGEMENTS
The publishers thank the following for permission to reproduce pictures in this book: The Arts Council of Great Britain, Lady Betjeman, Rt. Rev. the Bishop of Ely, Bill Brandt, City of Manchester Art Galleries, Alec Clifton Taylor, Jamie Compton, Lord Gnome, Alfred Hecht, The Institute of Chartered Accountants in England and Wales, Peter Mayer, Canon G. Morgan, Sebastian Piper, HM Queen Elizabeth the Queen Mother, Hon. Miranda Rhys, Hon. Reresby Sitwell, The Tate Gallery London, Usher Gallery Lincoln, Sir Marcus Worsley, Bt.
 They also thank Ben Johnson and Marlborough Fine Art (London) Ltd for providing photographs.
 The authors and the publishers thank the following for permission to publish or reprint copyright material: Sir John Betjeman and John Murray Ltd (for six lines from 'Christmas' published in *Collected Poems* by John Betjeman), Geoffrey Grigson, Lord Horder, Frank Magro (for passages from articles by Sir Osbert Sitwell in the *Listener* and in a catalogue of John Piper's Derbyshire paintings, *The Sitwell Gallery*), John Piper.

Index

Compiled by Douglas Matthews

Figures in bold indicate illustration numbers

Abbotsbury, Dorset, 29
Adam, Robert, 122
Adderbury, Oxfordshire, **32**
Aldeburgh, Suffolk, **2**
Aldington, Richard, 14
Allingham, Helen, 53
Alpheton, Suffolk, **7**
Anglesey, 88
Ansorge, Rev. Gerald Percival, 88
Appledore, 118
Architectural Review ('Archie'), 36–7, 41, 43, 50, 87, 118, 123, 166
Ardizzone, Edward, 83
Arkwrightstown, Derbyshire, 102
Askrigg, Yorkshire, **75**
Aubrey, John, 123
Avebury, **106**, 123
Avington, Berkshire, **27**
Aythorp Roding, Essex, 15

Backwell, Somerset, **6**
Bacon, J., 73
Baldwin, Thomas, 135
Bangor, N. Wales, 135
Banks, Sir Joseph, 135
Barlborough, Derbyshire, **83**, 101
Bassingthorpe, Lincolnshire, **138**, 166
Batcombe, Somerset, **6**
Bath, 127
Bawden, Edward, 37
Beaton, Sir Cecil, 16
Beck, Maurice, 44
Beddington, J. L., 43–4
Bentley, Nicolas, 43
Betchworth, Surrey, 21, 25
Bethesda, N. Wales, **92**
Betjeman, Sir John: as collaborator, 14, 43–7, 49–50, 88, 122, 136, 174; at *Architectural Review*, 36, 43; background, 43; on Pevsner, 44; and *Shell Guides*, 43–4, 46–7, 122–3; paints Piper prints, 54; and English heritage, 88; and Murray's guides, 122; on Walpole St Peter, 169, 171; on Ely, 174; *English, Scottish and Welsh Landscape Verse* (ed.), 135; *First and Last Loves*, 50; *John Piper*, 13; *Poems in the Porch*, 50
Bignor, Sussex, 53
Binham Abbey, Norfolk, **69**
Blake, William, 22, 37
Blakeney, Norfolk, 14
Blenheim Palace, Oxfordshire, 46
Blomfield, Sir Arthur, 38
Blunden, Edmund, 15
Blythburgh, Suffolk, **58**
Bodinnick, Cornwall, 95
Bolsover, Derbyshire, **82, 83**, 101–2
Bone, Stephen, 44
Boston, Lincolnshire, 166, 169
Botallack Chapel, Fowey, **79**
Botolph, St, 169
Bowra, Sir Maurice, 43
Boxted, Suffolk, 122
Brighton, Sussex, **endpaper, 40, 41, 42**, 12, 54
Brightwell Baldwin, Oxfordshire, **35**
Britten, Benjamin, 12
Bromyard, Herefordshire, **36**
Brookland, Kent, 114
Brown, Lancelot ('Capability'), 54, 58, 122
Brundish, Suffolk, **9**

Burford, Oxfordshire, 46
Bury, Huntingdonshire, 174
Butterfield, William, 169
Byland Abbey, Yorkshire, **68**, 77
Byron, Robert, 44, 123

Caerhedryn Uchaf, Pembrokeshire, **120**
Caernarvon Castle, N. Wales, **129**
Calder, Alexander, 21
Capesthorne, Cheshire, 166
Cardigan Bay, 136
Carew Castle, Pembrokeshire, **131**, 144, 158
Carew Cheriton, Pembrokeshire, 144
Carreg Sampson, Pembrokeshire, **124**
Castle Howard, Yorkshire, **51**
Cheetham, J. H., 123
Chelmarsh, Shropshire, 47
Cherhill, Wiltshire, **106**
Chesil Beach, Dorset, **19**, 29
Chisbury, Wiltshire, 95
Chiselhampton, Oxfordshire, 43
Clark, Kenneth (*later* Lord), 72
Cleddau, River, 144
Cley-next-the-Sea, Norfolk, **142**
Clonmore, Lord William C. J. Howard, 44
Coalport, Shropshire, 47
Cobbett, William, 46
Collins Guide to English Parish Churches (Betjeman), 50, 122
Constable, John, 22, 37, 123
Cotman, John Sell, 22, 46, 74, 77, 127, 173–4
Coventry, Warwickshire, **71**, 87
Coventry, Margaret, 122
Coxon, Raymond, 15
Cranford, Middlesex, 41
Croome D'Abitot, Worcestershire, **100**, 122
Cross Hands, Carmarthenshire, **122**
Crowland, Lincolnshire, 174
Cwm Idwal, N. Wales, **89**

Davie, W. Galsworthy, 53
Dawber, E. Guy, 53
Deane, Hampshire, 74
de Morgan, William, 174
Dentdale, Yorkshire, 93
Derbyshire Domains (painting), **83**, 101
Devizes, Wiltshire, **105, 106**, 127, 132
Douglas, Lord Alfred, 54
Dryslwyn Castle, Carmarthenshire, **137**, 136
Dungeness, Kent, **11, 98**, 21, 22, 114, 118
Dyer, John, 135, 136n
Dymchurch, Kent, 118

Earl Stonham, Suffolk, **3**
Easegill Kirk, Yorkshire, 93
Easton, Portland, Dorset, **20, 21, 22, 23**, 29
Egham, Surrey, **134**
Elizabeth the Queen Mother, 72
Ellesmere, Shropshire, 47
Elwin, Malcolm, 89
Ely, Cambridgeshire, **144**, 174
Epsom, Surrey, **30**, 14, 42
Esdaile, Katherine: *English Monumental Sculpture since the Renaissance*, 122
Eton College, Buckinghamshire, **53**
Ettington Park, Warwickshire, 166
Ewelme, Oxfordshire, 46
Exton, Rutland, **101**, 122

Fairfield, Kent, 118
Fawley Bottom, Buckinghamshire, **4, 5**, 11–12, 49, 88
Fens, The, 166, 169–77
Festival of Britain Pleasure Gardens, Battersea (London), 88
Fishguard, Pembrokeshire, 136
Fleet, Lincolnshire, 169

Fleming, Peter, 174
Flintham, Wiltshire, 166
Foel Goch, N. Wales, 105, 108
Fonthill, Wiltshire, **49**
Fotheringhay, Northamptonshire, 15, 177
Fowey, Cornwall, 79
Fox-Talbot, W. H., 127
Fry, Roger, 173

Garn Fawr, Pembrokeshire, **114, 115, 116**, 136
Gedney, Lincolnshire, 169
George VI, King, 72
Gibbons, Grinling, **101**, 122
Gibbs, James, 63
Gilpin, Rev. William, 54, 123
Girouard, Mark, 63
Glyder Fawr, Caernarvonshire, **90**, 105
Glyders, The, Caernarvonshire, 105, 108
Gordale Scar, Yorkshire, **74**, 89, 93
Gower Peninsula, S. Wales, 135
Great Coxwell, Berkshire, 72
Great Dixter, Northiam, Sussex, 14, 53
Greatstone, Kent, 118
Green, W. Curtis, 53
Griggs, F. L., 14
Grigson, Geoffrey, 14, 36, 88–9, 95, 135
Grongar Hill, Carmarthenshire, **110, 111, 112**, 135
Gunwalloe, Cornwall, 93

Haddiscoe, Norfolk, 15
Hafod, Cardiganshire, **108, 109**, 135
Hamsey (near Lewes), Sussex, 72
Hardwick, Derbyshire, **83, 85**, 101
Harlaxton, Lincolnshire, **133, 135**, 166, 169
Harrison, Martin, 174
Hartley, Alan, 14
Hartwell, Buckinghamshire, **62**, 73
Hastings, Hubert de Cronin, 36, 43, 74
Hengoed, Shropshire, 47
Henley, Oxfordshire, 42
Hesketh, Peter Fleetwood, 122
Highways and Byways series, 14, 29, 43
Hoare, Henry, 54
Hoddinott, Alun, 12
Holding, Eileen (Piper's 1st wife), 15
Holgate, Shropshire, **28**
Holkham Hall, Norfolk, **48**
Hopkins, Gerard Manley, 88
Horder, Mervyn, 2nd Baron, 12, 15n, 49, 54, 63
Horton Tower, Dorset, **66**
Hovingham, Yorkshire, **56, 57**
Hughes, Pennethorne, 123
Huish Episcopi, Somerset, **6**
Hulcote, Bedfordshire, 73
Hussey, Christopher, 2
Hussey, Edward, 2
Hythe, Kent, 114, 118

Inglesham, Wiltshire, 127
Ingworth, Norfolk, 14
Ironbridge, Shropshire, **33, 34**
Ivychurch, Kent, **96, 97**, 114

James, Henry, 46
Jerome, Jerome K., 46
Johnes, Col. Thomas, 135
Johnson, Celia, 174

Keiller, Alexander, 123
Kelham, Nottinghamshire, 166
Kenna, Father Victor, 14, 177
Kent, William, 54, 63
Kestleman, Morris, 15
Kingsbury Episcopi, Somerset, **6**
Kingsclere, Hampshire, 74
Kinsham, Herefordshire, **39**

Knowle, Bristol, Avon, **72**
Knowlton, Dorset, 65

Lacock, Abbey, Wiltshire, **104**, 127
Lamberhurst, Kent, **2**
Lancaster, Karen (Osbert's first wife), 88
Lancaster, Sir Osbert, 11, 49, 88
Langtoft, Peter of: *Chronicle*, 36
Lavenham, Suffolk, **9**
Leicester Galleries, London, 54, 98
Lezant, Cornwall, **78**, **81**
Lidlington, Bedfordshire, **60**, 73–4
Lincolnshire Old Churches Trust, 166
Little Hereford, Herefordshire, **38**
Littlestone-on-Sea, Kent, **99**, 114
Llanddona, Penmon, Anglesey, 88
Llandegigi Fawr, Pembrokeshire, **113**, **119**
Llangloffan, Pembrokeshire, 136
Llanthony Priory, Monmouthshire, **70**
Llawhaden, Pembrokeshire, 144
Llyn Llydaw, Caernarvonshire, 108
Llyn Ogwen, N. Wales, 105
Llyn Teifi, Cardiganshire, **107**
Login, Carmarthenshire, **126**
London: St Bride's Church, **73**
Long Mynd, Shropshire, 47
Long Sutton, Lincolnshire, **143**
Long Sutton, Somerset, **6**
Long, William, 123
Ludford, Shropshire, 47
Lydiard Tregoze, Wiltshire, 122

Malham, Yorkshire, **74**, 93
Marlborough Down, Wiltshire, 123
Mereworth Castle, Kent, **52**
Merthyr Tydfil, Glamorgan, **123**
Mildenhall, Wiltshire, **59**, 72
Milford Haven Estuary, 158
Millbrook, Bedfordshire, 50
Mill Gill, Askrigg, Yorkshire, **75**
Milton Ernest, Bedfordshire, **136**, 166
Milward, Frank, 14, 114, 135
Monnington, Thomas, 15
Moore, Henry, 37, 88
Morris, William, 46, 72, 127
Moylgrove, Pembrokeshire, **127**
Much Wenlock, Shropshire, 47
Murray, John, 122

Nant Ffrancon, N. Wales, **86**, **87**, 105, 135
Nash, John, 135
Nash, Paul, 22, 44, 118
Nation (journal), 15–16
Neath Valley, 93
Nene, River, 177
Nettlebed, Oxfordshire, 174
Newbury, Berkshire, **29**
Newcastle Emlyn, Carmarthenshire, **132**
Newchurch, Kent, **94**
Newhaven, Sussex, **12**, **13**, **14**, 21, 25
Newport, Pembrokeshire, 136
Newtown, Montgomeryshire, **121**
Nicholson, Ben, 21
North Moreton, Berkshire, **61**

Ockham, Surrey, 122
Old Cottages and Farmhouses, 53
Oundle, Northamptonshire, 177
Oxfordshire (in *Shell Guides*), 46–7, 122

Palmer, Samuel, 22, 46, 88
Parracombe, Devon, 88
Pembroke Castle, 144
Pendeen, Cornwall, 93
Pen-lan, Moylgrove, Pembrokeshire, **127**
Pennant, Thomas: *Tour to North Wales*, 105

Pentre Ifan, Pembrokeshire, **125**, 136
Petton, Shropshire, 47
Pevsner, Sir Nikolaus, 43–4, 114
Pilgrim Trust, 72
Piper, Charles Alfred (father), 14
Piper, Edward (son), 14
Piper, Gordon (brother), 14
Piper, John: life and career, 11–15; abstracts, 21–2; and seaside, 26, 29; and *Architectural Review*, 36–7, 41; relations with Betjeman, 43–7, 49–50, 122, 136, 174; and *Shell Guides*, 44, 46–7, 122–3; confirmed in Church of England, 49; as war artist, 72; gifts for charity, 166; stained glass, 174, 177; *Brighton Aquatints*, 54, 63; *British Romantic Artists*, 12, 173; *Romney Marsh*, 118
Piper, Myfanwy (wife), 11–12, 14–15, 29, 37, 46, 49, 93, 135, 169, 174
Plomer, William, 118
Pontrhydfendigaid, Cardiganshire, 135
Pontyglazier, Pembrokeshire, 136
Pope, Alexander, 58
Portland, Dorset, **16**, **17**, **18**, 12, 25, 29
Prescely mountains, S. Wales, 136
Pugh, Edward: *Cambria Depicta*, 105
Pyrddin, Vale of Neath, **76**, **77**

Quennell, Peter, 43–4

Raglan Castle, Monmouthshire, **130**, 158
Ramsay, Sir Andrew Crombie: *Old Glaciers of Switzerland and Wales*, 105
Ravilious, Eric, 36
Read, John, 25, 122
Read, Russell, 166
Reading, Berkshire, **29**, **31**, 41, 50
'Recording Britain', 72
Redgrave, Suffolk, 122
Rees, Vyvyan, 144
Renishaw, Derbyshire, 83, 84, 98, 101–2
Richards, J. M., 36–7, 41, 43, 49, 88, 123, 174; *The Castle and the Ground*, 42
Rogers, Samuel, 135
Romney Marsh, 12, 14, 114, 118, 166
Rothenstein, Sir William, 15
Rowlstone, Herefordshire, **26**, 37
Roxburgh, J. F., 54
Royal College of Art, 15, 21, 54
Royal Holloway College, Egham, **134**
Royal Military Canal, Kent, **93**, 114
Ruishton, Somerset, **6**
Ruskin, John, 46, 74
Rye, Sussex, **10**, 12, 25, 114

St David's, Pembrokeshire, **128**, 136, 144
Salisbury Plain, Wiltshire, **103**
Salvin, Anthony, 2, 135
Scotney, Kent, *frontis.*
Scott, Sir Peter, 177
Scott-James, Anne (Lady Lancaster), 11
Seaton Delaval, Northumberland, **50**
Selsey, Sussex, 25
Shadwell Park, Norfolk, 166
Shell Guides, 14, 43–4, 46–7, 58, 122–3, 144, 166; Piper edits, 123
Shilton, Oxfordshire, 46
Shrewsbury, Shropshire, 47
Shropshire (in *Shell Guides*), 47, 49–50, 122
Silbury Hill, Wiltshire, 123
Simpson, Buckinghamshire, 73
Sitwell, Dame Edith, 98
Sitwell, Sir Osbert, 54, 98, 101
Smith, Juliet, 123
Smythson, John, 101
Snape Maltings, Suffolk, **2**
Snargate, Kent, **95**, 14
Snowdonia, 12, 105, 108, 135

South Wales, 135–6
Spelsbury, Oxfordshire, 122
Stadhampton, Oxfordshire, 46, **63**
Stamford, Lincolnshire, 174
Stansfield, Suffolk, **7**
Stockbridge Mill, Hampshire, **64**
Stokesay Castle, Shropshire, **37**, 53
Stone, Reynolds, 105
Stonehenge, Wiltshire, **102**, 36, 123
Stourhead, Wiltshire, **46**, **47**, 54, 58
Stowe, Buckinghamshire, **43**, **44**, **45**, 54, 58, 63
Strata Florida Abbey, Cardiganshire, 135
Strumble Head, Pembrokeshire, 136
Suffolk, Alice, Duchess of, 46
Summerson, Sir John, 49
Sutton Scarsdale, Derbyshire, **83**, 101–2

Talbot family, 127
Talland, Cornwall, 93
Teifi lakes, Cardiganshire, 135
Teme, River, 174
Terrington St Clement, Norfolk, **139**, 169
Thomas, R. S.: *The Mountains*, 105
Thorold, Rev. H. C., 166
Toddington, Bedfordshire, 73
Toller Fratrum, Dorset, **25**, 37
Tong, Shropshire, 47
Towey valley, S. Wales, 136
Trecarrel, Cornwall, **81**, 95
Tretio, Pembrokeshire, **117**, **118**
Treves, Sir Frederick, 29
Tryfan, N. Wales, **91**, 105
Turner, J. M. W., 21–2, 37, 46, 77, 123

Upton Court, Little Hereford, **38**

Valle Crucis Abbey, near Llangollen, 77
Vanbrugh, Sir John, 54, 63
Varey, David, 123

Waddesdon Manor, Buckinghamshire, 166
Walpole St Peter, Norfolk, 169, 171
Wansford, Northamptonshire, 177
War Artists' scheme, 72
Ward, James, 89
Waterhouse, Alfred, 47
Waugh, Evelyn, 43, 98
Wavendon, Buckinghamshire, 73
Wellington, Hubert, 15
Wenlock Edge, Shropshire, 47
West Walton, Norfolk **140**, **141**, 171, 173–4
West, Anthony, 21–2; *John Piper*, 13
Westall, William: *Views of the Caves . . . in Yorkshire*, 89
Whistler, Rex, 43
Wiggenhall St Peter, Norfolk, **67**
Wightwick Manor, Staffordshire, 166
Williams-Ellis, Sir Clough, 58
Willingale Doe, Essex, 15
Willingale Spain, Essex, 15
Wilson, Richard, 105, 144
Wiltshire Archaeological Society, 123
Windsor Castle, Berkshire, **53**, **54**, **55**, 72
Wisbech, Cambridgeshire, 169, 174
Woods, S. John: *John Piper*, 13
Woolf, Virginia, 16
Wordsworth, William, 173
Wymondham, Norfolk, **8**

Y Garn, Caernarvonshire, 105, 108
Yatton, Herefordshire, **80**, 195
Young, Lady Hilton (Kathleen Bruce; Lady Kennet), 177
Young, William, 93
Ystwyth river, Cardiganshire, 135

Zennor, Cornwall, 93

Endpapers: front and back, Brighton, Sussex 1939